DIGITAL PHOTOGRAPHY EXPERT

Nature

AND

Landscape
Photography

DIGITAL PHOTOGRAPHY EXPERT

Nature

AND

Landscape
Photography

MICHAEL FREEMAN

LARK BOOKS
A Division of Sterling Publishing Co., Inc.
New York

Digital Photography Expert:
Nature and Landscape Photography
10 9 8 7 6 5 4 3 2 1

Published by Lark Books, a division of
Sterling Publishing Co., Inc.
387 Park Avenue South, New York, N.Y. 10016

Text © The Ilex Press Limited 2004
Images © Michael Freeman

This book was conceived, designed,
and produced by:
Ilex,
Cambridge,
England

Distributed in Canada by Sterling Publishing,
c/o Canadian Manda Group,
One Atlantic Ave., Suite 105
Toronto, Ontario, Canada M6K 3E7
All rights reserved

A CIP record for this book is available from
the Library of Congress.

If you have questions or comments about this book, please contact:
Lark Books
67 Broadway
Asheville, NC 28801
(828) 253-0467

Printed in China

ISBN: 1-57990-545-5 ——

For more information on this title please visit:
www.mfxous.web-linked.com

Contents

Introduction

In all photography there is the question of what contributed most to the success of an image—the inherent qualities and interest of the subject, or the way in which the photographer interpreted them. In landscape and nature, this issue is at its strongest, partly because the subjects simply cannot be re-arranged—they are as they are—and partly because they invoke formal study in geography, botany, zoology and so on. Whether the landscape photographer likes it or not, many viewers will look at the images for information—how do these places look?

The two characteristic features of the photography of outdoor places is that they are highly accessible to everyone, and they don't intrinsically change very much. On the positive side, this makes landscapes, nature and cityscapes highly amenable to a planned day's shooting. You can simply go out and do it. There may be some restrictions on access to some locations, but by and large these are freely available subjects. This also means that they are free to every other photographer, and even without being competitive there is the undercurrent of wanting to shoot a little differently. Every photographer likes to feel that he or she has put a unique stamp on an image. Landscapes and other more-or-less permanent views that have been judged the finest of their type, have all been heavily photographed. Despite differences in personal taste, there is a remarkable consensus among people in deciding what looks scenically beautiful.

With a well-known, well-loved, and heavily photographed place, it is sometimes better not to see what others have done, but simply respond to it in your own way. Find the viewpoint and decide the treatment that seems best to you, without trying to build on, or avoid, the efforts of other earlier photographers. So what if the image bears some resemblance to an iconic image by Edward Weston or Ernst Haas? That would just be coincidence, and arguably better than turning away from a fine view just because it had been done before.

Of all the controls you have as a photographer outdoors, natural light is the greatest variable, and it makes the biggest difference of all to the mood. As light never remains the same the landscape itself is also in a constant state of change. It is often the lighting that suggests a photograph, but you can also, with experience, anticipate it. When you come across a possibly interesting view for the first time, think about whether it would look better at a different time of day. Early and late are often the most interesting times, not only because of the obvious picturesque qualities near sunrise and sunset, but because the light changes more quickly and can give you, in a short space of time, a wide choice of images. Weather, too, is all-important to all outdoor scenes. It controls the way the light strikes, from the soft raking sunlight of a hazy September morning to a flat gray overcast one. Be prepared for weather when planning a shot, and be ready to take advantage of any unexpected changes.

Natural **Landscapes**

Landscape implies image. By themselves, mountains, lakes, valleys, and forests are physical features, but combined and organized into a particular stretch of country, they become a landscape—something we can look at and appreciate visually. And what we can see, if it impresses us, we can make into pictures.

To make a good landscape photograph, it's important to appreciate the complexity of the place itself. Most landscapes create a wide variety of impressions, from the quality of the lighting and the sense of space to the details of rocks and plants. The aim is to distil one image from the total of sensory inputs. Anyone can appreciate a fine landscape, but turning this into a single still image takes skill. Ansel Adams, one of the greatest American landscape photographers, called this "the supreme test of the photographer—and often the supreme disappointment." Adams identified the essential problem, writing that, "Almost without exception, the farther an object lies from the camera, the more difficult it is to control and organize."

And landscapes are mainly far from the camera, and can't be moved around. Instead, the experienced landscape photographer begins by understanding what is appealing about a particular place. This is likely to be a combination of things—the wind, the sounds, the smell of the sea from a cliff-top, the scudding clouds. Not all of these aspects are visual, but it is only through the visual that a photograph can communicate the experience. To capture the rustling of leaves in a wood on a blustery day, the photographer has to find a view and a framing that shows the branches and the sky. Viewpoint, composition, and waiting for the right weather and light are the practical controls that you have.

There are many approaches that you can take to landscape photography, although most of these fall into three basic types. The first is representational—a realistic, straightforward treatment. The second is impressionistic, in which obvious detail is suppressed in favor of a more atmospheric and evocative image. The third explores abstract, graphic possibilities, also at the expense of recording all the details. Many landscape photographs combine these approaches. The first, representational, group is by far the largest, because showing what things are like is what the camera does best. The impressionistic and abstract approaches take more effort and run the risk of being seen as more mannered. Yet even within representational photography there are many styles, from formal to minimal.

It's important to remember that photography follows a long history of landscape painting, during which many ideas, perhaps all possible ideas, were at some point tried out. The ethos of much photography is that of breaking new ground, and this has become almost expected. And yet there is much pleasure to be had from hiking an area of natural beauty and simply capturing it in the way that we experience it individually. There is not necessarily any need to strive to be different. Landscape photography is as much about expressing a personal, simple enjoyment of the outdoors as it is about aiming to create fine art. For many people, it is more so.

A long tradition

"I own I like definite form in what my eyes are to rest upon; and if landscapes were sold, like the sheets of characters of my boyhood, one penny plain and twopence coloured, I should go the length of twopence every day of my life."

Robert Louis Stevenson

Digital landscape photography follows in a tradition that began in the fifteenth century—the idea of treating the land and its views as a subject for art. Until then, landscapes had been depicted only as the background for people and events, and the notion that a scenic view could be celebrated in its own right proved to be revolutionary for painting. The landscape gradually assumed more importance in painting, although it was still often just a scene in which things happened. It was only in the nineteenth century that landscape was finally elevated to its own distinct genre, celebrated by great painters like Caspar David Friedrich, J.M.W. Turner, and John Constable.

Photography followed, with its own special dynamics. Chief among these was the urge to show what places looked like, particularly exotic places. This was landscape photography as discovery, recording amazing sights. This happened all over the world, but because the evolution of photography coincided with the opening of the American West, wilderness landscape

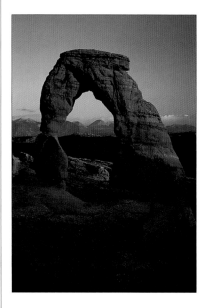

Arch
Landscapes can reveal the natural beauty of the environment, as in this shot of Delicate Arch in the Arches National Park, Utah.

Taj Mahal
There are so many well-worn "beauty spots" in the world that it's important to look for a new angle, such as viewing the Taj Mahal from the opposite bank of the Yamuna river.

photography was really an American phenomenon. When the first of these photographers, including Carleton Watkins, William Henry Jackson, and Timothy O'Sullivan, ventured West, they were explorers in two senses. They were trailbreaking and discovering new sights, but they were also working out the imaging possibilities of the camera, which was then still a new invention.

This was the other special dynamic that photography brought to landscape—the curiosity about what the camera could do. From Alfred Stieglitz and Edward Weston onward, many photographers have found that the purest way of working is to explore through the camera, and to be guided by the surprises that it delivers. This was landscape photography as a creative act—using the landscape as raw material from which to construct images in the photographer's own unique style.

Although landscape painting may seem far removed from digital photography—even further than from traditional film photography—its long history still has a lot to teach us. Not least among the lessons is that there can be a philosophy of landscape; an underlying intention behind the picture. This easily gets overlooked in the sheer simplicity and speed of making a photograph, and in the many things you can do to the image with software.

Ultimately, though, the great pleasure and excitement of digital landscape photography is the freedom that it gives you to explore and capture the beauty of nature—and, above all, the colors of nature. Digital imaging has introduced photographers to a new way of thinking about color because it makes available a toolbox for adjusting every minute and subtle aspect of color. You can choose your palette according to your style: perhaps delicate and undersaturated; perhaps close to monochrome; perhaps vibrant and full of contrast. This may be far removed from landscape painting in time, but it is closer in terms of artistic freedom.

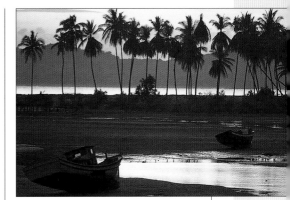

Rivermouth
Time of day is essential in getting the perfect landscape; here, the dusk light sets off this Malaysian scene beautifully.

Toronto
Urban environments and manmade vistas can be just as impressive as nature, as this dusk shot of downtown Toronto, Canada, reveals.

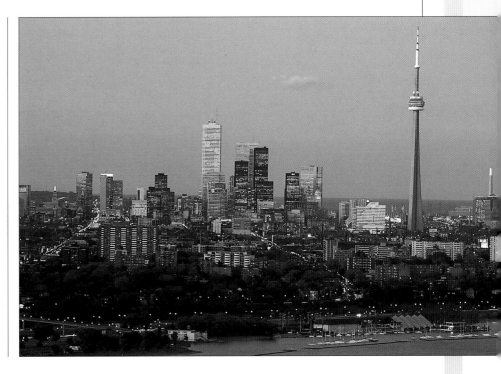

Digital landscape

Digital cameras restore the kind of control that was possible in the classic days of large-format black-and-white landscape photography—and go even further.

The arrival of digital photography, with its rapid supplanting of transparencies and negatives, has meant that all the varied fields of photography have needed to be reassessed. What differences, if any, are there between shooting with a digital camera and shooting with a film camera? There are the technical issues in doing what essentially seems to be the same thing–creating a particular image that you have in mind. But more than that, does digital capture actually change the way in which photographers think about particular subjects? The answer is more so in some fields and less so in others. In landscape photography, there may be less need to do exotic manipulations and distortions than in, say, advertising photography, but digital brings an extraordinary and welcome control over the all-important image qualities.

I happened to be looking at the *National Geographic Photographer's Field Guide*, written in 1981. Right at the beginning it declares, "An image doesn't start with a camera–it ends there," going on to say that once you've released the shutter, the picture is recorded for better or worse. No longer. The premise in that old manual was that you had better get it right on the spot, because the vagaries of natural light were unforgiving. Now, however, once a digital image is on the computer, you can correct, optimize and improve–if you shoot in the camera's RAW format, even more so. And, as we'll see, you can solve problems of viewpoint and lighting that were impossible to conceive of earlier. Back before the days of near-universal color photography, black-and-white film, and the darkroom offered a similar, though limited, opportunity to print one

Simulating filters
A plug-in filter from nikMultimedia simplifies the process of adding a graduated filter, combining color, angle, density and position controls. This is a highly effective substitute for an actual glass or plastic filter, and of course has the advantage that it is applied post-production.

image in several ways, according to the photographer's changing creative ideas. Digital brings back this almost lost feature of photography.

This ability to change your mind, at least in regard to some of the technical decisions in shooting, is one side of the newly minted digital coin. The other side is the feedback you have from being able to see what you shot immediately. Having released the shutter, concentrate on the LCD screen image. This is like a perfect Polaroid test shot—perfect in the sense that it is the actual image, not just a trial run. This feedback applies to any field of photography, but landscape in particular benefits from it, because there is nearly always enough time to redo the shot. This is in contrast to wildlife photography, which we come to later in this book. Having found your viewpoint and decided on the framing of the landscape image, you can usually work calmly, checking your decisions about exposure, color, and saturation, as well as less technical aspects such as composition. Unless the weather and light are extremely changeable, you have time to do this. The hills, trees, and water are not going anywhere.

A final benefit to using digital cameras for landscape photography is that the equipment is lighter and more compact than ever. Dedicated landscape shooting involves walking, trekking, and even climbing. Only a few good viewpoints are next to the road; most have to be sought out on foot, and the heavier the equipment, the more difficult this is. Large-format cameras were once the mainstay of landscape photography, and although the average digital camera still trails behind on resolution and detail, it is more than adequate for normal print sizes, while offering outstanding control over the image qualities. With this light equipment, you can move farther and faster.

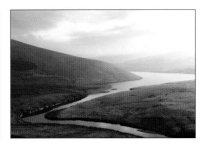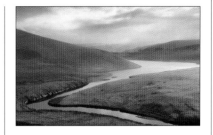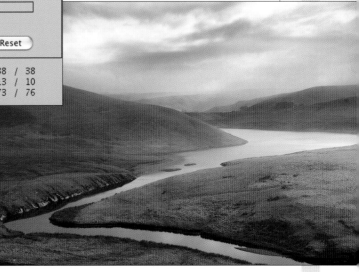

Sky and land
Shooting into backlit clouds in a Welsh valley gave two alternatives, correct for either sky or land, but not both. Combining the two exposures as layers allowed the best of both worlds. The too-dark areas of the shot exposed for the clouds were erased with a soft brush.

Enhance
In a second stage, the composited result from above was optimized using third-party editing software. In its automatic mode, iCorrect editLab recommended an increase in saturation and contrast.

Wide-angle

Many of the most successful wide-angle views evoke a sense of being there, drawing in and involving the viewer in the experience of the landscape.

Landscapes are among the most amenable of all subjects in photography—they can be treated in almost any style imaginable, and with any lens. The character of each focal length has an important effect on the way you deal with a landscape. The major difference, naturally enough, is between wide-angle and telephoto views. Many modern zoom lenses cover a serious range of focal length, from wide to telephoto, while SLR users have a large choice of different lenses. The most obvious use for a wide-angle lens is to take in more of a scene without moving farther back with a standard lens—quite often in a landscape, there are only a few choices of viewpoint, and stepping back may be impossible or obscure some of the view. However, it is the graphic effect of a wide-angle lens that is usually more interesting. Lines and shapes are stretched toward the edges—and even more toward the corners—giving an exaggerated perspective.

Vertical

Used in vertical format, a wide-angle lens such as this 20mm efl covers a wider range than we normally pay attention to. This works well if you have a distinct foreground and want to include the horizon, as in this shot of a petrified tree in Arizona.

Diagonals become a strong part of wide-angle views, often converging towards the distance, and you can use these to put energy into a photograph.

Wide-angle lenses play two roles in landscape photography. The first is the all-embracing view. From an overlook, or some other open viewpoint, they give a broad, sweeping view with something of the feeling of a panorama. Depth of field is rarely an issue in this case—these are distant views, taking in a large part of the horizon. The other role is in bringing a strong sense of depth to a scene by including the close foreground. In this type of shot, the

What defines wide-angle

As most sensor sizes are smaller than a 35mm frame, the actual focal length that denotes a wide-angle effect may be unfamiliar. Some camera manufacturers quote the old 35mm focal lengths as "equivalent focal length" (efl), and by this designation wide-angle is anything shorter than about 28mm. The angle of coverage is what counts, with standard at about 50°. Extreme wide-angles are more than 90°. The actual focal lengths for two popular sensor sizes are also shown—the third being common on digital SLRs.

focal length for 24 x 36 mm	focal length for 5.3 x 7.2 mm	focal length for 6.6 x 8.8 mm	focal length for 15 x 23 mm
28	7	6	18
24	6	5	15
20	5	4	13

Getting the strongest perspective effect

To make a wide-angle lens work to its maximum effect, include both foreground and background, and shoot from close to the nearest objects. You can create strong, and sometimes surprising, relationships between the near and far parts of a scene. If you also turn the camera for a vertical shot, this will bring even more of the foreground into view.

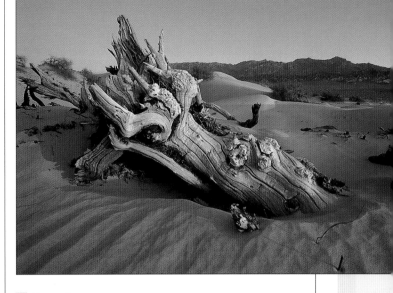

Near–far
Shooting very close to a foreground object, within a few feet, allows you to relate the near detail of a landscape to the distant topography, as here in Death Valley, California. Minimum aperture is usually essential if the depth of field is to extend right through the scene.

details of the landscape, such as flowers, rocks, and grass, are juxtaposed with the distant large-scale features like mountains. The success of this approach depends on how well you set up the relationship between near and far. In terms of technique, the camera position usually has to be quite low, and the aperture small to ensure great depth of field. The closer you are to a foreground object, the larger it appears relative to everything else. Use the viewfinder to experiment with the composition, keeping it to your eye as you move around—a small change in the camera position will make a big difference to the image. One of the benefits of most camera sensors being small (that is, smaller than a 35mm film frame) is that the depth of field is greater. Set against this is the drawback that small sensors make it more difficult to manufacture very wide-angle lenses.

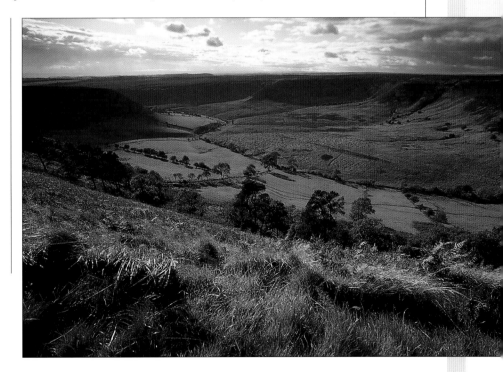

Capturing the overall scene
Another classic use of a wide-angle lens is to take in a wide area of landscape, usually from some kind of overlook—in this case, the lip of a huge bowl in the Yorkshire Moors, in northern England.

Case study: **Monument Valley**

With a wide-angle lens, which reproduces nearby objects large in comparison with those in the distance, you have an almost infinite choice of composition. By altering your viewpoint only slightly, the structure of the scene through the lens can change quite radically. In this case study, the subject was a well-known group of sandstone rocks, known as the Yei-Bichei Rocks and the Totem Pole, eroded into pillars in Monument Valley, on the border between Arizona and Utah.

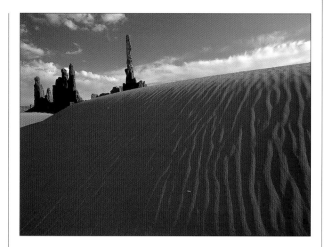

△ 1 From the start, I knew that I wanted to juxtapose desert foreground and the graphically strong, distinctive shapes of the rocks. Even small in the frame, they would dominate the horizon. I began at about an hour before sunset, and immediately found a sand-dune that I could use to "crop" the rocks away from the rest of the horizon

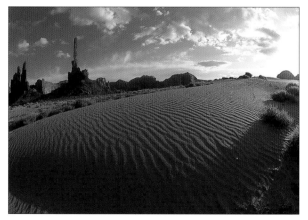

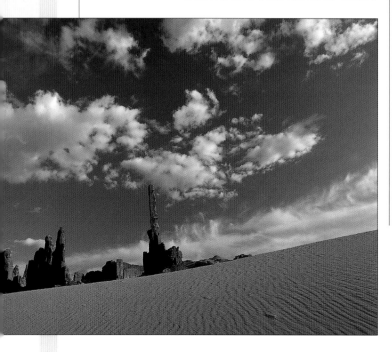

△ 2 For the topmost of these two shots, I positioned myself at the point on the sand-dune where the sunlight just grazed the ripples, and offset the rocks for a composition that would balance them against the pattern of ripples at right (smaller versus larger). This was a clean image, but it would perhaps have been better with the sun a little lower. In any case, I needed to explore farther to see what other opportunities there were. I walked around to my left, to create a shot with a similar treatment but with a less interesting shape to the sand (here reproduced to the left).

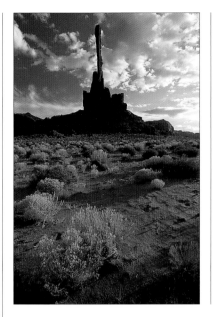

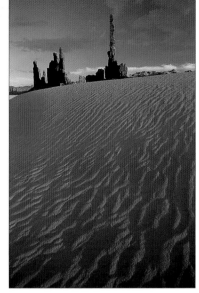

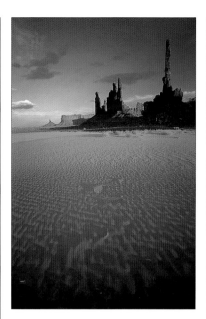

△ 3 Moving farther still, I spotted some desert flowers, and used a vertical composition to make the most of them.

▽ 4 I then moved back to the original viewpoint to capture the setting sun, going very slightly to the right as the grazing effect of the light had shifted by then. The composition of this shot is essentially the same, but with the camera aimed a little to the right to include the glowing cloud.

△ 5 I then tried out a vertical composition, so that the ripples spread out below me (another wide-angle effect).

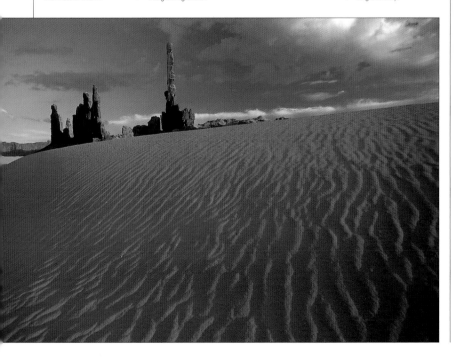

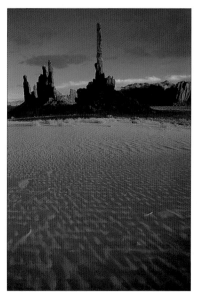

△ 6 Finally, when the light had fallen off the dune, I walked to the right where the sand was level, and caught the last of the sun there. In the final analysis, all of these shots work, and from time to time I prefer one over another. Basically, however, the second visit to the sloping sand-dune is probably my favorite. As so often happens when trying to make the best of one situation, the shots improve up to a point, and the last few prove that it's not going to get any better.

Telephoto

A long focal length, whether on a fixed-lens zoom or as a detachable lens, is an essential tool in landscape photography for closing in on details and compressing perspective.

With a telephoto lens you can select and isolate images from the scene in front of you, and this multiplies your options. In effect, it gives you a bigger variety of images from any one scene. For example, from one good overlook, you could expect at the most a couple of distinct wide-angle views, but there are likely to be several with a telephoto lens. The longer the lens, the greater the selectivity, and also the more unexpected the

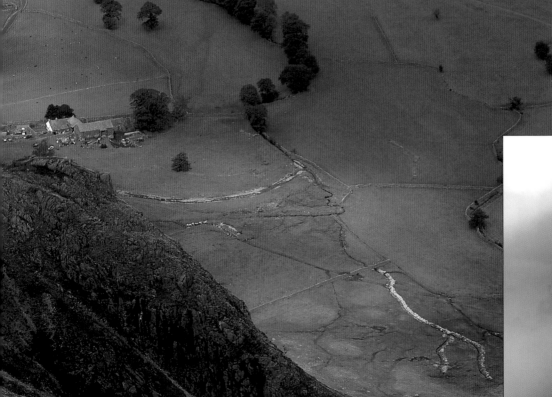

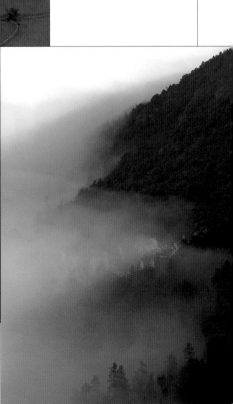

Detail from a distance
A standard use of a telephoto in landscape is its magnifying ability, which allows you to close in on a small part of a scene. Here, a small farm in the English Lake District is seen from one of the crags above the valley.

Compressed planes
Long focal lengths compress perspective. This is most obvious when there is a receding row of features, such as these spurs of a forested range of hills in the Gila Valley in the southwestern United States.

What defines telephoto

The term "telephoto" refers to a special design of long-focus lenses. The arrangement of lens elements allows the physical size of the lens to be shorter than its focal length—an obviously useful factor. For most photographers, the most important quality in a telephoto lens is how much it magnifies the view: between 2x and 4x for medium telephoto, and approximately 6x and more for a long telephoto.

focal length for 24 x 36mm	focal length for 5.3 x 7.2mm	focal length for 6.6 x 8.8mm	focal length for 15 x 23mm	angle of coverage	magnification
100mm	21mm	25mm	63mm	24°	2X
200mm	42mm	50mm	127mm	12°	4X
300mm	63mm	75mm	190mm	8°	6X
500mm	103mm	127mm	317mm	5°	10X
1000mm	206mm	254mm	634mm	2.5°	20X

▼ **Isolating detail**

Provided that the camera position gives some separation in color or contrast between subject and background, a telephoto will help to isolate one element from a landscape. In this example, a tree rises through the mist on the slopes of Mount Kinabalu in northern Borneo.

images. The wide-angle possibilities are usually obvious as soon as you reach a viewpoint, but the longer, cropped-in views may take a little while to discover. Depth of field is much more shallow than that from standard and wide-angle lenses, and this is no bad thing. You can use it to help subjects stand out against soft, unfocused backgrounds.

Telephotos are valuable in landscape photography in another way. They compress perspective and are therefore very effective in terrain that has strong relief, such as several ranges of hills stretching away to the horizon. In such cases, the different distances appear like stacked planes.

Long lenses outdoors also need some care in use: they not only magnify the view, but also any camera shake. A tripod helps composition and reduces this risk, but may be no protection against a breeze. On a windy day, shelter the lens and tripod, or shoot from a low position. Alternatively, rest the camera firmly on a wall, rock, or branch, using a jacket or any other material to protect it from scratching. Ultra-telephotos with wide apertures, available for SLRs, are longer and heavier than other types. They use very large front elements, making them even bulkier, and need rather more care in use. These lenses are definitely best used on a tripod.

Just as the small surface area of most sensors reduces the wide-angle effect of short focal lengths, it increases the apparent magnification of a telephoto, and is a definite bonus for closing in on distant detail. With fixed-lens digital cameras, the telephoto end of a zoom range can be more powerful, and with most digital SLRs, your existing long lenses will typically gain about 50 percent in effect.

Organizing the scene

Composition in photography is the way in which you order the different elements visually in the frame, and has a special importance when it comes to landscapes.

Landscape is nature, and often—all too often—chaotic. This is at the heart of the problem for photographers—how to bring some sense of visual order to the scene in front. Edward Weston, one of the great American photographers in the formal tradition, at first believed that landscapes were a lost cause for the camera, calling them in general "too crude and lacking in arrangement." Later, significantly, he went on to master them, but Weston put his finger precisely on the issue. He, like most photographers, wanted to make graphically strong images of his own choosing, but landscapes are what they are, and they can't be physically re-arranged in the way that a still-life can.

The view, however, can be altered, simply by moving around it. Finding a good camera position may sound such an obvious thing to do that it's hardly worth mentioning. In practice, however, many people simply shoot what they see from where they first see it. This is by no means always the lazy option—photography is often about catching the immediate on film, and there may just not be enough time to move around before shooting.

▽ Minimalist
The combination of snow and thick cloud on a winter's day in Massachusetts produced scenes that were inverted in tone and almost abstract. Even so, I felt that the beach needed something tangible to hold the composition together, and walked until I found this long piece of driftwood. The camera viewpoint is high enough to locate the tree trunk entirely against the snow. Being slightly off-center with the roots at the right, it draws the eye across the frame from right to left.

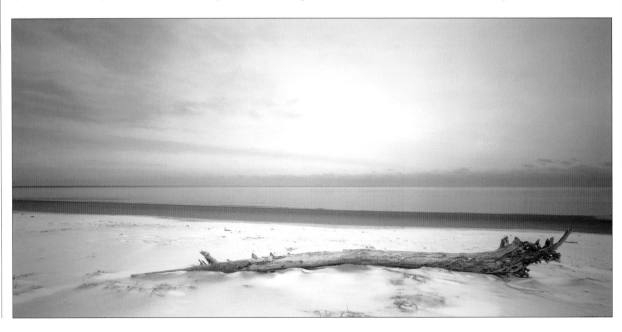

Nevertheless, when there is time, use it to make sure that you have the best viewpoint for the shot. Sometimes this may be no more than a matter of improving slightly on your first position; at other times, you may find that a radical change gives you a picture you had not imagined existed. To an extent, and with experience, you can anticipate the view from different positions, but it is always better to walk around and try out the possibilities. Fortunately, landscapes tend to be less transitory than many other camera subjects, except when the weather is changeable.

When you are making this kind of reconnaissance, try out, or at least keep in mind, your different focal lengths. Viewpoint and lens are inextricably linked, and with unusual viewpoints—from above and below—wide-angle and telephoto lenses give completely different types of image, even more so than from ground-level. The view with a wide-angle lens changes much more than with any other kind as you move around the terrain—provided that you are close to the foreground.

Graphic vs. disorganized landscapes

The type of terrain has a decisive effect on composition. Without doubt arid, coastal, and mountain landscapes that feature bare rock and strong shapes have an advantage in the graphic department. Lush vegetation can, from many angles, simply look untidy, blurring the lines and shapes. Graphic is not the only ideal, but it certainly makes for stronger, more immediately striking, compositions.

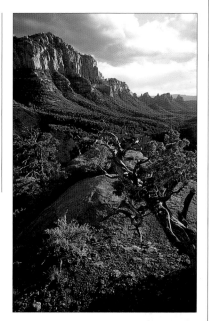

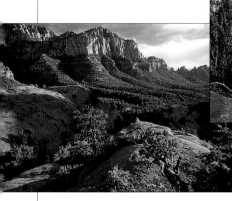

Finding the foreground

In this sequence, overlooking Bear Wallow canyon near Sedona, Arizona, the late afternoon light was right for the escarpment beyond. With a wide-angle lens, the missing component was a foreground that would relate compositionally with the cliffs. I climbed around an area of rock about a hundred yards in both directions, with these results. The most satisfying composition was the one shown right, when I crouched low so that the branch would fill the right part of the sky.

Figures for scale

With or without people? You may not always have the choice, but including—or introducing—figures into the scene creates a different type of image, with the potential for added dramatic effect.

Several of the techniques that we have looked at already, particularly those that exploit the special characteristics of wide-angle and telephoto lenses, have a secondary effect in that they help to establish the scale and proportions of a landscape. If you crouch down to include a clump of flowers in a view that extends to distant mountains, you are immediately making the scale and perspective clear to the viewer. Equally, focusing in on a distant tree with a telephoto provides a recognizable key. There is, of course, no rule stating that photographs have to be easily understandable, and a little later, on pages 60–63 we look at styles of shooting that deliberately take the context out of a landscape. Nevertheless, making a scene intelligible is a common approach, and scale is one of its basic qualities.

There are other reasons for including figures. One is simply that it humanizes a landscape. The figure has a relationship with the scene, and in a way stands in for the viewer, who can identify with the person and have some impression of what it feels like to be a part of that landscape. Figures were an essential component in Classical and Romantic landscape paintings for this reason; when they were depicted in the foreground looking away toward the distance, they were, in effect, inviting the viewer to stand by them and admire the scene. Yet another reason to include a figure in an image is that certain features in a manmade landscape, such as a winding road, look as if they ought to be in use. A passing cyclist, or even a car, often makes a shot look more satisfying than emptiness.

How large the person, or people, should be relative to the landscape is another question to consider. Imagine a scene in which someone is walking along a path toward you, their image getting larger. At a certain point, the figure takes over the image, becomes so dominant that the picture is no longer landscape-plus-figure, but figure-with-background. On occasions like this, it's a good idea to keep shooting and decide later which proportion of person to landscape works best for you. As a general rule, the smaller the figure, the more impressive the setting appears to be by comparison. If the figure is so small in the frame that it takes the viewer a moment or two to discover it, this can add an element of interest and surprise to the image.

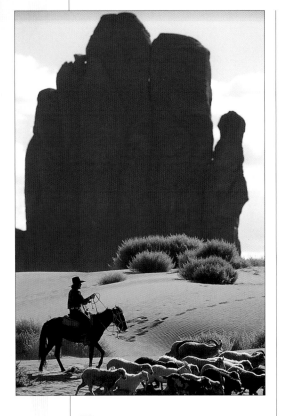

Monument Valley
This area of mesas and buttes on the borders of Utah and Arizona is a paradise for desert landscape photographers (see pages 16–17). This unplanned opportunity of a local farmer herding his sheep was too good to miss, and offered a different take on a landscape normally photographed without people. It also made the cover of a state guidebook.

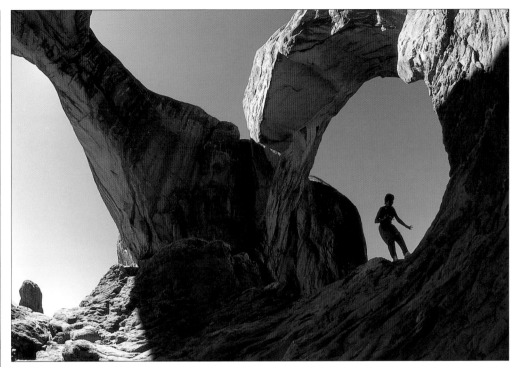

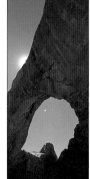

Arches

Arches National Park is known for its exotic arch and window landforms, carved out of sandstone by wind and water. In version shown left, the presence of a figure gives context and scale, while the other image is more graphic.

Cyclist

The shape of this gently winding road in New Brunswick, Canada, seen through a telephoto lens and glistening in the late afternoon sun, had the makings of a photograph, but not alone. I waited until a lone cyclist came pedaling by, giving not only a sense of scale, but a purpose to the shot.

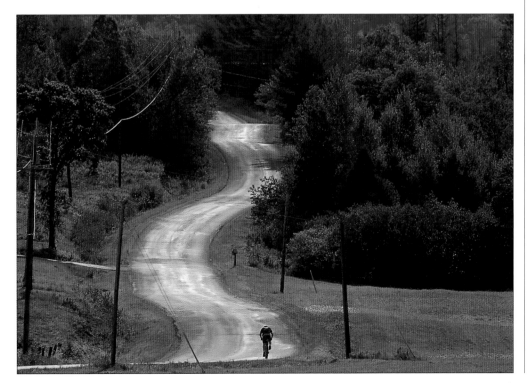

Overlooks

It is a part of human nature to want to climb up to survey the view—any view—and for the camera this offers the opportunity for a larger variety of images than just an overall establishing shot.

High viewpoints have a particular value for photography. They often give a sweeping overview of the landscape–an all-encompassing shot that sets the scene–but also give the opportunity to pick out details. As we saw on pages 14-15 and 18-19, different treatments can be made with wide-angle and telephoto lenses, and overlooks are places to experiment with this.

Overlooks define themselves. They are locations, usually quite small, that offer a wide view over the surrounding country. Built in to this definition is that it is a worthwhile view, and of course the range and impressiveness of the view varies enormously. But it seems that most of us have a natural urge to look out over things, and good overlooks are usually signposted, marked on maps and recommended in guides. This was less of a problem in the early days of photography when fewer photographers– indeed, fewer people–scoured the countryside looking for grand views.

This is all right as long as you don't mind repeating images that other people have shot. One added limitation of overlooks is that, because of topography in hilly terrain and vegetation, particularly trees, there may be

▷ **Paradise Valley**
As the road climbs up to the snowline on the slopes of Washington's Mount Rainier, it switchbacks through the pine forests. For the most part, the trees obscure the view, but at each outer bend there are possibilities, more or less good. Driving up slowly, I finally found one break that gave the basic conditions for an overlook view—foreground trees but to one side; a middle ground slope falling away; and a clear view to two ranges of mountains. The whole scene tied together as a continuous landscape.

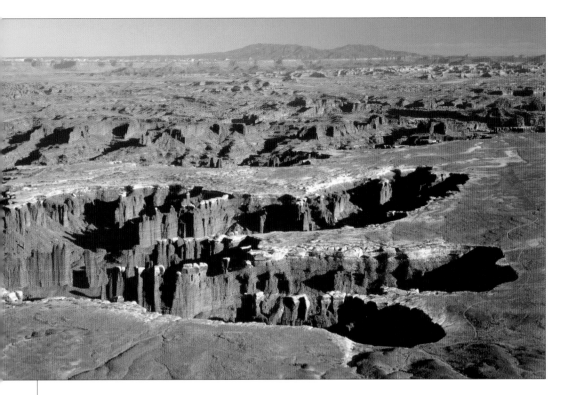

Variety of image
One ever-likely possibility from an overlook is that there may be quite different images depending on the focal length of lens and the cropping. Here is a simple example from a viewpoint in Canyonlands National Park in Utah. In addition to the obvious main shot taken with a wide-angle lens (left), there are also details to explore with a telephoto, such as the characteristic caprocks (below), where a harder band of pale sandstone has resisted weathering more than the red.

little choice in the camera position, and so little opportunity to vary the composition. To a certain extent you can play with different focal lengths, and so also with the position of the horizon, or whether to include it at all. Here is what Ansel Adams wrote about one of his most famous photographs, Clearing Winter Storm, shot in 1940 in Yosemite: "At this location one cannot move more than a hundred feet or so to the left without reaching the edge of the almost perpendicular cliffs above the Merced river. Moving the same distance to the right would interpose a screen of trees or require an impractical position on the road. Moving forward would invite disaster on a very steep slope falling to the east. Moving the camera backward would bring the esplanade and the protective wall into the field of view. Hence the camera position was determined..." This is entirely typical of shooting from overlooks.

What can make the difference, and allow you to make an individual image, is the light and the sky. Changeable weather, as we explore on pages 52–53 and 66–67, can make a stunning difference. With storm clouds in particular, there can never be two exactly similar images. There may be a strong temptation to shoot close to sunrise and sunset in clear weather, but this may not result in an original image.

Framing the view

The frame that you see through the viewfinder is not the only format for a photograph, and many landscapes benefit from having an appropriate shape of frame.

One of the less-than-obvious benefits that digital cameras have brought to photography is that they have released it from the tyranny of the fixed frame. Not all photographers have yet realized the full implications of this development, but the ability to choose the shape of the final image–on screen or in print–is a worthwhile creative freedom. And landscapes, more than many other subjects, need this extra thought, particularly the many views that suffer from uninteresting skies and foregrounds. Being able to crop out certain parts of a scene is an extension of the natural process of composing the image.

And yet digital cameras themselves have a picture format as fixed as any film frame, so why should there be anything different? The answer is in the way that digital photography is now open-ended. Unless you go straight from memory card to printer, you have the intermediate steps of opening and optimizing the images on the computer, where cropping tools are common. And because you can do this, there's every reason to consider exactly how each image should be cropped. Paradoxically, this takes photography back to the days when black-and-white ruled, and it was normal to treat enlargement and printing in the darkroom as a follow-on creative stage. It was color slides and fast, efficient, photo-finishing labs and shops that removed printing from the hands of most photographers.

Low horizon, big sky
From this viewpoint In Big Bend National Park, Texas, there was little of interest in the foreground. There would have been little incentive to shoot were it not for a sky full of different clouds.

The family of frame shapes

One of the following picture formats will best suit a particular subject. The decision of which to use is personal. Within these basic shapes are opportunities for precision cropping.

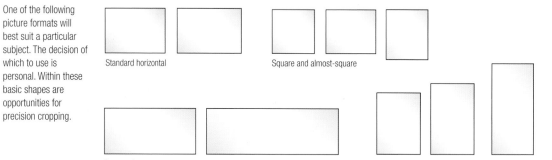

Standard horizontal

Square and almost-square

Panoramic

Standard vertical

Tall vertical

Now you can treat each image as its own special case. Most digital sensors—and so the viewfinder and LCD frame—are in proportions of about 4:3, with a relatively small number of digital SLRs offering the 3:2 proportions of 35mm film. Of course, almost any view can be made to work visually in one of these standard frames. In fact, a large part of photography has to do with fitting a scene into the space that the viewfinder allows you. Nevertheless, you should not feel restricted to the format of your camera. You have the option of cropping the picture area later, and this means two things. One is that you can improve the composition of a shot when you come to image editing. The other is that you can anticipate at the time of shooting how you will later crop it.

Fine-tuning the crop should be a normal part of image editing—for instance, taking a little off to remove a twig intruding into the frame. However, the first decision is the basic format, and the choices are shown in the box opposite. Most photographs are shot as horizontals because cameras are made to be used that way (though there is something of the chicken-and-egg in this, as cameras are designed for the way most people take pictures). Also, a horizontal frame is easier to look at because of our binocular vision. In many landscapes, the scene is laid out horizontally, and so suits this shape well. Unless you have a high viewpoint and strong relief, it's likely that this horizontality will be very strong. This is where panoramic formats come into their own, and we look at these in more detail on the following pages.

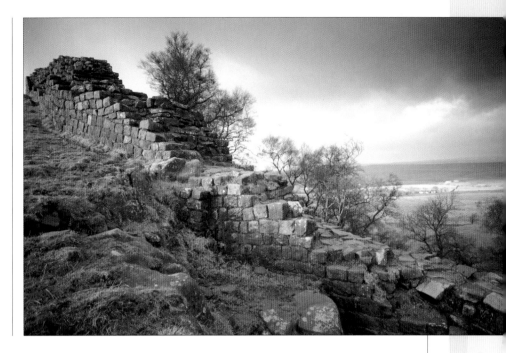

Filling the frame

Hadrian's Wall was built by the Romans across northern Britain. Here, where it courses down a steep slope, it was possible to make it occupy the full horizontal frame as a diagonal, using the storm clouds at upper right to balance the composition.

Cropping to horizontal

This shot is of high moors and wetlands in central Wales. Seen from a slight elevation, the horizontality of everything in view, from the marshy river to the series of low hills beyond, made for a very spare composition. Strong cropping top and bottom emphasized this.

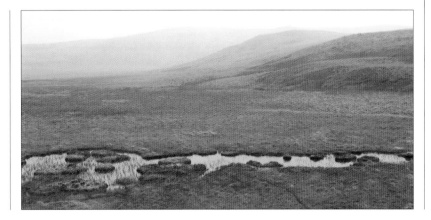

Other frame shapes

Vertical and square picture formats have their role in landscape photography as well as horizontal formats, and digital cropping can improve the final image.

The camera can always be turned on its side for a vertical view. A vertical frame is often worth the slight extra effort to think about and shoot, if only to bring some variety to your pictures. In landscapes, this tends to work best with a telephoto lens (see pages 16-17) and from some elevation, as in the example shown left. Under the right circumstances, the compressing effect that a long lens has on perspective helps to make a compelling image simply because it shows us what we don't normally see in a landscape—features stacked one above the other.

Wide-angle views are much less amenable to the vertical treatment, mainly because of what happens above the horizon line—or rather, what doesn't happen, for surprisingly few skies are interesting enough to fill the larger part of a picture frame. A distinctly wide-angle lens takes in at least an 80-degree angle of view, so this is always an issue, unless the foreground is really worth concentrating on. By the same token, if you can make this work, the image will have the value of being less than common.

Another way of using a vertical frame is when your main focus of interest is relatively small. A vertically framed photograph is slightly less easy to view, and the eye naturally tends to fall to the lower half of the picture—often the most comfortable place to position a subject. Vertical framing obviously also works for tall, thin subjects, such as a lone pine tree. Occasionally, it's worth considering an extreme vertical cropping for subjects like these—the effect is unexpected and so has a certain surprise value.

A square format, very much a hangover from the more old-fashioned medium-format cameras, seems at first glance to fall between the two stools of horizontal and vertical. Nevertheless, it has its own particular character, albeit a fairly rigid and formal one. This makes it suitable for subjects that have an element of symmetry to them, and also to graphically simple, minimal scenes (see pages 60-63). These can be refreshing occasionally, but can dull if used in succession. Patterns and textures, however, often work very well in a square frame, simply because it doesn't have a bias one way or another. And, naturally, a square format also suits any subject that fits neatly into it, such as a broad single tree in full leaf.

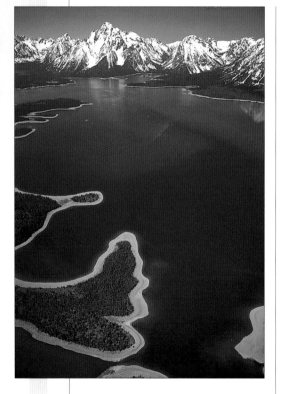

▲ Vertical aerial
To work vertically, overall landscape views generally need foreground interest to sustain the composition. In this aerial of Jackson Lake and the Grand Tetons, Wyoming, shot with a 20mm efl lens, the shoreline made an obvious counterpoint to the mountains beyond. I began shooting horizontal frames, but as the aircraft approached the lake, the visual separation between the shore and the mountains increased, and I switched to vertical framing.

Giant fern

A square frame, giving no bias in either direction, perfectly suits this shot of a giant tree fern on the slopes of a mountain. The essence of the image is the evenness of texture and color, which fill the picture frame.

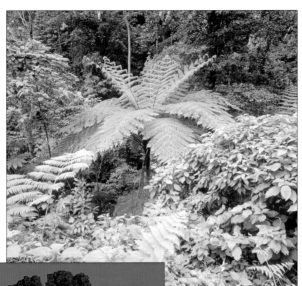

Cropping or extending

The natural way to alter the frame shape is to use the Crop tool in an image-editing program, and this is intuitive. An alternative is to enter new dimensions for the canvas size. But you could also consider extending the frame by taking an additional shot or two that overlaps with the first. These can be assembled easily, as discussed on pages 32–33.

Extreme verticality

A huge Douglas fir growing in a narrow sandstone canyon is one of the spectacles of Bryce Canyon National Park, Utah. The viewpoint is limited to just this, and the extreme verticality of the image makes this strong vertical cropping a natural.

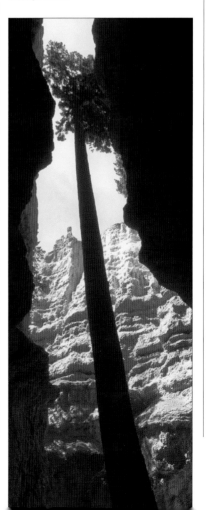

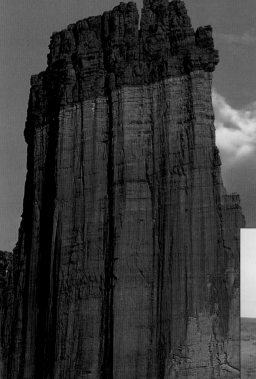

Meas Llia

A lone standing stone from the Bronze Age high on a Welsh pass is another natural for a vertical shot. A horizontal framing, also valid, would have created more of an overall landscape punctuated by the stone.

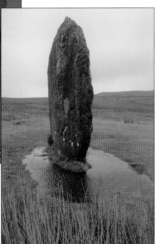

SLR ratio

The proportions of this sandstone tower coincide closely with the 2:3 ratio of a digital SLR, making it an easy fit that emphasizes the color contrast between the rich red of the rock at sunset and the surrounding margin of blue.

Panoramas

Although the shape of this format is extreme, a panoramic frame has a special place in photography—and above all in landscape imagery, with which it has a close affinity.

There are no precise definitions of a panorama, but it is normally accepted to be at least twice as long as it is high—proportions of 1:2, 1:3 or even more. The dynamics of this kind of picture frame are quite different from those of the standard rectangles in digital photography (3:4 and 2:3), and work as well as they do in landscapes because they fit neatly into the way in which human vision works.

We see by scanning, not by taking in a scene in a single, frozen instant, meaning that the eyes build up a composite impression of a view by moving rapidly across it, lingering over details one at a time. The easiest movement for the eyes is from side to side, which is why we tend to "see" and remember open scenes, such as those from an overlook, as panoramas. Expansive landscapes are exactly the type of subject that comes closest to these conditions. In fact, the majority of landscapes, as we experience them, are essentially horizontal, frequently dominated by the horizon and by the linear

▽ Pleasure in detail

To work for the viewer, a panorama needs to be reproduced large and seen from close. The effect is of immersion within the scene. At this scale of reproduction (ideally even larger than below), the eye can explore the details of a landscape, which does not, therefore, need to contain obvious and dominant features. Here, the play of light after an evening storm picks out the fine details of fields and hillsides.

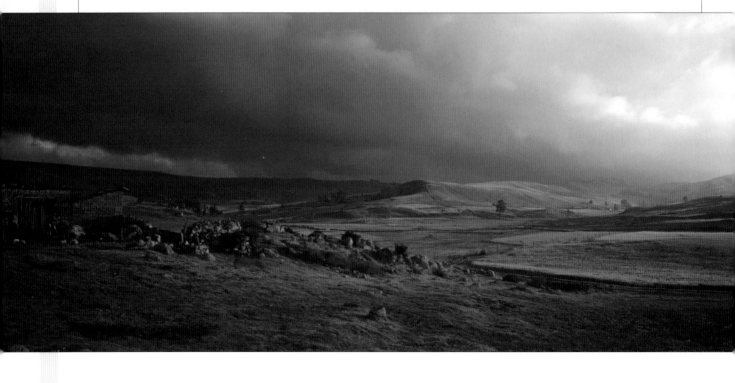

appearance of features that recede into the distance, such as ranges of hills and mountains. By contrast, we tend to ignore the upper part of the sky in a view.

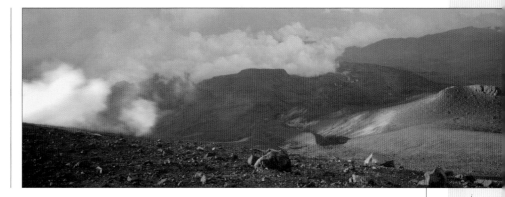

To work optimally, a panoramic image needs to be reproduced large and viewed from close—in other words, approaching something of the scale of a real scene. This gives added importance to the way in which you display and present the image, ideally as a large print or on a large screen (the desirability of so-called "cinema" monitor displays and letterbox formats is further evidence of how attractive this format is to most people).

One of the features of a longish panorama, say 1:4 proportions, is that if you view it at a sensible distance, so that the height seems adequate, it is not possible to see the entire image at once. Parts of it remain peripheral, and this replicates the way we look at an actual landscape. It adds an element of realism to the picture, and, in theory at least, slows down the viewing process and prolongs the interest of exploring the image.

Digital photography is arguably the best means ever of reproducing a panoramic landscape. In the days of film there were just two alternatives. One was to crop the image down from the top and bottom of the negative or slide, with the obvious disadvantage of losing resolution if a small frame had to be greatly enlarged. The other was to use a special panoramic camera, of which several designs are still made, each using a wide strip of film; these are a costly additional piece of equipment. With a digital camera, however, it is possible to build up a larger, longer image by shooting several overlapping frames from one side to another. Indeed, now that Stitcher software is widely available, this is not just possible but easy. Many camera manufacturers include this capability on the software package that accompanies the camera; this attests to the popularity of stitched panoramas, which we examine on the following pages.

Moving the eye horizontally

It can help to strengthen the composition of a panoramic frame if you use features in the landscape that give a direction across the image from one side to the other. In this late afternoon view from close to the summit of a volcano in the Andes, the slope of the terrain, partly defined by the clouds, is from left foreground to right distance. The plume of gases from a fumarole at left sweeps down the hillside in a blur (because of the long exposure in fading light), adding to the sense of direction.

Stitching and mosaics

Now an integral part of digital photography, software to join adjacent frames is at its most useful in creating images featuring broad panoramic sweeps of a wide landscape.

Panoramas have a time-honored role in landscape imagery, and they have truly come of age with digital photography. In a striking example of how technology can have a positive creative effect, the invention of stitching software has made it extremely easy to shoot overlapping frames and join them together into one seamless image. The software is available from a number of sources—even included with the camera in some instances—and its success has been due as much to simplicity in use as to engineering. The software varies in its user-friendliness. The better-designed ones require no special skill, and it is only by being fast and practical that stitching is useful as a part of landscape photography.

18133.18.tif
18133.19.tif
18133.20.tif
18133.21.tif
18133.22.tif
18133.23.tif
18133.24.tif
18133.25.tif

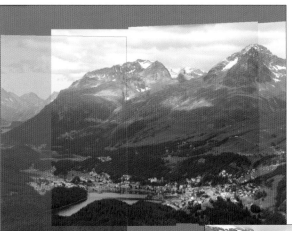

Stitcher

Using the Stitcher 3.5 software from RealViz, this sequence was shot and compiled with minimum preparation. Using a 160mm efl lens without a tripod, the sequence was shot rapidly from a mountain overlook in the Swiss Alps, from right to left, overlapping by approximately 40% from frame to frame. The long telephoto lens offered no distortion problems, and the only disadvantage to not using a tripod was a slight loss top and bottom because of the unevenness in the sequence.

What to look for in stitching software

1 Drag-and-drop loading and placement of images.
2 Largely automated.
3 Can stitch hand-held sequences.
4 Predicts lens focal length and distortion.
5 Handles the file format that you usually shoot.
6 Manual "force" stitching override.
7 Planar output as well as cylindrical and other interactive formats.

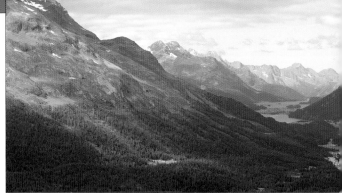

The basic use for photographers is to assemble a panorama. While stitching software is also designed to produce cylindrical and even spherical images, for a normal, flat photograph you simply need planar output. The stitcher works by matching identical features in adjacent frames, so the more information it has, the better. A good rule to follow is to allow 50 percent overlap. The easy way of doing this is to pan and shoot from one side to the other, using an obvious detail close to the leading edge of one frame as a reference point, then centering this in the next frame (see box). Strictly speaking, the camera should be rotated around the nodal point of the lens, but in practice it doesn't have to be so accurate, unless you are shooting with a very wide-angle lens and very close to something. The second step in the process is equalization, in which the software computes the blending of tones and colors. To do this accurately, the exposures should all be the same; hence manual, not automatic.

A second use is to build up a larger image from smaller sections. There are two reasons why you might want to do this. One is to make a higher-resolution image than your camera is capable of in one shot—simply switch to a longer focal length and cover the same area with a pattern of frames, then stitch. The second is when you can't step back far enough to cover the view. Again, take two or more (as many as you like) shots and stitch on the computer.

These are essentially realistic solutions, but there are other approaches. One is to make a multifaceted portrait of a location by shooting from a number of camera viewpoints, then combining the different images in a mosaic. There's no question here of a seamless image, but you can take more of a Cubist approach. The digital component in this treatment is really the ease of cutting, pasting, and joining.

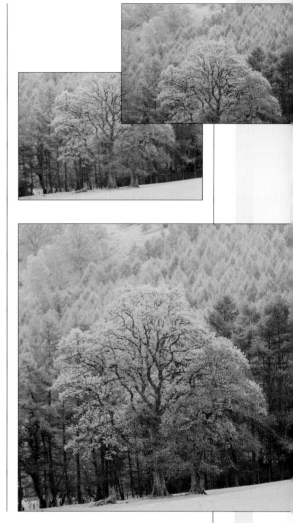

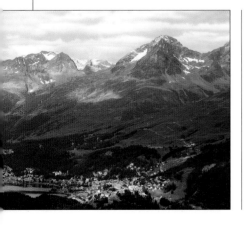

Shooting a panoramic sequence

Choose a convenient viewpoint and shoot the entire sequence from there. Make a dry run first to see how many frames you need to complete the panorama, allowing for a large overlap. Work from left to right or right to left in one sweep, and use details at the far edge of each frame as a focus for the center of the next frame. For accurate blending, which applies especially to the sky, switch to manual exposure and find a setting that will cover the widest range of tones. In a cylindrical or very wide panorama, the sun is likely to be in shot somewhere. One solution to avoid flare is to stand so that it is shaded by a natural feature, such as a tree.

Achieving higher resolution

It was not possible to get far enough back along a country lane to include all of this tree with a 270mm efl. The solution, with the added benefit of higher resolution, was to build up the image from two partial shots, taken with the 270mm efl lens, using stitcher software to create a composite.

Interactive landscapes

Panoramas encourage viewers to explore and find their own views within, but to make the most of this involvement, the images need to be presented large.

The first reaction to an interesting landscape is to try to take it in as a whole. It will be most immediately absorbed as a wide vista, stretching to the horizon. The eyes sweep across the scene, taking in the sense of scale, the mass of detail, and the relationship between the foreground and the background. These are the appealing qualities of a panoramic view—it is expansive yet full of hidden interest. The stretched frame forces the eye to flick from side to side, just like viewing a real landscape.

To convey this impression in an image takes care. Human perception views the scene quite differently from a photograph taken from the same viewpoint. With the real landscape, our eyes build up a composite impression by scanning, lingering over details one at a time. To allow this to happen with a photograph, it must be reproduced at a scale so that at a normal viewing distance it cannot be taken in without moving the eyes. Panoramic frames such as these give the eye a chance to roam around the picture. Provided that you view it close enough, you discover different things within the picture, even if this takes only a few seconds. This draws people into a panorama, and helps to make it more interactive than a normal image, in the same way that wide-screen movies, like those shot in Panavision, have something of a "wrap-around" feeling. In composing a panorama, don't feel compelled to integrate everything. The frame can act like a storyboard, with things going on in different parts. It even works to have the frame "divided" into panel-like areas. Where possible, include plenty of detail or events in the frame, so that the eye has every opportunity to explore.

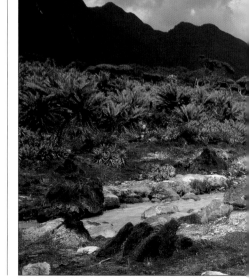

▷ **Andean landscape**
Panoramic formats are easier than any other for landscape composition and framing because they seem so natural to the eye. The main concentration of interest here is the pale-colored stream fed by geothermal springs. The expanse of vegetation right and left, instead of being redundant, helps to enhance the setting.

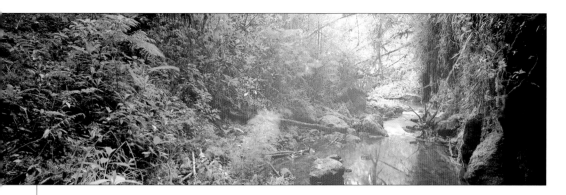

Rain forest
This enclosed view of rain forest deliberately excludes any horizon or open space. By extending the view left into a mass of vegetation, the panoramic frame gives an entirely accurate sense of forest stretching on endlessly.

Sunset
This minimal panorama was shot late in the evening in uncharacteristically clear weather in the Scottish Hebrides. With the sun just touching the low hills at the end of the loch, everything of interest was compressed into a narrow horizontal band. No other format would have done adequate justice to this scene.

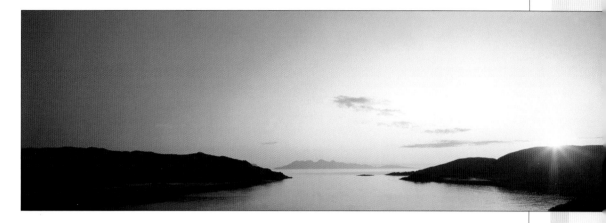

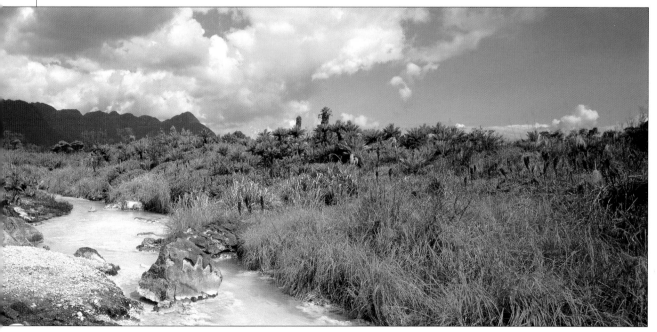

Natural frames

Although hovering on the edge of a cliché, the use of overhanging branches and natural windows as devices to organize a scene can be effective if used sparingly.

Occasionally you can find—or make—a kind of frame within the scene that you are photographing. It might be something as obvious as an archway or the overhanging branch of a tree, or it might be more inventive—an arrangement that exists only because of the way you position the camera. Like any other strong technique, it succeeds when used occasionally, not most of the time, and also when you exercise some originality. If the device is repeated too often or if it is too obvious, it becomes a cliché.

When it does work, it gives a graphic completeness to a picture. This is partly because the frame is natural—in the sense that it is part of the scene itself, and not just an arbitrary rectangle like the camera's viewfinder. There is a kind of formality in this kind of composition, because the natural frame contains the view. This is exactly the opposite kind of picture design to that in which you allow the elements in the scene to spread out and flow beyond the edges of the frame. The emphasis here is on concentrating the view and directing the attention inward. There is another reason why it tends to integrate an image—the frame is a distinct foreground. Combined with the scene beyond, this gives a sense of depth, and helps to pull viewers into the picture, giving them the impression that they are looking through from one scene to another.

Natural frames include branches of trees (this tends to be most effective when you include part of the trunk and the lower curve toward roots), rock arches, cave

Window onto a beach

By a happy coincidence, this natural window, formed by an old piece of driftwood, not only faced out toward the sea on a Washington beach, but also corresponded in shape with a rocky island just offshore. The combination of lens focal length (wide) and camera position was important in creating a tight frame.

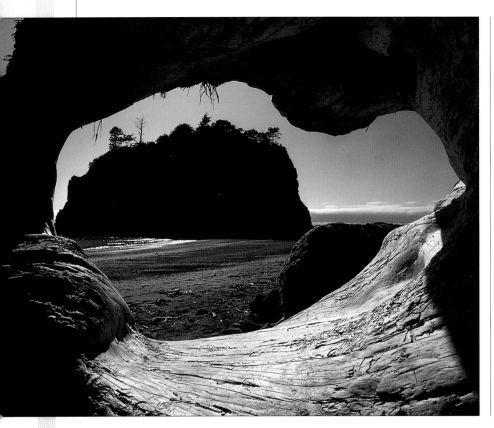

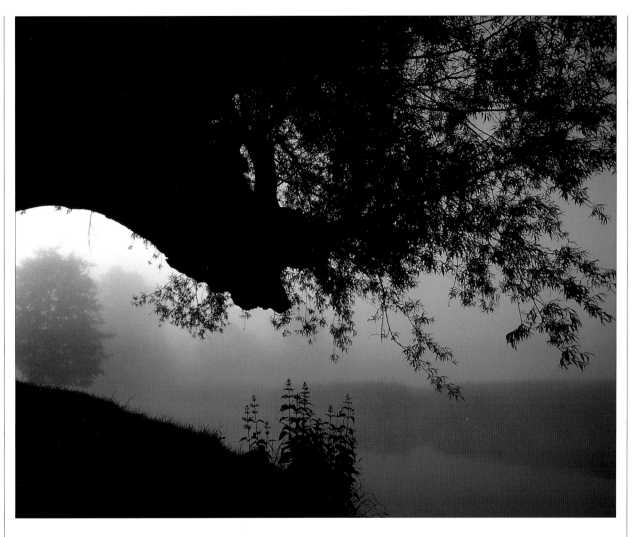

openings, gaps in fences and gates, and more. Pay attention to the light, color, and detail on this natural frame. The cleanest graphic appearance is often when the frame is in shadow and the scene beyond brightly lit, but an interesting texture, such as the bark of a tree trunk or weathering on an old gate, will usually add to the image. Also experiment with the size of the frame that you've found in relation to the picture frame in the viewfinder. If you leave too much space between the outer frame edge and the inner natural one, the full framing effect will be less. If there is only a narrow gap between them, this in itself can make an interesting shape. Silhouetted frames, such as those that you can find when looking outside from a darkened interior, are graphically the strongest of all.

Overhanging branch

Morning mist along the banks of the Stour River in eastern England gave all kinds of silhouette possibilities with the oaks, willows, and other riverside trees. The curve of this thick, overhanging branch was begging to be used as a frame. As in the picture opposite, the choice of lens focal length and distance determined the framing—in this case, of a misty tree in the distance.

A point of focus

One classic approach to landscape photography is to emphasize one particular subject within the scene, making it the key to the composition.

At the heart of landscape photography is the appreciation of how the image differs from the experience of actually being present. The image frame fixes the view and our response to it. Instead of the eye roaming around a real scene, concentrating for a moment on a detail, then moving elsewhere so as to build up a composite impression, a photograph is channeled into a tighter way of seeing. And the eye naturally looks for reference points—for objects in the landscape that give some sense to it.

Ansel Adams, who wrote extensively about his own exacting methods of landscape photography (which is why I make no excuse for quoting him a number of times), was of the opinion that "in landscape work, we must strip the image of inessentials." In other words, decide what the picture is about, concentrate on one or two elements, and compose the image to make these prominent. There are other ways of designing a landscape photograph, as we'll see in some following pages, but it's no bad idea to begin with a single, dominant subject.

The essence of a subject

The subject here is a forest waterfall. This was attractive enough in long shot, but not particularly distinctive. This was a feature that would benefit from a less obvious treatment. Using a longer lens made it possible to fill the frame with falling water, but keeping the focus on the leaves in the foreground. A long exposure turned the water into a streaked blur, but it is still very much the subject of the shot.

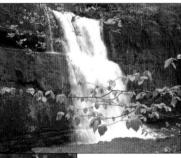

With a single subject there are all kinds of choices. You can move the frame around and make it larger by moving closer or by switching to a telephoto. As the pictures here show, each different choice gives a new sense to the subject. If it fills the frame, the visual impact can be immediately striking; if it is small and isolated, the subject is set firmly in its surroundings. First decide which approach would work best for the scene in front of you. Filling the frame lets you show more detail in a subject, and also cuts out irrelevant or distracting surroundings. On the other hand, the setting may be very important to the subject—it may be unusual, or put the subject in context, or simply help make an interesting design.

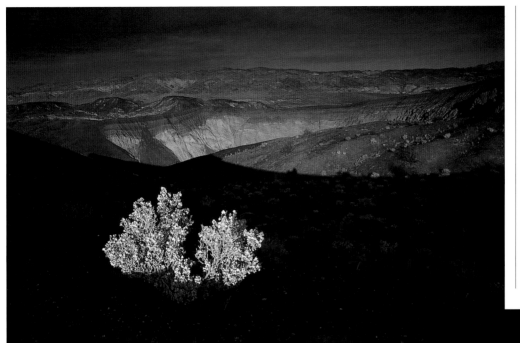

Supposing that you choose to show the background, you can then usually place the subject anywhere in the frame. Each position would make the whole photograph work in a different way. Take the example of a tree that has grown in an exposed, windswept position, such as on top of a coastal cliff, leaning slightly and with most of the branches extending away from the wind. This is an obvious example of a feature that contains implied movement, a sense of direction. If you place the subject close to the edge of the frame, you will have added motion, either inward or outward depending on which side of the frame you choose. Position a small figure near one corner, and the background takes on a new and interesting role. Don't necessarily do the obvious: aiming the camera like a gun to place the subject in the bull's-eye center is often the dullest idea of all. In fact, the closer in you are, the less room there is to move the subject around in the frame. Consider moving in toward or farther away from the subject, or to change the focal length (*see pages 14-19*). This is easiest to do with a zoom lens. When you are really close, it becomes a matter of simply fitting the subject into the frame. Generally speaking, if you fill the frame and leave very little room for the background, the image will have a stronger, more immediate impact; this does not necessarily mean that it will be better, however.

Lighting determines the focus

Late afternoon at Ubehebe crater in Death Valley. The black volcanic soil makes a strong contrast with almost anything, and, as the sun just grazes the rim of the crater, it throws a lone silver bush into sharp relief. This is very much an opportunistic point of focus, and it was a simple matter to find the lens and position that would set this against a more distant sunlit patch—the far rim. This completed, I looked for a counter-image, shooting the silhouette of the bush from below. This was also quite interesting, though less informative and less striking.

The horizon

Landscapes, more than any other class of subject, present you with the possibility of having a horizon line in the frame—and the compositional choice of where to place it.

In landscapes and in many other long shots, the horizon line insists on making its own division of the picture, and the more the contrast between sky and land, the stronger it cuts through the photograph. The horizon also tends to overwhelm the composition when it is flat (and so lines up with the top and bottom edges of the frame), and when the view is bare and simple.

Depending on the actual view, you can choose where you place the horizon line at any height in the frame, from close to the top to right at the bottom. The two most conventional positions are roughly a third of the way down from the top or a third of the way up from the bottom, and much depends on whether the landscape or the sky is more interesting. Usually, intuition will guide you best, and the specifics of the view tend to suggest the most natural position. If in doubt, shoot different versions and select later. The extreme positions—at the top or bottom—can be more exciting, but need some justification. If the horizon is very low in the frame, it gives the sky overwhelming prominence. This is a good choice if there are interesting clouds or when you want to create the impression of wide open spaces.

If the horizon is very close to the top of the frame, this type of placement might in theory seem to take attention away from the sky, but it often has the opposite effect. Because it is such a deliberately unusual way of handling the horizon, it can actually concentrate the viewer's attention on the very narrow band of sky. This is good way of making an effective feature of stormclouds, for example.

▼ Horizon at the base

Every scene containing a prominent horizon line needs to be considered on its own merits. For this water-level view of limestone islands in Thailand's Phangnga Bay, shot from a boat, there was nothing of interest below the horizon other than a few reflections, but plenty of interest above. This made an otherwise extreme placement, at the bottom of the frame, the natural choice.

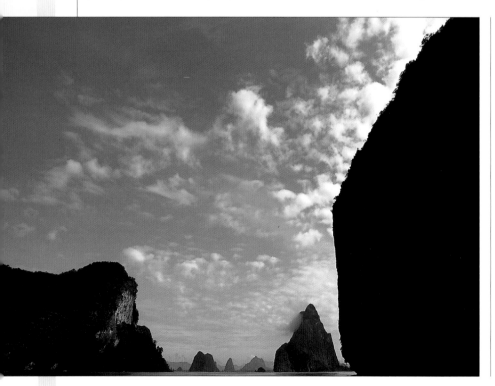

In all cases, make sure that you keep the horizon level; an angled horizon line is hard to ignore and spoils a picture. Some digital cameras have the menu option of displaying a grid—the equivalent of fitting a special grid focusing screen into a traditional SLR—and this is an excellent way of keeping the horizon level. In any case, the horizon can be straightened later by rotating the image slightly in an image-editing program.

A final choice that you have is to break the horizon line by changing your viewpoint so that part of the foreground comes more strongly into view. In a landscape, for instance, lowering the camera position may make a rock or plant appear higher in the frame. This reduces the graphic effect of the horizontal break.

Mono Lake

There are no rights and wrongs in locating the horizon, as long as there is some logic to it. In this view of Mono Lake in California, taken on a perfectly still evening, the reflection of the sky in the water, and the minimal simplicity of the scene, made both these versions acceptable: the more conventional off-centered placement, and the one in the center, which exploited the mirrorlike appearance of the scene.

Aligning the horizon line

If the horizon is at an angle in the image, use one of the rotation tools in an image-editing program to realign it. Switch on the grid to assist; you can specify how dense or open this should be in the program's references.

Managing bright skies

Including both ground and sky in one shot sometimes brings technical problems of contrast and brightness, which you can solve both at the time of shooting and later, digitally.

While there is no compulsion to frame the view so as to include the horizon, most landscape images tend to follow this composition. Indeed, for any overall view, you would have to work quite hard to avoid it. Including the horizon creates a division between sky and land, which brings with it the question of brightness. This is largely a technical issue, and depends very much on the weather. If the sky is much lighter than the ground, a straightforward shot will fail to record both adequately. The most extreme conditions are "cloudy bright," with unbroken but not particularly heavy cloud.

There is a matter of creative judgement involved in dealing with this. Most photographers would see the high-contrast split between sky and ground as a problem, but it is also possible to use the large area of white in the upper part of the picture as a strong element in the composition. It can even suggest more depth to a landscape, which is why traditional black-and-white landscape photographers (Ansel Adams, for example) often used a blue filter to increase haze and decrease visibility.

Nevertheless, there are ways of overcoming the difference between the sky and ground exposure, more so with digital than ever before. One straightforward method is to reduce the sky exposure by using a neutral grad filter—this is still one of the most useful accessories in the outdoor photographer's kit. It works

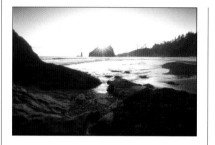

Exposed for foreground
Shooting into the sunset, when the exposure is good for the foreground rocks, the sky is blown out—a large area at 255 on the histogram.

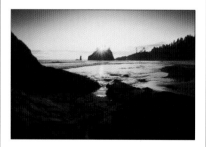

Exposed for the sky
Reducing the exposure brings the sky back into range, particularly around the sun's flare halo, but the foreground is now far too dark.

Low-contrast correction
A standard reverse S-curve lowers the contrast, but still fails to preserve details at the shadow and highlight ends of the scale.

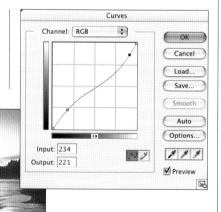

only with standard to wide-angle lenses, not telephoto, and is best when there is a clean horizon break. If a tree, rock, or other feature rises above the horizon, this too will be darkened. The most useful strengths are one f-stop (ND 0.3) and two f-stops (ND 0.6). There are also digital grad filters, such as the comprehensive set from nikMultimedia in its ColorEfex suite, but these simply add a visual impression and do not help to restore any of the original sky detail lost in overexposure.

There is a certain amount of tone compensation that you might be able to apply, depending on your camera's menu, and lowering the contrast will help overall. However, this will also lower the contrast of the landscape, which you may not want at all. In order to capture everything, you need to combine two different exposures during the image-editing stage. Overlay one image exposed for the ground in perfect register with a second exposed for the sky (and so much darker overall), and erase the sky in the upper layer.

One way to achieve the two exposures is to shoot with the camera firmly on a tripod, but if you shoot in RAW format, you can work with a single, handheld image. The RAW format will give you an exposure leeway of at least two f-stops, and can create two differently exposed images using the camera manufacturer's editing software or a RAW plug-in with Photoshop, for example.

Flare

Flare is a by-product of a bright sky that can work against the photograph. Cheap lenses and zooms with many elements are prone to flare, and the manufacturing solution is to apply extremely thin coatings to the lens surfaces. Basically, the better the lens, the less the flare. With bright skies, flare appears insidiously as an overall degradation and desaturation. Digitally, you can work on flare in image editing by setting the black point on the darkest part of the image and by turning up the saturation in the HSB controls. Needless to say, it's better to avoid this by minimizing the flare when shooting, by shading the lens.

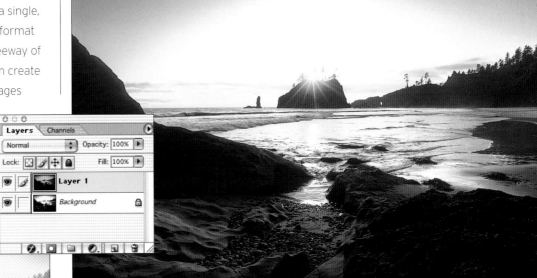

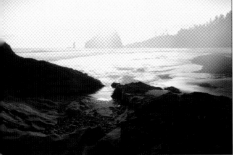

Layer composition
By superimposing the dark exposure frame over the light version, in register, the sky from the upper layer can be erased. Note that the left foreground rocks have been protected by a selection mask while the large eraser brush is applied.

Ruby Beach
The final version is a composite of two halves, upper and lower, each well exposed within their tonal ranges. If you use TIFF or JPEG, shoot two frames to do this. In RAW, you may achieve a similar pair from one shot, opened on the computer with different exposure settings.

Golden light

The most reliable time to search for idealized, romantic landscapes is when the sun is within an hour of rising or setting—this is the "sweet" light for outdoor photography.

Trying to evoke the special and the beautiful in photography is part of a long line of tradition that strives for a kind of perfection—capturing scenes that are idealized and evocative. The light, above all else, is the engine for creating this kind of image, and even though the subject and composition is extremely important, what normally motivates photographers is first and foremost the special lighting. They then go looking for a good view to make the best use of it.

This is the Hudson River School of painting brought up to date—gorgeous skies and the warm glow of sunlight raking across the land to alternate with deepening shadows. This school of American painters were following the tradition of European Romantic landscape painting, which was concerned less with subject than with luminosity and sensuality. Their preferred time of day was typically the end of the afternoon, with long shadows and warm, soft sunlight. Similarly, when photography followed in this tradition, after the invention of Kodachrome with its famously saturated colors, this more often than not became the lighting of choice for sensual and evocative scenes. Photographers such as Ernst Haas and Jay Maisel made regular use of these rich and theatrical colors. Digital photography can make even fuller use of this light because you can choose exactly what color balance to use, as well as altering contrast and saturation. Although there is a temptation with this new-found color freedom to go for extremes and exaggerate the effect, a more muted and restrained approach is usually more successful.

One modern master of the dramatic landscape photograph, Galen Rowell, called the brief time when daylight is at its most colorful the "magic hour." The sunlight becomes warmer (that is, more orange), while

▽ Bryce Canyon
The tops of rock formations of Utah's Bryce Canyon are lit as the western slope falls into shadow well before sunset, but the rock reflects the opposite canyon wall.

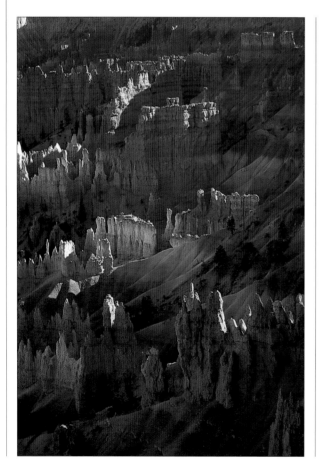

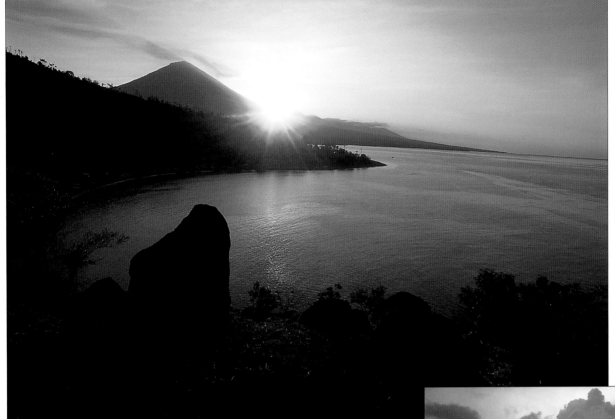

the shadow and sky tones become bluer and cooler. It evokes a predictable admiration from most people, the major exception being sophisticated viewers of photographs treated to a surfeit of such luxurious lighting. As to why this lighting has such a universal appeal, the reasons are complex, cultural, and tied up with the idealism that is at the heart of Romanticism.

As we'll see in the following pages, there are practical, as well as expressive, reasons why the golden light of early morning and late afternoon is so often used by landscape photographers. It allows completely different kinds of image, from the deep color saturation with the sun behind the camera, to crisp silhouettes when shooting into the sun.

Eastern Bali

Two features help this late view up the eastern coast of the Indonesian island of Bali. One is the marked silhouette of the island's largest volcano, Gunung Agung; the other is the plume of smoke rising from its summit, which diffuses the sunlight into a soft glow.

Clearing tropical storm

At the end of the hot season, storms frequently build up in the tropics during the late afternoon due to convection—the land heats up and rising air builds up into thunderheads. The complex layering of clouds, as in this view over the Gulf of Thailand, is unpredictable but always worth looking out for.

Case study: **a summer's morning**

The golden light that we looked at on pages 44–45 depends partly on time of day, but also on the weather. This is Dedham Vale in eastern England (coincidentally Constable country) in June. This valley of the Stour River often has morning mist in the summer, which gives a softness to the light as it gradually burns away. The sun rises early, at 4:30 a.m., which gave me a good hour of delicate warm light, sufficient to fully explore the scene.

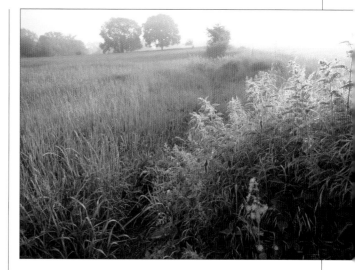

Meadow, Dedham Vale
Morning dew among the water meadows catches the sunrise to give a sparkling halo around the flower heads.

Dawn mist on river
The banks of the Stour River. The branches of a fallen tree obscure the sun's disk for this into-the-light shot.

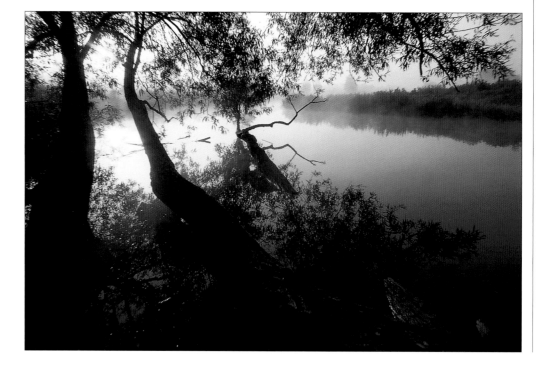

◢ Duck on river
A duck and her chick paddling away from the camera give a charming point of focus, from both a visual and photographic perspective, to this tranquil early-morning image. They also provide a much-needed touch of movement to an otherwise virtually lifeless scene.

◢ Caddis fly
A caddis fly warming up on a leaf blade. The shot is enhanced by the dew, which catches the morning sunlight and adds definition. The fly feeds on plant juices and nectar, so will often pause on a stem like this for quite some time.

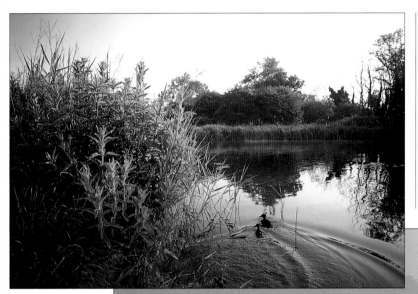

◢ Trees in morning mist
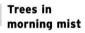
The mist slowly rises up the valley slopes, dividing the tress and hedgerows into separate planes.

Sunrise, sunset

Often a postcard cliché and a magnet for snapshots, the setting and rising sun can still, with enough care and imagination applied to it, make for a strong image.

The hour or two around sunrise and sunset are special times for photography. Provided that the sky is not overcast, the light will usually be interesting, varied, and very picturesque. There's something of a risk of cliché attached to these moments, as they have been photographed so many times and are often used commercially in sugary ways, but this is precisely because so many people find them attractive. They obviously strike some chord in us. The more you photograph sunrises and sunsets, the more discriminating you become, and you quickly tire of seeing simply the red disk of the sun hovering near the horizon. To work best, the sun usually has to make some contribution to the design of the image.

For photography, these short moments also offer a tremendous variety of lighting effect. Every quality changes from minute to minute, and there is usually the pleasure of unpredictability. With the sun so low, you can often choose from frontal lighting, side-lighting and back-lighting. A wide-angle lens will capture the full sweep of the sky, while a telephoto can concentrate on the detailed effects of color, silhouettes and reflections.

Although the timing is important for the particular location, there is no intrinsic difference between sunrise and sunset. In a photograph, if you were not familiar with the place, you would find it impossible to tell the difference. In the summer at least, sunset is usually a more convenient time to shoot—but there are likely to be more people around as well, which you might not necessarily want in a view. Sunrise rewards early risers with (normally) peaceful and empty scenery.

Amazon sunrise

Here the sun rises over the Estreito de Breves, a set of narrow channels in the lower river. Timing was important to catch the right combination of sun and clouds—and the lone canoeist. The dense and unusual cloud pattern makes the shot.

Clouds can either kill or make a sunrise and sunset view, and you can rarely be certain exactly what will happen. Overcast is usually a wash-out, but mixed clouds offer the possibility of the sun breaking through over different parts of the landscape. In any case, unless you have a pressing engagement for cocktails, stay on for dusk after the sun has set. The most frustrating thing is to pack up after you think you have captured the best of a sunset and then, on the way home, suddenly see the sky light up for a resonant twilight that you miss shooting—see pages 50-51. If you are shooting at sunrise, try to set up the camera at least half an hour earlier than the actual time of sunrise.

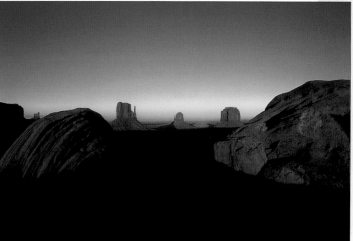

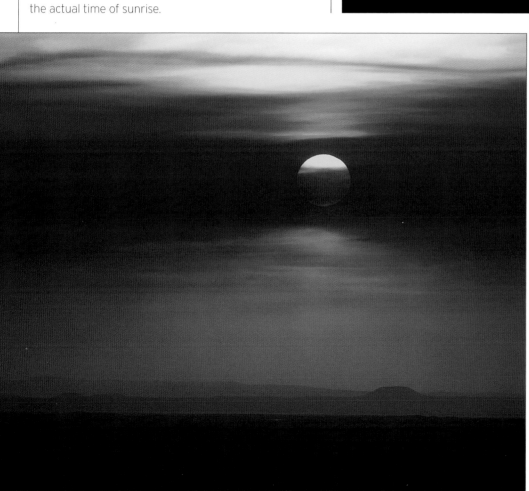

Mitten Buttes
A view of Monument Valley famous for its symmetry. The clear desert air kept the intensity of sunlight until the very last minute of setting, with the rich red increasing all the time.

Into the sun
Photographs of the sun's disc close to the horizon with a telephoto lens (here 500mm efl), risk being clichéd through their overwhelming popularity. Nevertheless, this does not invalidate them, provided that something of interest is happening in the sky apart from the sun—in this instance, the veiling of a band of clouds.

Twilight

After the sun has set, and a little before it rises in the morning, the sky can go through some remarkable changes, creating a delicate, sometimes magical, effect.

Twilight is the brief period when the sun lights the sky from below the horizon. How long it lasts, and what happens to the colors, depends on the season and the latitude. Summer twilight in Northern Europe and the northern part of North America can last for a few hours (in the far north, all night in high summer); in the tropics it lasts less than an hour.

On an overcast day, there is no special light to speak of—it simply fades to black—but in a mainly clear sky, the colors shade from the horizon upwards. Like sunrises and sunsets, the effects are often unpredictable, but the sky colors can occasionally be intense. A classic twilight in clear weather goes from orange on the horizon, through yellow, to deep blue. Occasionally, there is even a trace of green between the yellow and the blue. The reflection of the sky in water can give a useful balance to the composition of the picture.

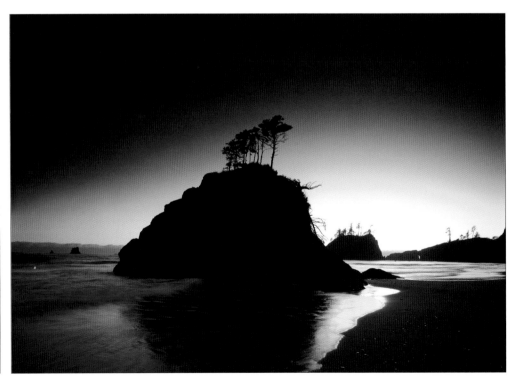

The strength of silhouettes

Twilight is almost always pure backlighting, with no detail visible in the shadows. This makes it important to have clearly distinguishable shapes that give coherence to an image. Two small islands weathered down from rock stacks on the Olympic National Park coast of Washington contrast with reflections in the sea. Compare this with the photographs on pages 36 and 42–43, which were taken at the same location earlier in the day.

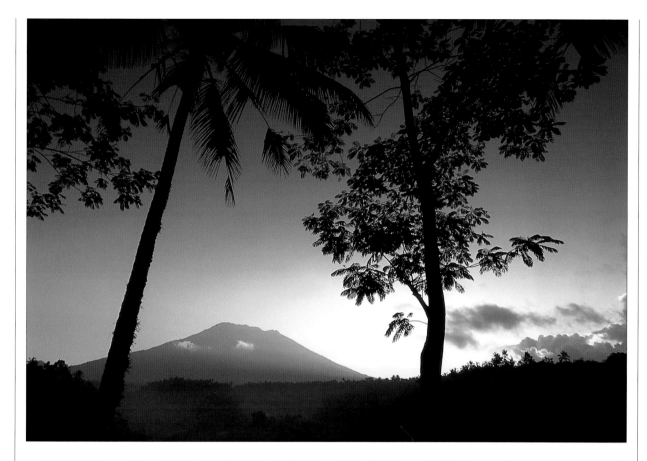

High clouds sometimes light up briefly during twilight, and this effect can happen very suddenly. After sunset, even if the sky looks as if it is just fading with little color, try and wait for a little longer. The few occasions when a brief flash of red or orange hits high wisps of cloud are worth the many times when nothing more happens.

To get the full range of this smooth gradation of color and light, use a wide-angle lens, which takes in more of the sky. For detailed silhouettes of objects on the horizon, use a telephoto lens. In either case, bracket the exposure: more light records more of the lit sky but with weaker colors, while a shorter exposure shows a narrower band of bright sky in more intense hues. If you are hand-holding the camera, select a higher sensitivity, with the risk of noise. A tripod allows you to work with the camera's lowest ISO setting. Details and close-ups in twilight benefit from the softness of the light, but as one side of the sky is brighter than the other, there is a directional quality to the light that is missing, for instance, on an overcast day.

Gunung Agung

This is the sacred volcano of Gunung Agung on Bali, shortly before sunrise. I spent the day looking for different views of this mountain, and this was the first (for the last, see page 45). The difficulty with dawn shots in an unfamiliar place is that you have to guess how the light will develop. The color of the lighting and clouds around the volcano were the reason for the shot, although the viewpoint could have been much better. The moment lasted for only several minutes, and I made what use I could of foreground trees to help the composition.

The dramatic

Less predictable than most are those landscape images that, through wild weather and light, convey the powerful, elemental side of nature.

Conventional landscapes tend toward the gentle and placid, but with some effort and luck it's also possible to inject excitement and surprise into an image. Although as a subject landscape is not normally associated with energy and raw power, drama can be found, and it depends heavily on the lighting conditions.

The key to this is to take advantage of looming weather conditions, and storms in particular. Drama in landscape was a development of the Romantic style of painting, and with it came the concept of the Sublime—pictures that were intended to inspire awe in the face of powerful, elemental nature. One of its greatest exponents was the English painter J.M.W. Turner, one of the most original of all landscape artists, who developed an approach that was almost abstract in its use of swirling color

▼ Breakthrough
The shifting patterns of stormclouds and their effect on sunlight are always unpredictable in detail, but they are often reliable conditions for spectacle. This shot shows an afternoon build-up over the Gulf of Thailand.

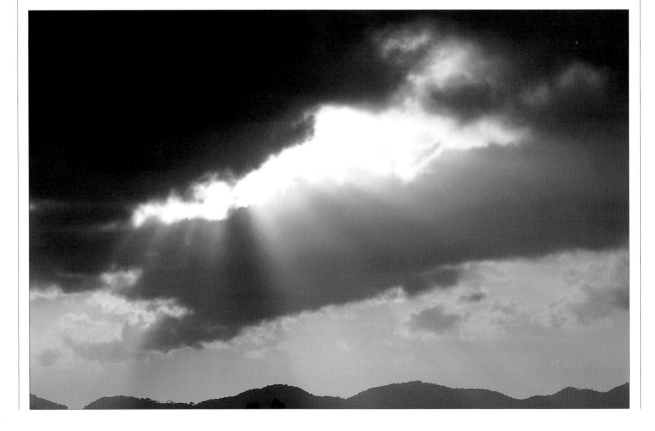

and light to convey the power and beauty of nature, as in one of his most celebrated pictures, *Snow Storm: Steam-Boat off a Harbour's Mouth, 1842*. Much of his work, and certainly this painting, was considered to be controversial, but Turner expressed the view very clearly that he wasn't trying to make attractive pictures. About this one, he explained that he had experienced that storm and that it had been "a terrifying experience," adding, "Nobody has any business to like that picture!"

To recreate this in photography requires searching out what Galen Rowell called "the dynamic landscape," pursuing the extremes of place and weather. Rowell's specialty was mountains, which have more than their share of both. If you are actively looking for what most people would consider bad weather, then the least predictable element is light, which Ansel Adams believed to be "the protagonist of the drama." High winds and lashing rain or sleet can completely transform a scene, particularly if you can show their effect–trees bending, waves being whipped up. Yet simply having a storm may not be enough to make a good image–it is the breaks within it that are likely to produce the most exciting conditions. This means, above all, staying flexible and ready to respond quickly to changing circumstances. Inevitably, the more time you spend in wild conditions, the more likely you are to come across the special juxtapositions of weather.

Rainbows

Rainbows are among the most unpredictable elements of weather. To see the full arc, you need a combination of sunlight, rain, ideally dark clouds behind to show off the colors at their strongest, and a low sun. Rainbows are projected with the sun behind you, the observer, so they are at their largest and fullest when the sun is almost on the horizon. Because of all these associations, they are traditionally an element of the dramatic, sublime landscape. Also see pages 66–67.

The Storr

The potential for drama in a landscape is at its strongest with a combination of two elements: striking landforms and a powerful skyscape. Shattered walls of volcanic rock and ancient landslips have created a spectacular, brooding landscape at Quiraing on the Isle of Skye, Scotland (the name means "pillared stronghold" in Gaelic). Here, one of the giant pillars, The Storr, emerges from rolling morning mist below a herringbone pattern of clouds. Printing in black-and-white enhanced the dark mood of the scene.

The unusual

More than anything else, photography is concerned with producing fresh images—views of the unexpected and different ways of looking at our surroundings—and this applies as much to landscapes as to any other subject.

The exotic and unexpected can be found in terrain and landforms that are inherently striking and unusual, and also in the treatment that you apply to a landscape. Typically, strange landforms are found more often in wilderness areas than in the landscapes softened by grasses and trees and tamed by humankind. Mountains, deserts, seacoasts, snow, and ice are all good places to look for extremes. Searching for exotic locations can be arduous and time-consuming, but the results can be extremely rewarding. Much of the world is already familiar, either through personal travel or through television, magazines, and so on, but there are still some surprisingly accessible places that are quite unknown to the majority of people. In North America, there are many spectacular scenes within easy reach of good highways—such as Arches National Park, or Death Valley, for example. The well-populated parts of Europe have, by definition, few really unknown landscapes, but Iceland and northern Scandinavia are just two examples of areas that are rich in potentially exciting views. Every part of the world has pockets of the unusual, and popular travel guides and television travelogs have by no means exhausted them all.

▶ **Arch**
The shape and proportions of this long span of rock in Utah's Arches National Park are arresting enough under conventional lighting conditions. However, by finding a camera position on the edge of the arch's shadow, with the sun just visible, and by underexposing, I gave the image an added element of abstraction.

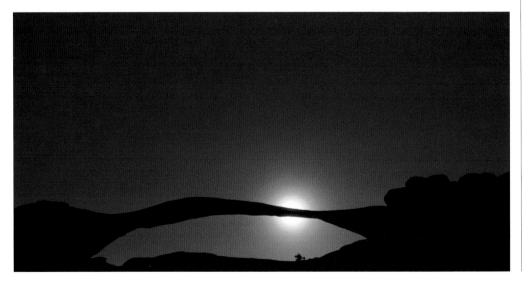

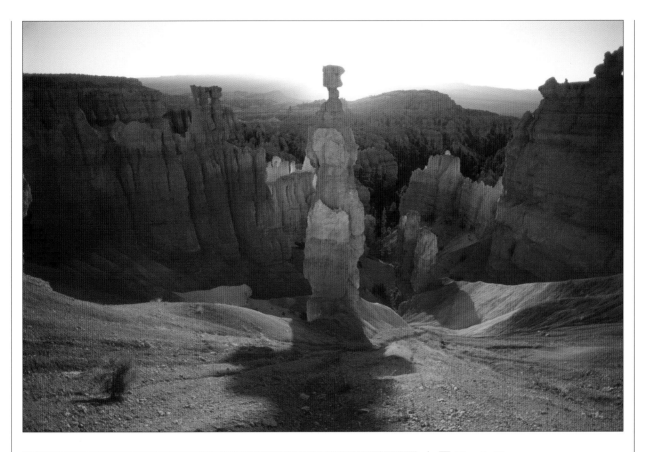

Aiming for the unusual

Creating the unusual with your own style and approach to photography enables you to work with more familiar and easily available scenes, but there is a considerable challenge in attempting to find a fresh image of a well-known view. One worthwhile approach is to reduce a landscape to basic graphic elements, creating a view that is more abstract than naturalistic. Essentially, this relies on your being able to find graphic possibilities to begin with, but there are a number of helpful techniques.

1 Wait for the light. Silhouettes at dusk, dawn, or against a low sun can reduce rocks, trees, and other objects to simple shapes.

2 Ultra wide-angle and long telephoto lenses introduce unfamiliar perspectives.

3 Alter the tone compensation for higher or lower contrast to help emphasize shape and pattern.

4 Experiment with the white balance and/or hue adjustment.

5 Deliberately over- or underexpose, particularly in high-contrast lighting conditions, such as shots directly into the sun. You can exploit the graphic possibilities of silhouettes and experiment with any reflections off shiny surfaces.

6 At the image-manipulation stage, you can push any of the above features to extremes. There are also many effects filters to consider, but beware of using those that will merely look like gimmicks—see the following pages.

Thor's Hammer

One strange rock formation is the hoodoo—tall, isolated pinnacles of soft rock formed by differential erosion. They are a remarkable feature of Bryce Canyon in Utah. One of the most striking is this giant, called Thor's Hammer for its prominent caprock. I researched the view the previous afternoon, and found the spot where the rising sun would be exactly behind the "hammer." Naturally bright reflections from sunlit cliffs behind the camera give the warm glow.

Digital enhancement

Without straying too far from reality, the tools available in a digital camera and in image-editing software give you the means to exaggerate and strengthen many image qualities.

Digital photography has made post-production the occasion, not just for reassessing an image and making minor corrections, but also for a different kind of creativity. There is a scale of intervention that goes from simply editing the images in the browser, through to any degree of manipulation imaginable. Most landscape photographers tend to prefer to stay within the bounds of a nominal reality.

Steps to abstraction
The aim here, only partially realized during shooting, was to create a highly geometric image, flat in perspective and almost posterized. A long telephoto lens went some of the way, but the first step in post-production was to crop the scene with precision.

Crossing saturation with brightness
One method of intensifying colors is with this effects filter from nikMultimedia's Abstract Efex suite. It analyzes the image pixel by pixel, and replaces the luminance value for each with saturation. The adjustments are made with slider controls.

Selective saturation
The standard HSB sliders, used selectively hue by hue, allow quite extreme enhancement effects. For maximum precision, use the Eyedropper tool to sample the particular color in an image.

However, the play of light on a landscape and what it does to color, tone, and the visual relationship between the different parts, is another matter. Optimizing the brightness, color balance, contrast, and saturation is a normal part of preparing digital images once they are on computer. These qualities, or at least many of them, are a part of the camera settings, and standard image-editing software allows these to be adjusted later. Steps beyond this take us into enhancement, and here there are many interesting software tools. With experience and effort, almost anything can be done in a large image-editing suite like Photoshop, but there are good-value third-party suppliers who offer procedures aimed at specific effects. These are normally in the form of plug-ins.

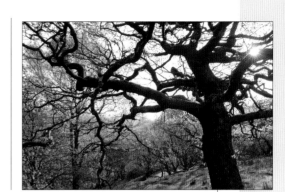

One major area of enhancement in landscape imagery is altering the sky. We've already looked at dealing with over-bright skies on pages 42–43. You can also use colored grad filters and bi-color filters (essentially, two opposing grads, one for the upper part of the image, the other for the lower). For more serious sky manipulation, first select the sky so that you can work on it separately, using a selection tool, including knockout software such as Extract in Photoshop. Then selectively alter color, or even replace the sky entirely with another sky or with digital gradients.

Sunshine is a difficult lighting effect to mimic, because it interacts with a landscape at all levels of detail, creating highlights and shadows down to the scale of individual blades of grass. As no software can analyze the content of an image, the solutions are limited. Nevertheless, by selectively altering contrast, hue, and saturation, it's possible to enhance weak sunlight, and even to give the appearance of hazy sunlight to a shot taken under an overcast sky. Third-party software company nikMultimedia specializes in digital photographic filters, and has an impressive Sunshine filter in their Color Efex suite. Adding on top of this flare artifacts such as streaks can further enhance the impression of the sun.

Finally, there are various ways of stylizing an image to give a different mood, or the suggestion of evening, or an antiqueing effect as if an old photographic process had been used. There is no limit to these possibilities, and they all involve distressing the image selectively, using HSB controls, blur, and noise filters, often in layers for maximum control.

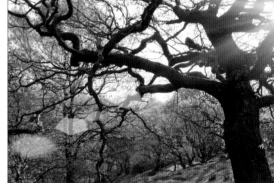

Adding flare

Normally, flare is something to avoid. However, it does give a sense of sun-in-the-eyes actuality. A number of flare filters are marketed, including Knoll Light Factory, which allows an enormous variety of flare effects to be customized and positioned precisely.

The critical view

Landscape photography is not always about celebration, and can be used to make statements about how we use, and abuse, the environment.

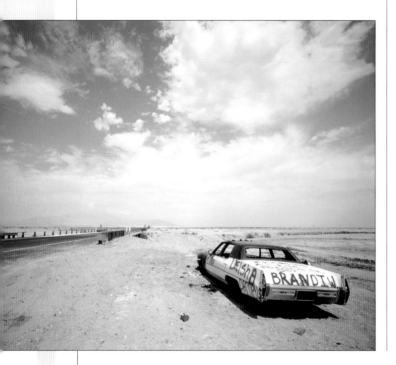

▲ **Salton City**
Abandoned automobiles are an unavoidable feature of the open roads of the American West, and occasionally contribute a strange kind of beauty to empty landscapes—although this is a matter of opinion and cultural familiarity.

There is a certain amount of nostalgia in natural landscapes, because the wilderness areas of the world are in retreat, and need our protection. Untrammeled views toward a horizon with no hint of humankind are becoming something of a rarity these days, and transmission towers or wind farms are increasingly likely to decorate those horizons. Wilderness photography is, as we saw earlier (*pages 10-11*) a very American phenomenon, and because of its still-spectacular natural landscapes, it also has the most garish examples of what might be called visual pollution—strips, billboards, trailer parks, and roadside trash.

The response of most photographers whose sights are set on wild nature is to drive on by and ignore the casual wrecking of the landscape. But in fact, it's a perfectly valid subject for landscape photography because it calls for comment. The most obvious comment is straight condemnation, an exposé of man's bad habits, most easily achieved by juxtaposing as strongly as possible the good (natural beauty) and bad (vandalism). The techniques for doing this are exactly those for bringing together different scales and different features in a wild landscape, as we saw earlier, on pages 14-21. Wide-angle and telephoto treatments can both do this.

But there are other, less strident, treatments possible. For instance, the abandoned automobile by a desert highway can certainly be seen as just something dumped inconsiderately. But from another point of view, it has its own, dare I say it, nostalgia—part of America's road culture with memories of Route 66. And abandoned mine workings from the nineteenth century? Most people would see these now as historical sites that are worth preserving (and many of them are in fact protected), even picturesque. But in principle they are no different from modern scarring such as strip-mining and burnt, clear-cut forest. Today's despoiling can sometimes become part of yesterday's historical romance.

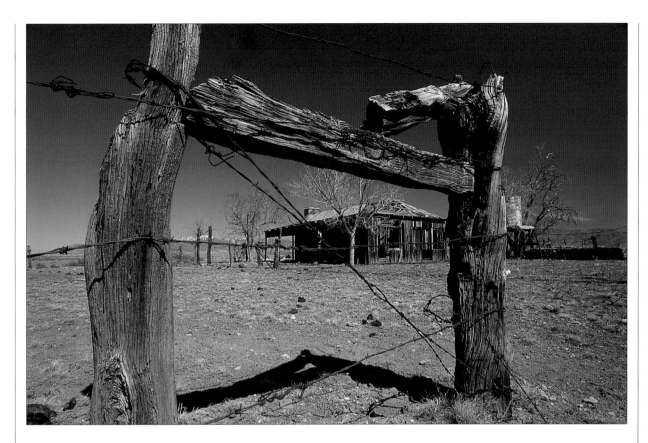

Damaged landscapes exist, and if you believe that photography should be as open and as truthful as possible, that's a good argument for photographing them, whether with a cool, objective eye or a committed, conservationist one. The photographer Robert Adams, among others, has explored this largely ignored area of imagery.

The American photography critic and curator John Szarkowski makes the argument that with so much photographic exploration of natural beauty already done, from Edward Weston and Ansel Adams to David Muench and Jim Brandenburg, there's less incentive for younger photographers to follow the same road. He wrote, "...one must begin with respectful attention to what remains alive, even if scarred and harshly used, and trusting that attention will grow into affection, and affection into a measure of competence, so that we might in time learn again to live not merely on the earth but with it."

Failed hope
Abandoned enterprises, from mines to farms, bring a sense of nostalgia and historical context to wilderness areas. Here, a derelict farm slowly decays in New Mexico.

Power lines
One widely recognized form of modern visual pollution is the power line. In this image, however, the graceful curves of the cables intersect with a misty view of English countryside.

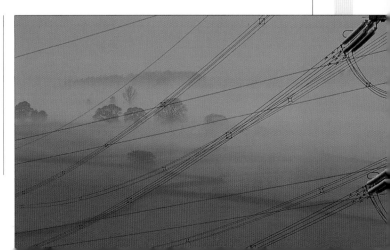

Abstract

Instead of representing the landscape, a very different approach is to use carefully selected parts of it to construct personal images that rely on purely graphic qualities.

In all art, there is tension between subject and expression, and in photography more than any other graphic art, subject tends to dominate. Abstraction is an attempt to liberate shape, line, tone, and color from the subject. It relies heavily on being able to find some aspect of a landscape—whether that is the way light falls on it, an arrangement of colors, or a viewpoint—that is lacking in the usual references of perspective, modeling, or recognizability.

Ansel Adams disliked the term "abstract," and preferred "extract" to emphasize the fact that photographers are choosing from what exists in front of them. He added that, as far as composition was concerned, "I think in terms of creating configurations out of chaos, rather than following any conventional rules..." Edward Weston, a friend of Adams, worked even harder at emphasizing the graphic features of an image, saying, "composition is the strongest way of seeing." Without splitting hairs on definition, abstracting

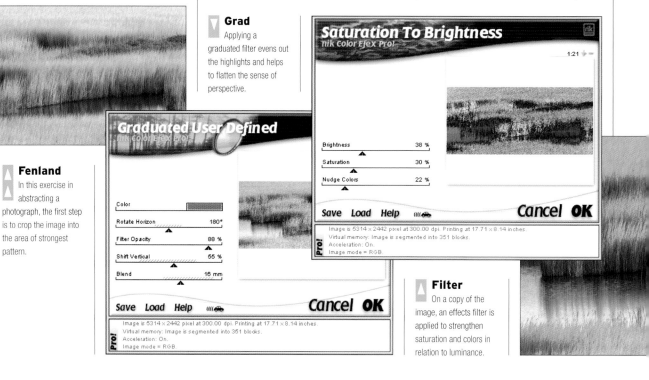

Grad
Applying a graduated filter evens out the highlights and helps to flatten the sense of perspective.

Fenland
In this exercise in abstracting a photograph, the first step is to crop the image into the area of strongest pattern.

Graduated User Defined
nik Color Efex Pro!

Color	
Rotate Horizon	180°
Filter Opacity	88 %
Shift Vertical	55 %
Blend	16 mm

Save Load Help ((((🚗

Cancel **OK**

Image is 5314 x 2442 pixel at 300.00 dpi. Printing at 17.71 x 8.14 inches.
Virtual memory: Image is segmented into 351 blocks.
Acceleration: On.
Image mode = RGB.

Saturation To Brightness
nik Color Efex Pro!

1:21

Brightness	38 %
Saturation	30 %
Nudge Colors	22 %

Save Load Help ((((🚗

Cancel **OK**

Image is 5314 x 2442 pixel at 300.00 dpi. Printing at 17.71 x 8.14 inches.
Virtual memory: Image is segmented into 351 blocks.
Acceleration: On.
Image mode = RGB.

Filter
On a copy of the image, an effects filter is applied to strengthen saturation and colors in relation to luminance.

shape, line, and color from a landscape has an honorable history, going back to painters such as Corot, who prefigured Cubism by analyzing and emphasizing the planes of rocks and the land. It is certainly a way of seeing, and, if done well, it reveals aspects of a scene that most other people would not have thought of.

You are always limited by the realism of the subject, unless you elect to do serious retouching in the image-editing stage, but one or more of the following techniques will usually help to abstract an image:

1. Crop out the obvious references, such as a horizon or anything immediately recognizable and commonplace. Cropping in this sense means working the zoom or moving the camera.
2. Angle the camera to fit lines and shapes more interestingly into the picture frame.
3. Choose subject matter that itself contains clean lines, such as rocks, snow, or sand.
4. Work at the two extremes of contrast—on the one hand, images with very subtle variations in tone, such as distant views in haze, or mist; on the other hand, scenes that are divided between deep shadow and intense highlight, as in silhouettes, or objects against pure snow. These extremes can be exaggerated with the in-camera settings, and even more so during image editing.
5. Work at the two extremes of saturation, in a similar way to 4 above. On the one hand, delicate, pastel hues throughout; on the other, intense differences between hues.
6. Look for scenes in which two or three solid colors dominate, and crop in on those.
7. Look for scenes in which there are very few directions of line, such as rows of planted crops but cropped right in on these.
8. Look out for regular patterns, such as drying cracks in mud, or ripples in sand.

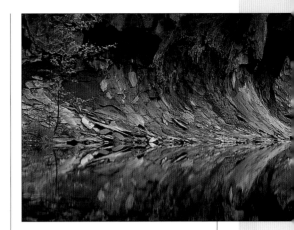

Mirror image
The quiet water of a stream near Sedona, Arizona gave an almost perfect reflection of the curving weep of rock strata on one bank. Shooting from very low, close to the water line, maximized the reflectivity.

Patterns of nature
Natural processes, such as cracking of mud under the sun, gives potential for abstracted imagery. A flamingo feather gives the scale.

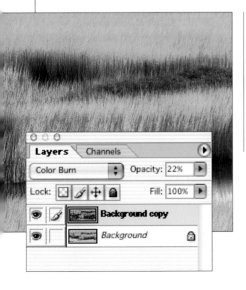

Final composite
The extreme effects created at left are then applied more delicately to the entire image by blending the upper "effects" layer at a modest opacity.

Minimal views

Photographs of very little have their own special visual language in which the frame is cleared of all detail and conventional subject matter, and replaced with a subtle exploration of tone and color.

If you eschew the idea that a photograph must have a principal subject dominating the frame, with foreground, middle ground, and background all in ordered array, there are possibilities of a different kind of imagery. If you take abstraction (as we just saw on the previous pages) in one particular direction, toward extreme simplification of tones, shapes, and lines, you arrive at minimalism. This kind of image is not for everyone, but its value and justification is in encouraging a different way of looking at landscape.

There are a number of ways of doing creating minimalist images, but all involve in some way looking away from the obvious, at the blank parts of a view, and concentrating on those. The American photographer Frederick Sommer, for example, made a series of images in the 1930s and 1940s of featureless parts of the Arizona desert—not empty graphic dunes, but scrub-covered hillsides, in flat lighting, without horizon.

In one sense, the camera is simply focused on a background to the exclusion of anything else. In fact, it is the distance, the openness, the very lack of feature that is the real subject of this kind of photograph. The principal is "less is more" and the style is minimalist. Photographic historian John Szarkowski called this "nominal subject matter," meaning that the subject itself was of much less importance than the graphics of the image. Another argument is that apparently featureless images encourage the viewer to look more carefully into the detail. Most photographs are full of detail, even if on the level of texture, but in images with strong subjects this tends to be ignored.

Samui Island
The only solid points of reference in this swirling arrangement of pinks, grays and blues are a tiny group of distant islands. To make the image even more minimal, the sky area was selectively darkened in image editing to make the tones more even across the frame.

Seascapes offer some of the most minimal possibilities to photograph, provided that you ignore the obvious foregrounds of the coast, and concentrate instead on the play of light and color. When confronted with a view of the sea, this is, in fact, very close to what we see and experience—an immense flatness, lack of feature, vastness, and distance, that challenges our sense of orientation. In real life we may well turn away from it, becoming

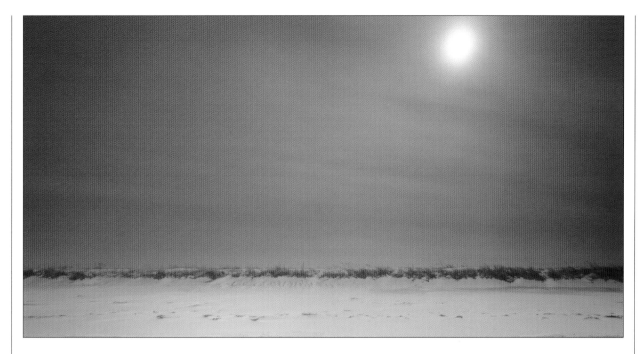

quickly bored without any focus of interest to hold our attention. Nevertheless, just because it is the antithesis of the organized, detailed, traditional landscape does not meant that this is invalid or without meaning. A number of photographers have explored this blankness, including the American Joel Meyerowitz and, more extremely, the Japanese Ikko Warahara and Hiroshi Sugimoto.

Another minimalist avenue to explore in landscape is time, as conveyed by a long time exposure. The blurring of form that happens with anything that moves, such as leaves in the wind, clouds moving across the sky, or, most famously, water, is another way of reducing the image, removing detail, while at the same time allowing a very photographic imprint to record itself on the image. Water, when photographed with a slow exposure, appears differently according to how it flows and how long the exposure is. With a moderately slow exposure (perhaps 1/8 sec or 1/15 sec for a fast-flowing stream over rocks) it takes on a silky appearance, but with very long exposures it turns into a mist; a rocky seacoast can look as if it is covered by a ground-hugging fog.

Winter beach
This bleak scene on a Massachusetts shoreline in winter gains its strange quality from the heavy grayness of the sky, with the weak sun glowing faintly.

Mist and softness
A very long telephoto (600mm efl) used across marshland scene in poor visibility achieves an impressionistic effect, enhanced slightly by the use of a digital grad filter.

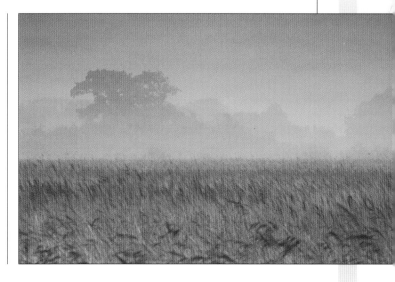

Skyscapes

Conventionally treated as a kind of accessory in landscape photographs, clouds and skies are often rich enough in character to qualify as subjects in their own right.

The world above the horizon line is often either ignored in favor of what is happening on the ground, or else drawn in as a counterbalance in the composition. But the sky is a world of its own, full of change and cloudforms that are often spectacularly different from each other. As with terrestrial landscapes, skyscapes also vary greatly in how interesting and photogenic they are. The sky that I can see out of the window right now is pale gray and, even by the most generous standards, fairly boring, but there are moments when you come across true spectacle. And at these times it may well be worth ignoring the landscape in front of you and aiming your camera upward.

The base, of course, is the horizon, and placing it very low in the frame, just having a thin strip at the bottom, has the effect of grounding the skyscape. This puts it in context, and, by making such an extreme contrast in the proportions of land and air, enhances the impression that the sky really dominates an open, boundless space. To be worthwhile, there needs to be some special character to the sky, and it's hard to predict when and how this will happen. Skyscapes are not subjects to plan for, but to react to. Many of the prime conditions that we've already seen in the previous pages as part of some other aspect of landscape photography also feature picturesque skyscapes. Early and late in the day, the appearance of the sky is likely to change fastest, simply because of the changing light, and twilight has a

Polarizing filter

One of the most obvious effects of a polarizing filter is the way in which it darkens a blue sky—often, but not always desirable. The filter quenches polarized light from a particular angle. Outdoors, the most strikingly visible polarized light is that reflected from the minute atmospheric particles in clear sky. This is strongest at right angles to the sun (from the camera viewpoint), and you can control the effect by rotating the filter in its mount.

Sky panorama
Panoramic formats work particularly well with the lower section of sky, because the acute angle of view to the clouds gives a vertical compression. This shot shows evening over the Colombian Andes near Popayan.

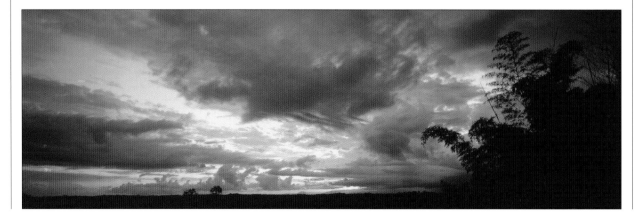

Reversed grad filter

The conventional use of a grad filter in landscape photography is to gently darken the sky so as to help bring it more into line with the darker tones of the land. But if you shoot above the horizon line with a wide-angle lens, the sky will naturally darken with height, and using a grad filter rotated 180 degrees will help to even out the brightness across the frame. Alternatively, you could progressively darken the sky when you reach the image-editing stage.

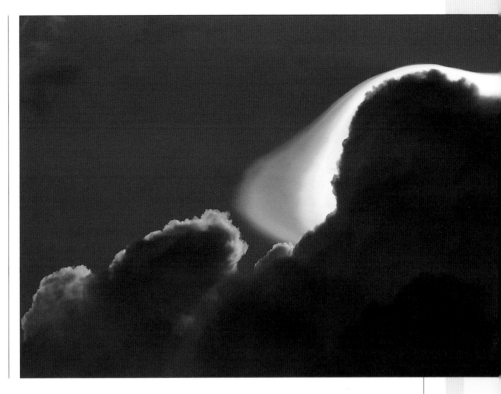

special value in this case. If the conditions are fairly clear, for a short period before sunrise and after sunset, the land is in complete shadow, while the lighting is purely on whatever clouds are in the sky.

Wide-angle is the focal length of choice for most skyscapes, in order to take in the visual reach that our eyes have when we look up. When there is at least some clear sky in view, a wide-angle lens will also reveal the range of tone. This is almost always noticeably darker high than near the horizon, where a greater thickness of dust, haze, and pollution mutes the color and tone. A polarizing filter is worth thinking about for its darkening effect and an associated increase in color saturation, but be careful when using it with an ultra-wide-angle lens. Because the polarization is strongest at right angles to the sun, a wide-angle view will show this as a band of darkness across the frame, which can look odd.

Use a standard focal length or a medium telephoto to pick out individual clouds or groups. Alfred Stieglitz, one of the founders of American photography, found in clouds images that were the "equivalents of my most profound life experience, my basic philosophy of life." He used clouds as an almost abstract subject in conveying a very personal vision.

Halo
Specific events and features of the changing skyscape make subjects in their own right, as revealed in this shot of a spectral halo behind a dense cumulus cloud.

Sea and sky
Unbroken visibility over great distances and a plain, simple horizon line make the sea one of the best locations for unbroken skyscapes.

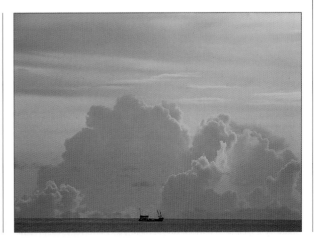

Weather

A bright sun on a clear day may often seem like the perfect prescription for a photographic trip, but more interesting light and skies come from weather and patterns of clouds.

Although the lighting on sunny days is easy, pleasant, and uncomplicated, the variety from less comfortable weather is infinite, from light, summer cumulus clouds to a complete overcast, and from thick morning fog in a valley to a high-altitude haze. Most important is what clouds do to the quality of light. Cloud cover softens shadows, and at the extreme of a really overcast day, they flatten the light completely. If your camera has tone compensation, a higher-than-normal contrast setting will help. This kind of lighting is difficult to make look interesting, and the color temperature will be a little higher than usual. Experiment with the white balance choices in the camera menu to warm up this slight blue cast. Ragged clouds can throw a patchwork of light and shade across a landscape, which can look attractive from an overlook. Billowing white clouds can sometimes act like giant reflectors.

Clouds These can obviously affect the light, but they also change the view itself in a broad landscape shot. If the clouds are well-defined and contrast well with the rest of the sky, then they are likely to make a stronger part of the photograph At times, they can even be the entire subject of a photograph—possibly with just a thin strip of the landscape at the bottom of the frame (*see pages 64-65*).

Rain Unless there is backlighting or sidelighting from the sun, which is unlikely, it is often difficult to catch falling rain in an image. Usually, and at a

▽ **Stormlight**
Evening sun breaking through very heavy clouds over the marshes at Ipswich, Massachussetts, after a day of driving rain. At moments like these, weather is the shot.

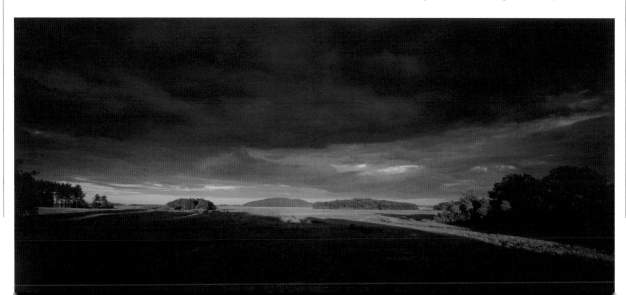

distance, it just looks like mist. To convey something of rain you would need to include some of the obvious effects—ripples in a pond, drops on car roofs, umbrellas, and so on. On the rare occasions when the sun shines through rain, you can expect to see a rainbow. This is an optical effect, so if you move, the rainbow appears to move as well—you can use this to change the background. To capture the full arc of a rainbow, shoot with a wide-angle lens. If the rainbow is weak, remember that you can make it appear richer later by increasing the saturation.

Fog It's often difficult to predict how long fog will last, and it can sometimes clear in minutes. Make the most of it whenever you find it, as the effects can be wonderfully atmospheric. Some of the most picturesque conditions are early in the morning, when the fog is just light enough to show weak sunlight filtering through; shoot toward the sun to capture silhouettes of trees and other features in the foreground.

Lightning The unpredictability of lightning flashes is the main problem, but as long as you shoot at night or in the evening, you can leave the shutter open until one or more flashes make their own exposure on film. A wide-angle lens will increase your chances of getting them in the frame. The exposure is not critical, but as a rule, at ISO 200, for example, use an aperture of about f5.6 for distant lightning (over 10 miles/16km), f8 for between about 2 and 10 miles/3 and 16km. If the flashes are even nearer, f16 may better, but then you probably shouldn't be out in the open anyway. Flashes usually occur in sequences, so there should be time to check the result on the camera's LCD from the first shot.

Threatening sky
Thunderclouds build up in the east in late afternoon over a valley in northern Thailand, providing a contrast to the sunlight falling on an abandoned monastery building and rice fields.

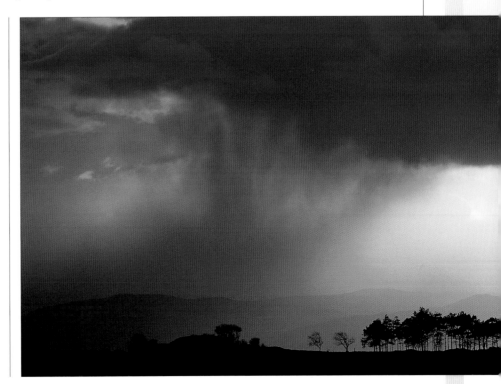

Falling rain
Backlit by the evening sun, plumes of rain drift down over the misty hills and inlets of a Scottish island in the Hebrides.

The color of light

Digital cameras have the tools to correct and adjust for all the color varieties of daylight. The skill is in knowing when and how much to use them.

Color temperature scale

12,000K	Open shade under high-altitude sky
10,000K	
9,000K	Open shade under exceptionally clear sky
8,000K	Open shade under normal blue sky
7,000K	
6,000K	Overcast sky
	Electronic flash (typically 5,400K)
5,000K	Midday summer sunlight in mid-latitude
	(CIE standard 4,800K, mean noon sunlight at
	Washington DC 4,200K)
4,000K	Between one and two hours from sunrise or sunset
3,000K	Strongly colored sunrise and sunset
2,000K	A red rising or setting sun

Cool, cloudy light
An overcast spring day in Montana casts a slightly bluish light over a herd of bison ambling past a deserted shack. A dusting of snow picks up this color shift.

The color of light changes during the day, particularly if the sky is clear. When the sun rises and sets, it can be orange or red, but during the middle of the day, when it is high, the light is what we think of as "white," or normal. In the shade, if the sky is clear the light will be quite blue, although our eyes register this much less than does color film. Similarly, at twilight, the light can be blue, depending on the weather.

The scale of colors along which daylight moves is known, for good scientific reasons, as the range of color temperature. The principle of this is that most light sources, including the sun, work by burning—that is, incandescence—and their color depends on their temperature. From warm to very hot, the range of colors goes: red, orange, yellow, white, and finally blue. The exact color, whether of a setting sun or a table lamp, has a temperature, measured in Kelvins (K), which are similar to degrees Celsius but start at absolute zero. So, a candle burning orange has a color temperature of around 2000k, white light from a midday sun is about 5,500K, and open shade under a blue sky is around 8,000K and upward. The only source of confusion is that in normal language we associate blue with cold and red with heat, so that unfortunately warming up a scene involves lowering the color temperature.

The color temperature of daylight changes because of the way that the atmosphere scatters it. When the sun is low on the horizon, its light passes through more atmosphere, and the molecules in the air scatter the shorter, bluer wavelengths more than the others. This makes the light redder. If you look at a clear sky, you see just these scattered blue wavelengths. In a sense, the neutral "white" light is being separated into two main components. In any case, what once was a rather arcane aspect of color film photography is now familiar to most photographers purely because digital cameras offer the controls to normalize color temperature. These controls are found under the "white balance" menu.

Tone compensation

Another control available on some cameras is tone compensation, which allows you to choose the contrast for a particular shot. Where available, the camera menu will typically offer a normal setting; one for high/more contrast; one for low/less contrast; and an automatic setting, in which the camera's processor will judge the contrast range of the imaged scene and optimize it. Doing this manually or automatically is the equivalent of setting the black and white points in image editing, and it is obviously better to do this when capturing the image. If you are shooting RAW format, you can rework the tone compensation without penalty. Only beware of overcorrecting the contrast in scenes where you might actually want the higher or lower contrast effect—see, for instance, the image on page 43, which works because of its lack of contrast.

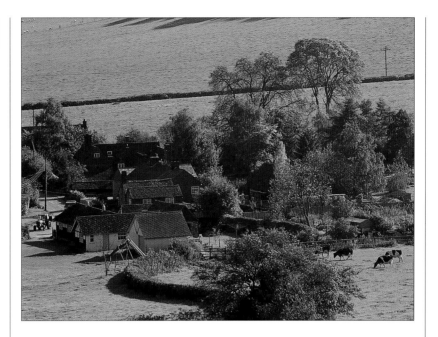

▲ White light
The middle of the day is the human eye's reference point for color; or rather, the lack of it. The color of sunlight falling on these fields in Surrey, England is a little less than 5,000K. Note the slight blue cast to the shadowed sides of the white buildings.

▼ Avoid overcorrection
Optimizing the color to neutral is not always appropriate. Shots taken with the sun close to the horizon, as in this view of Capitol Reef National Park, Utah, are expected to be warm in tone. A "sunlight" white balance setting is usually better than "Auto."

However, simply because it is available, there is no reason to be obsessed with correction. With only a few exceptions, the differences in color are small, and will not ruin the image, which can be adjusted with hardly any damage to the image later, in image editing. Shoot in RAW format and it really doesn't matter which white balance setting you choose, as you can reselect the setting later. Set the white balance when you have time, but don't waste time at it. One occasion when you should pay attention is close to sunrise and sunset. If you normally use an Auto white-balance setting, this will correct the orange lighting to white, which is probably not what you really want.

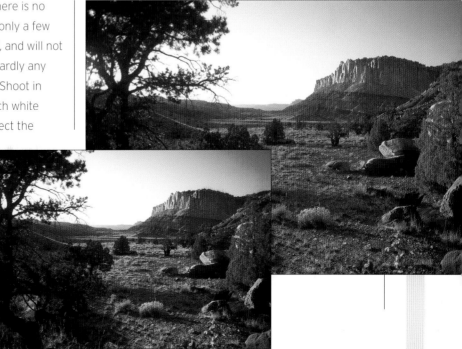

Packing and carrying

Shooting outdoors means taking extra care with the equipment, and digital cameras, with their many electronic functions, are generally more delicate than mechanical cameras.

With the exception of SLRs, digital cameras are lighter and more compact than most film models, and the total amount of equipment that you need is less. There are, however, more accessories, particularly cables and electronic items such as chargers, and if you choose to take a laptop computer, that will add to the bulk and weight. Nevertheless, there is a significant difference between the equipment that you might need for the duration of a trip and what is necessary while shooting. For this reason, consider buying a protective case for transporting, and a shoulder bag for shooting. Certain habitats impose special needs—such as a backpack for hiking and mountainous areas.

The three worst conditions for equipment are water, dust, and heat. Water corrodes metal parts and shorts electrical circuits—saltwater more rapidly

Backpack
A backpack has two major advantages. The first is obvious; it is an easy way to carry a lot of equipment. The second is more subtle: backpacks are less obvious than some of the other cases here, and might attract less unwanted attention.

Rigid cases
Rigid plastic cases can protect their contents against water and knocks, so long as the padding is appropriate for your equipment.

Canvas
Very traditional among photographers is the canvas bag, which is well suited to traveling in good conditions. A wide variety of sizes are available, including the conveniently small.

than fresh. Light rain does no harm if you wipe the drops off quickly, but only specially weatherproof cameras can survive full immersion in water and come out still working.

Dust and sand are a danger because of what can happen later—the grains can work their way into the camera's mechanism and grind or jam the moving parts. They can also scratch mirrors, lens surfaces, and film. Unlike water, just a little exposure can be enough to do damage. Take particular care if you're working on a sandy beach—salt makes the grains sticky, and if you drop the camera it will pick up a lot.

Heat becomes a problem for the electronics at temperatures over about 35-40°c. A silver case is better at reflecting heat than any other kind. Keep everything in the shade when you are not using it. In the tropics, where the air may be humid as well as hot, pack sachets of silica gel (a standard dessicant) in with cameras, as its crystals absorb moisture. When the silica gel has absorbed all it can (some types change color at this point), dry it out in an oven.

Cold weather in itself does little harm, but if you carry cold cameras into a heated room, they will get wet by condensation, just like the inside of a windowpane. After cold-weather shooting, warm the camera up slowly—for instance, leave it in a colder part of the house for a while. Another precaution is to wrap the equipment up tightly in a plastic bag, so that condensation forms on the outside rather than inside. Don't breathe on the camera in sub-zero weather. Batteries last for a shorter time in the cold, so carry spares.

▶ Hot metal
To protect against heat, a case with a light, shiny exterior will reflect more heat than a darker one. Not only that, but they are very sturdy.

Outdoor camera care

Keep to a regular regime of checking and cleaning, and keep equipment safe and covered when you're not using it.

Make a habit of cleaning cameras and lenses regularly and often, and at the very least after each trip. Most digital cameras are sealed, and do not invite dismantling. Given their complexity, this is a good thing, but if there are any parts to disassemble (and this includes removable lenses for an SLR), do it in a clean, dry place. The cleaning materials shown here cover most needs, but on location a blower brush, cloth, lens tissues, and cotton swabs will usually be enough.

Cleaning sequence

For a thorough cleaning, follow this sequence:

☐ Remove whatever is intended to be removed (normally very little, but include batteries and screw-on lens filters) and open the parts that do (such as a swing-out LCD screen).

☐ Clean batteries and their contacts with an eraser and cloth. Make sure no bits are left in the compartment.

☐ Remove outside dirt with stiff brush (and use a toothpick if necessary for the crevices).

☐ Use compressed air or a blower brush all over the outside (cleaning the sensor of an SLR is a different matter—see box).

☐ Clean crevices with cotton swabs moistened with lens cleaning fluid.

☐ Wipe all nondelicate surfaces with a soft lint-free cloth.

☐ To clean the lens, breathe gently on it to form a little condensation and wipe with a lens tissue.

Protecting your camera

If you have to use the camera in a dust- or sand-storm, or in heavy rain, wrap it in a clear plastic bag (1). Secure the bag's open end around the front of the lens with a rubber band (2), and if you can't see clearly enough through the viewfinder, cut a small hole around the eyepiece (3) and secure this too with a rubber band (4). A plastic bag works best with an automatic, auto-focus camera, as there are fewer controls to work.

1

2

3

4

Cleaning kit

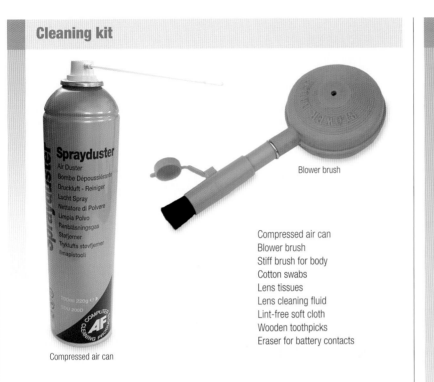

Blower brush

Compressed air can

Compressed air can
Blower brush
Stiff brush for body
Cotton swabs
Lens tissues
Lens cleaning fluid
Lint-free soft cloth
Wooden toothpicks
Eraser for battery contacts

Cleaning dust from an SLR sensor

Digital SLRs are prone to collecting dust and other minute debris on the surface of the sensor. Even though the mirror protects it when you remove a lens, there is no "airlock," and dust that enters the exposed mirror chamber can then work itself back onto the sensor when you shoot. Frequently check for this by shooting a featureless target, such as the sky, and examining the image at full magnification (either on the camera's LCD, or better, on a computer screen). Follow the manufacturer's advice for cleaning, which involves a method of powering down the camera before exposing the sensor (as an AC adaptor). If you simply set the shutter to "bulb" and press the release, the sensor will still carry a charge and so attract more dust. Also, compressed air cans carry a propellant, and if this gets deposited on the sensor you will have an expensive repair bill. It is safer to use a blower brush.

Freeing stuck filters

If a screw-on filter seems to be jammed, it may be because you are using too much force rather than too little. If it really is jammed, however, press it firmly against a rubber pad and twist.

Emergency procedures

Camera falls in fresh water
☐ Quickly dry with a cloth.
☐ Take off all easily removable parts (including battery and memory card), and open any part that can be opened (such as a swing-out LCD and connector covers).
☐ Dry by whatever means possible. A blow-dryer is ideal, with help from cotton swabs.
☐ Even if the camera still seems to work, have it checked professionally.

Camera falls in salt water
☐ As quickly as possible, wipe with a cloth wetted in fresh water.
☐ Dry with a cloth.
☐ Continue as for the fresh-water procedure.

Dust or sand
☐ Stop using the camera immediately. Otherwise, the grains are likely to work their way further in, such as through the lens as it opens and extends.
☐ Take off all easily removable parts (including battery and memory card), and open any part that can be opened (such as a swing-out LCD and connector covers).
☐ Clean with compressed air or a blower brush, followed by a soft brush and a pointed but soft implement such as a wooden toothpick for crevices.
☐ After cleaning, if you hear any grating or scratching from moving parts, take it to a professional repair outlets for cleaning.

Aerials

An hour's flight over an area of natural beauty, though not cheap, can be a good investment resulting in striking images from an unusual angle.

Aerial photography brings a fresh perspective to landscape. It has its own unique range of subjects and styles of picture, particularly if you shoot vertically downward to create unusual, abstract images. Patterns that are invisible on the ground can be the most striking part of an aerial photograph.

The single most important factor that separates ordinary from good aerial photographs is the lighting. Direct sunlight is almost always better than an overcast day; the contrast is higher and, being brighter, allows higher shutter speeds. A high sun in the middle of the day, however, tends to give flat lighting. This is even more apparent if you are

▽ Colors from the air

A combination of algae and mineral deposits around the Grand Prismatic Spring in Yellowstone National Park presents a striking array of colors. This was a candidate for a vertical shot using a medium-telephoto lens.

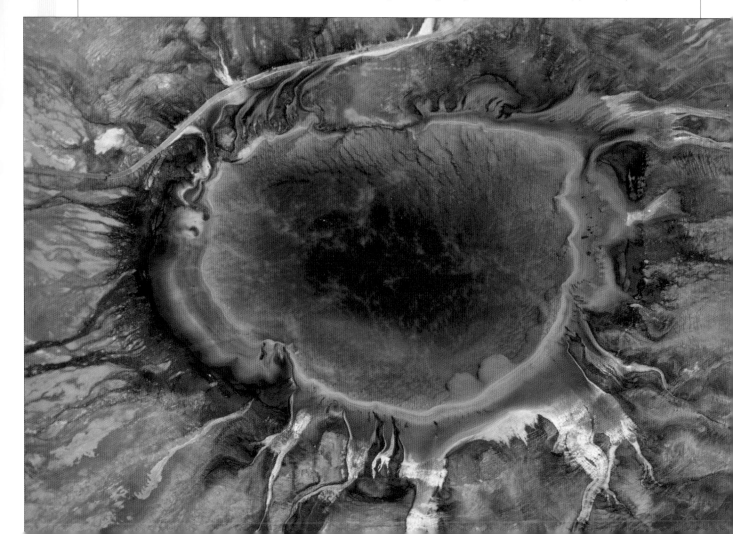

shooting vertically downward rather than obliquely. More reliably attractive is a low sun in the early morning and late afternoon; this casts longer shadows and gives a stronger and better defined image. One of aerial photography's special problems is haze, because of the thickness of the atmosphere through which you have to shoot. The simplest solution is to fly low—say, at about 1,000 feet (400 meters) above ground level—and use a wide-angle lens. A UV filter will also help to sharpen contrast and cut through any atmospheric haze.

Normal-level flight allows only diagonal shooting at a shallow angle, which works well enough for distant views. For close, graphic shots, however, a steeper shooting angle is usually better, and the most extreme—directly overhead—can sometimes be the most striking of all. There are three ways of doing this with a fixed-wing aircraft. The pilot banks the aircraft, which puts it into a turn, so you may have only a few seconds for shooting. Or the pilot can slip the aircraft sideways toward the subject, reducing the throttle to dampen vibration. The third alternative is to fly in a tight circle over the subject, as in the diagram on page 77.

As on the ground, different focal lengths give different types of image. Wide angles (28mm efl and less) are particularly good for overall views with less haze effect (see above). The standard focal length of around 50mm efl is obviously useful for most subjects, while a moderate telephoto can be used

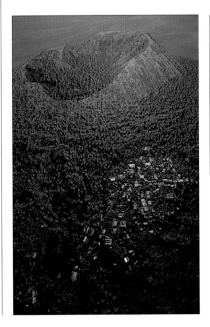

to pick out smaller subjects like a flock of birds. Keep the aperture wide open and set the highest shutter speed possible (at least 1/250 sec) to avoid camera shake. Aircraft vibration makes manual focusing difficult to judge—autofocus is better—and also limits the length of telephoto lens.

 Comoros Islands

This volcanic crater on the coast of an island in the Mozambique Channel was shot from about 1,000 feet (300 meters). The height ensured good contrast and saturation.

Isolation

An empty road, so little used that sand drifting across has almost covered it in one short section, passes an isolated dwelling on the Hopi-Navajo reservation in Arizona.

Preparing for a flight

Save time and money by making all possible preparations before you fly, and allow for the different shooting circumstances between types of aircraft—fixed-wing, helicopters, and balloons.

Flying time is expensive, so time spent planning the flight, briefing the pilot and preparing the aircraft and cameras always saves money—and gives you more time for shooting in flight; basically, do as much as you can before take-off.

☐ Mark the flight plan on a map, anticipating exact locations as much as possible.

☐ Check with the pilot and airfield personnel what the weather conditions are likely to be. Generally, the best conditions for photography are a fairly low sun, clear air and minimum cloud. Either early morning or late afternoon may be best, depending on local weather.

☐ Prepare a list of subjects that you are interested in, and show it to the pilot, who can probably make suggestions. Consider wide-angle views of the whole area, closer shots of special features such as waterfalls or lakes.

☐ Brief the pilot on the type of shots you want, and how you would like him to position the aircraft for them (see box).

☐ Open windows, hatches or doors as necessary for an unrestricted view. Never shoot through glass or plastic. However clean and unscratched the window, it will reduce sharpness and increase flare. If you cannot avoid doing this, keep the camera as close to the plastic as possible, and use a piece of dark cloth, or your hands, to eliminate reflections. Don't shoot when sunlight strikes the window, as this will cause flare and show up scratches. Adjust your seat and shooting position while still on the ground.

☐ Lay out camera equipment so that it is secure but accessible.

▲ Fixed high-wing
For general aerial photography, a single-engined aircraft like this Cessna is probably the best choice. Flying time is relatively inexpensive, the aircraft is maneuverable, and the view unrestricted. If the wheels are retractable, so much the better, as they give a wider view.

▲ Fixed low-wing
Larger low-winged aircraft are generally more popular among pilots, and they have the advantage of speed (useful if the airfield is distant from where you intend to shoot). The disadvantage is limited visibility. The rear luggage hatch may be the only unrestricted camera position, and this is cramped.

◄ Helicopters
Although helicopters are the most expensive of all aircraft to rent, particularly large models such as the Bell Jet ranger, they have the advantages of relatively high speed to reach the subject without delay, great maneuverability and a clear view. Light, twin-seater helicopters usually have very good visibility with a bubble dome, and a complete door can often be removed before take-off. All helicopters vibrate strongly when hovering, and slow forward flight gives less camera shake. Avoid including the rotor blades in frame.

Banking

Banking the aircraft makes possible near-vertical shots such as this of a cinder cone in California's Lassen National Park.

Shooting angles in flight

Level flight

Normal flying allows only diagonal shooting at a shallow angle, which is satisfactory for distant scenic views but not for close or graphic photographs. The shorter the focal length of the lens, the more restricted the angle, as the wing tips and wheels mark the limits of view.

Banking

A steep shooting angle, even vertical in some instances, is the most generally useful—it gives good possibilities for composition and allows close approach. For this, the aircraft must be banked, and as this puts it into a turn, shooting may be limited to only a few seconds. One technique is to slip the aircraft sideways toward the subject, reducing the throttle to dampen vibration. The alternative is the circular flight pattern. For shots that include the horizon and sky, the aircraft must usually be banked away.

Circling a subject

For a sequence of near-vertical shots of a single subject, a tightly banked circular pattern is best. In practice, however, it is not always easy to center the circle over the subject, and the tendency is to place the aircraft over the subject and out of view. Discuss this with the pilot before takeoff.

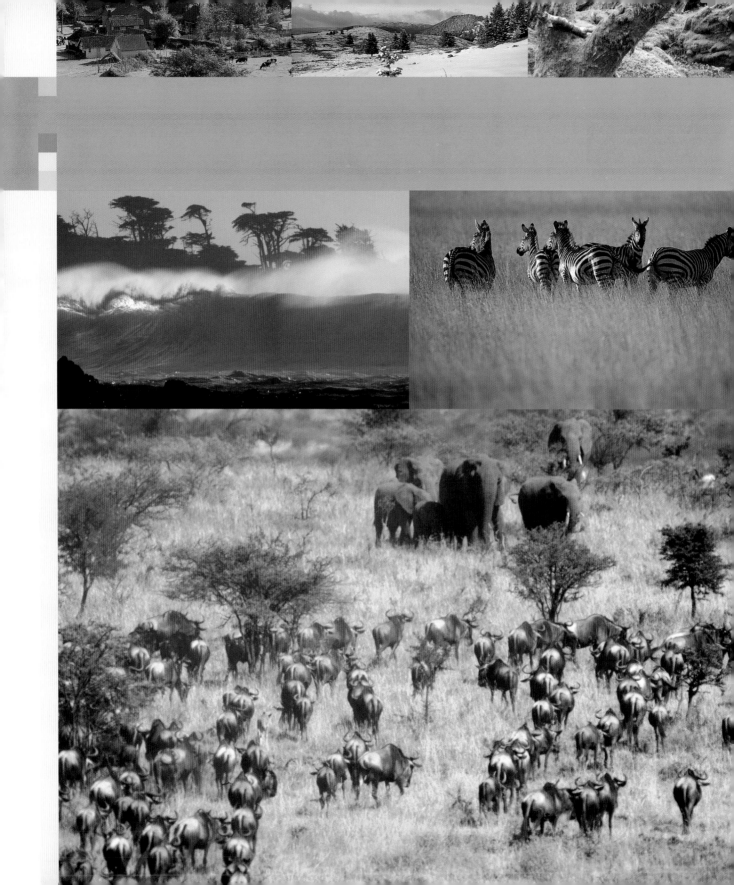

Wildlife and **Habitats**

Wildlife is one of the most challenging and rewarding subjects in the natural outdoors. There may be less of it around than formerly because of environmental pressures, but it is, for the most part, better protected. One of the strongest guarantees for wildlife protection is tourism, upon which an increasing number of places have become dependent financially. In locations as varied as Yellowstone, Florida's Everglades, and Africa's Rift Valley, wild animals have become commercial assets.

Photography is one beneficiary of this development, and digital photography in particular has valuable advantages. A great deal of wildlife camerawork involves long periods of waiting interspersed with brief flurries of fast-reaction shooting, nearly always pushing against the constraints of shutter speed and light. Digital cameras give instant feedback, which allows you to set up more confidently in uncertain situations. Working from a hide, for example, you can test the settings well before an animal appears. Digital cameras are also highly flexible, so that, when stalking, you can switch instantly between sensitivities as you move from sunlight to shade. You can also rework many of the settings later, making any mistakes of exposure, color balance, and so on almost irrelevant. For the most part, the cameras are also very quiet, and, with sensors usually smaller than 35mm film, telephoto lenses have a greater magnifying effect.

Photographing wildlife means immersing yourself in the animal's habitat. Each habitat is like a complex machine of many interlocking parts; an environment with a particular population of creatures and plants that has evolved in special conditions of geology, landforms, and climate. It makes no sense to consider animals and their habitats separately, particularly when it comes to photography, and in this section we will look at the dozen most distinctive and important kinds of habitat.

By understanding how a habitat works, you can plan to photograph the highlights of the system. For instance, if you were fortunate enough to be in a desert for one of the infrequent showers that heralds a sudden, brief blossoming of flowers, then a combination of shots–of the desert in bloom, a close-up of flowers, veils of rain falling from a rare stormcloud, and the desert in its normally parched state–would tell a larger story than just shooting close-ups.

Modern wildlife photography comes close to research. Gone are the days when the ideal was just to shoot a portrait of an animal. Now the aim of the best wildlife photography is what one behavioral biologist called "a determined effort to portray the actions of nature rather than merely animals or plants." For professionals, this has upped the ante as more and more behavioral scoops are logged. For a wildlife assignment these days to count as remarkable, a great deal of research, time, and expertise are involved, and still photography is often combined with filming. Nevertheless, for amateurs the situation has never been better. More wildlife locations are accessible for visitors; foreign travel is less expensive; and digital photography's ability to deliver under less-than-ideal conditions makes capturing successful images more likely.

Animals in the landscape

Not all wildlife shots have to be frame-filling. A distant view of animals can, with skillful composition, make a good scene-setting image that establishes the context.

Getting close to the animals is the key to most wildlife photography, and this is usually a challenge. Fortunately, one class of shot dispenses with this necessity—a longer view that shows an animal, or a group of animals, firmly established in its habitat. Not only can this make a strong image in its own right, it's also a very useful solution to a situation in which there is insufficient cover to approach the animals. Indeed, it sometimes happens that in paying so much attention to getting close for frame-filling shots, the photographer can forget how important it is to set the scene and context in at least one image.

Compositional skills become all the more important in this kind of picture, and are crucial when the viewpoint is less than satisfactory. If you are sufficiently close or have a long enough lens for the subject to fill at least two-thirds of the frame, then there is really little choice in the composition—the picture area will appear full—but if the animal is smaller in the frame,

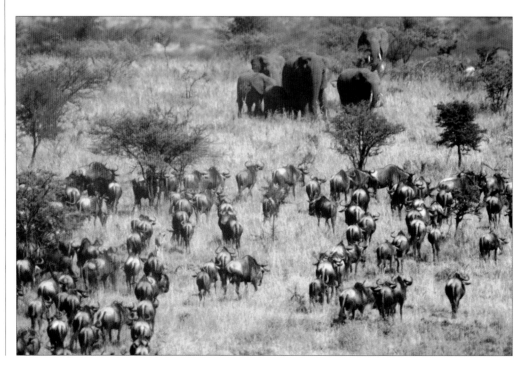

◀ Wildebeest migration
The annual migration of wildebeest in East Africa's Serengeti concentrates large herds in a relatively narrow corridor. In this shot, an advance of the column moving up a slope among acacia trees encounters a small herd of elephants. A 900mm efl lens compressed the scene.

where you place it is important. The most "logical" position—in the middle—is usually the least satisfactory, emphasizing the emptiness of the surroundings and often showing a large area of unsharp foreground. A traditionally balanced position is off-centered, by about one-third from the top or bottom and from either side. This works well if the animal is facing into the frame. As well as producing a sense of balance, this off-centered placement also reduces the impression that the animal appears smaller than you would have liked.

Also, if you are using a telephoto lens, the depth of field is likely to be shallow, and keeping the animal low in the frame cuts out some of the out-of-focus foreground. This low placement emphasizes the surroundings more, so that the photograph becomes animal-plus-setting rather than just the animal alone. Alternatively, by including a second focus of interest nearer the edge of the picture, the composition can point out relationships, such as those between an animal and its source of food. Basically, placing the main subject eccentrically draws attention to the composition and tends to encourage the viewer to search the image more closely.

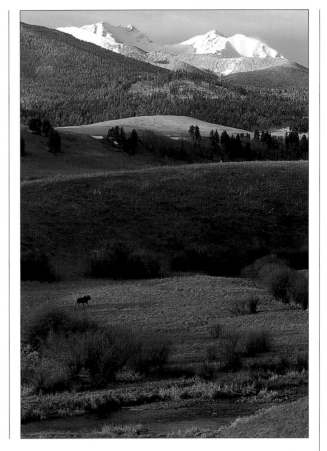

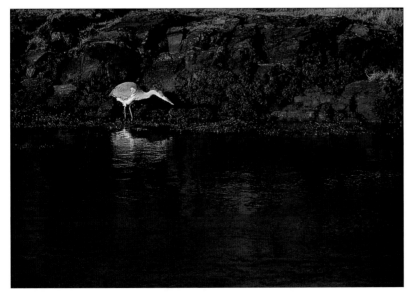

◀ At the water's edge

Herons are relatively common, and rather than using a longer lens for a frame-filling view of a bird that is frequently photographed, I preferred to show its feeding activity as it patrolled the rocky margins of a Scottish loch in the late afternoon. As it was facing to the right and moving slowly in that direction, I composed the shot so that it would be facing into the larger part of the frame.

▲ Figure for scale

The small figure of a moose crossing a meadow in Montana in the spring gives action to this landscape and a sense of its vast scale. The size of reproduction of the image is important, because while a slight delay in spotting the animal adds interest to the picture, it must be large enough to be seen by the viewer.

Animal behavior

More interesting than static portraits are behavioral photographs, which call for some research into wildlife activity. Knowing the key moments in behavior also makes it easier to find animals.

Most animals have a limited number of predictable activities. Some of these are tied to a particular location, time of day, or season, and awareness of these can be used to improve your chances of actually finding the animals. The most common activities are: feeding, drinking, fighting for territory, courtship display, nest building, mating, giving birth, feeding young, repelling or fleeing from predators, greeting, and migration.

Actually, the easiest way of finding wildlife subjects is to use an experienced local guide. In certain habitats, and with some species, there may then be no more difficulty than going to a particular site at the right time of day. Really, there is little substitute for good local knowledge. However, on the occasions when you have to rely on yourself, you will need two kinds of information: a general idea of the behavior of the animals you are looking for, and some specific clues about the place you are in. Advance research will give you some indication of what is likely; local information will then help you put this into practice.

For many animals, particularly mammals and birds, the most active times of day are in the early morning and late afternoon. Animals that live in colonies, such as some species of stork, seabirds such as puffins, gulls, and

▽ Bison spring
A female bison just after having given birth in a springtime snowstorm in Montana. Calving time had been anticipated, and was the reason for planning the session.

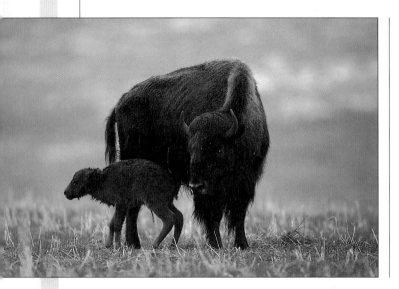

Prime locations based on behavior

Migration
Seasonal events are often very reliable for photography, especially in habitats that have a very pronounced regime. The annual migration of wildebeeste in East Africa's Serengeti (*see page 80*) is a good example of this.

Feeding
Often, the location of food is more predictable than the animals' rearing ground. In Sri Lanka's Yala sanctuary, for example, painted storks feed in the wetlands in the early morning (*see page 85*).

Water holes
Wherever there is a dry season, as in the East African savannah, water becomes very scarce. Water holes then become highly predictable locations in which to see animals.

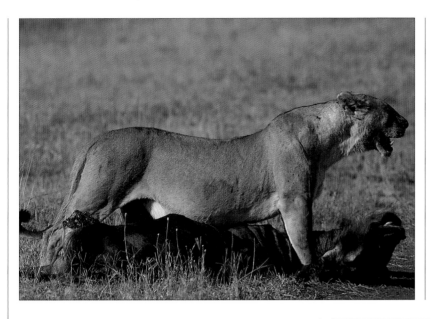

Lioness with carcass

Predators follow predictable patterns of hunting and rest. Having brought down a wildebeest and fed a little, this lioness was dragging the carcass back to the pride. We spotted her easily from a distance as we drove in a four-wheel drive, but she paid no attention whatsoever to us, concentrating entirely on the effort of moving the heavy animal.

Ngorongoro

February is the time for tens of thousands of flamingos to mass at Lake Magadi in Ngorongoro Crater, Tanzania. The seasonal movements of migratory species are predictable and a good starting point for planning a photographic shoot.

terns, and bats, tend to disperse for feeding—leaving and returning at more or less regular intervals. Most species of small mammals are active only during the night, or at dawn and dusk, and are therefore rather more difficult to photograph.

Some species migrate to follow sources of food and water, or to seek more congenial weather. This sometimes provides an opportunity to see and photograph spectacular concentrations of wildlife— wildebeeste in the Serengeti, geese on the central flyway of North America, or migrant waders in northwestern Europe, for example. Many animals also gather in colonies in order to breed, and striking gatherings can also be seen at these times. Seabirds, seals, and sea lions are good examples of species that are colonial breeders.

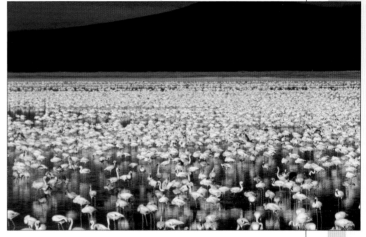

Large predators, never so numerous as their prey, are often difficult to find, particularly as stealth and concealment are their own well-developed skills. One useful tip is to watch the behavior of the species they prey on; if these are behaving nervously, a predator may be close at hand. For example, when a hunting leopard is near, deer often call to each other in alarm. Similarly, monkeys will warn of an approaching tiger. Also look for fresh tracks and other signs, such as droppings.

Sources of information

☐ Internet
☐ magazine articles and guidebooks
☐ local organizations such as conservation departments, national parks headquarters, and naturalists' societies
☐ in the field, park wardens, rangers, and guides, other naturalists with local knowledge.

Stalking

Wildlife photography relies heavily on fieldcraft, which means finding the animal, getting close enough for a clear view and a suitable position to shoot, in most cases unobserved.

As with candid photography of people, stealth, fast reactions, and being observant are the key skills for approaching animals in the wild. It also helps if you're so familiar with your camera that you can use it immediately without fiddling with the settings. Stalking involves both a knowledge of how to find animals and the ability to approach them unobtrusively. Be aware of the behavior of the species you are stalking. Many animals, for example, are at their most active around dawn and dusk, which means working in low light levels. Weather can affect behavior, and your stalking success. An impending storm makes many animals nervous. In rain, most seek shelter. For your own concealment, the fine weather associated with a high pressure system is often an advantage—the pressure holds down scent. Conversely, moist air makes smells easier to detect.

Moving unobtrusively involves a number of techniques, many of them similar to the ways in which animals themselves hunt or avoid being hunted. The following are the most important:

☐ Dress inconspicuously or, better still, use camouflage. Wear drab clothing and avoid anything that might glint in sunlight. Faces and hands normally appear bright and are easily visible at a distance. If you feel dedicated, apply streaks of dirt to conceal yourself.

How animals perceive

What seems good camouflage to human senses may not necessarily be effective for the animals you are trying to conceal yourself from.

Birds Most birds have better eyesight than humans, particularly in their ability to see detail at a distance. The eyes of a hawk, for example, can take in eight times more than human eyes. Most species also have a very wide field of view—up to 360 degrees in the case of some ducks. On the whole, birds respond more to movement than to any other visual stimulus. Their hearing also tends to be good, although in flight it is almost certainly less effective. On the other hand, few birds have a good sense of smell, apart from flightless species.

Mammals Because most mammals tend to be active at dawn, dusk, or nighttime, their eyesight is, on the whole, poor. Mammals that hunt or need to escape from predators at speed, such as cats and deer, are an exception. Their hearing is usually good—large ears are generally a sign of high sensitivity. Their sense of smell can be so well developed that it is difficult for humans to imagine how important a part it plays. It is probably the chief sense for most mammals.

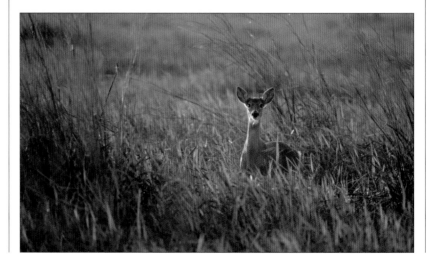

- ☐ Minimize your scent by being well clothed, moving around as little as possible, staying downwind of the animals you are tracking, and avoiding any deodorant or other scent.

- ☐ Walk economically, with as little unnecessary movement of your torso and arms as possible. Roll your feet when you walk, rather than slapping them down, and look where you put them, avoiding leaves or twigs that may crack.

- ☐ If, by mistake, you make a loud noise, freeze instantly and stay motionless for a few minutes.

- ☐ Try never to cross open ground, but instead use natural cover. Stay in the shade rather than sunlight, and never silhouette yourself against a skyline.

- ☐ When making the final approach to an animal in full view, keep low and move only when it is busy with some activity. At the times when it pauses to check its surroundings, keep still. Move directly forward rather than obliquely, so that the animal has difficulty in telling whether you are moving at all. If the animal sees you look down at the ground—avoid eye contact.

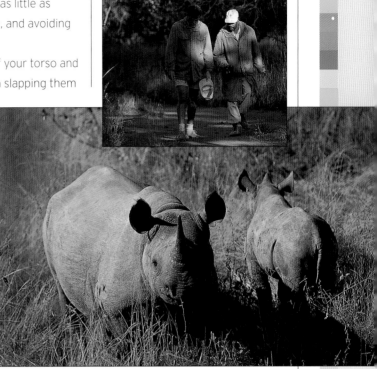

▶ Tracking rhinoceros

With dangerous animals—and a female Black Rhino with a calf certainly qualifies as one of these—it is essential to have professional help; in this case, park rangers in a South African wildlife reserve. It was the tracker accompanying me who decided that we should rapidly climb the tree from which this shot was taken, as the female makes a mock charge.

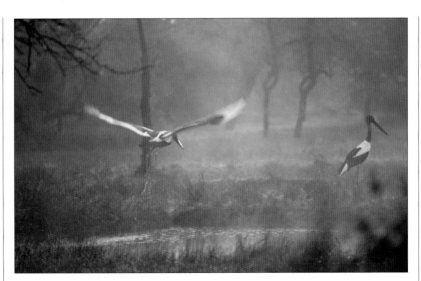

◀ Stalking wary subjects

Deer, unless tame or used to regular feeding, will only tolerate approach to within a prescribed distance, establishing, like many animals, an invisible perimeter for their feeling of safety. In this case, 50 feet (14 meters) was the closest approach. This white-tailed deer's alertness shows that only a few moments remain before it will take flight.

▲ Using trees as cover

The wooded margins of wetlands are, in many ways, easier photographically than open lakes and reed-beds. Even a little cover, as offered by the acacia trees in this Indian bird sanctuary, makes stalking possible.

Blinds

The alternative to stalking is to use a blind—a concealed location usually sited within the animal's territory that permits close observation and photography over a period of time.

There are many different kinds of blind, depending on the animal, the habitat, and the facilities available. Established wildlife reserves often have permanent blinds that are so well established that the animals accept them as part of the scenery. On the other hand, some wildlife photographers build their own blinds, setting them up temporarily in view of a particular nest or feeding place. At a less elaborate level, it is also usually possible to put together a makeshift blind out of available natural materials.

When choosing a site for the blind, remember that it should have a clear, unobstructed view of a place that is visited regularly by the animal or bird you want to photograph. A nest or lair is one possibility. Others are feeding, drinking, and bathing places. Avoid open spaces such as fields. Look instead for a background of vegetation, such as at the edge of a clearing, and certainly avoid a location where the blind is silhouetted against the sky. Make sure also that the lighting will be right for the subject at the time of day you will be shooting—in other words, avoid having the sun shining directly into the lens and the subject in deep shade. Try and site the blind downwind.

With animals or birds that live permanently in a particular territory, you will need to introduce the blind carefully, in such a way that you do not cause disturbance. Moving the blind right up close on the first day will probably startle the animal so much that its pattern of activity will be disrupted; it may even abandon the site. The normal method of introducing a blind is to set it up at a distance, moving it forward in stages over a period of time. When possible, move the blind at times when the animals or birds are elsewhere—if photographing a nest, wait until the bird is away feeding.

Portable blind

This canvas construction, supported on an aluminum tubular frame, is larger than the hides normally used for observing wildlife, to allow sufficient room for equipment. It can be transported easily to almost any location at ground level and can even be moved progressively closer to the subject over a period to avoid disturbance.

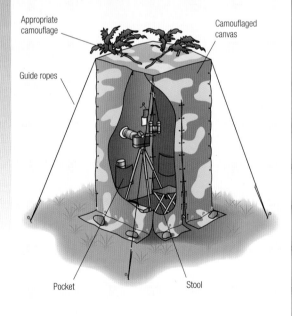

Appropriate camouflage

Camouflaged canvas

Guide ropes

Pocket

Stool

Permanent blind, baited location

With a blind that is permanent, or at least intended to last for a season, it may be possible to encourage some species to visit by regularly putting down food or water. In time, when the animals have become thoroughly accustomed to the blind, it may not even be necessary for observers to remain completely hidden. Baiting, however, can alter animal behavior and should be undertaken with caution.

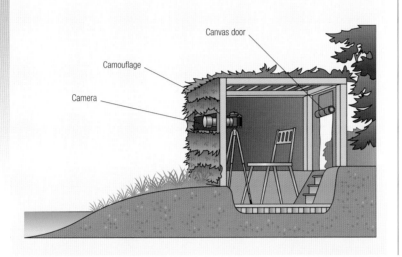

Canvas door

Camouflage

Camera

Using a hide

Even with a well-constructed hide, take the following precautions when using it, so as not to alarm the wildlife:

☐ Keep quiet.
☐ Don't touch the walls of a canvas hide or allow any visible movement.
☐ Move the camera and lens slowly and as little as possible.
☐ Use a tripod and cable release to cut down vibrations with long lenses.
☐ Don't wear artificial scents.
☐ Do not place your eye too close to the viewing hole, as it may be visible from outside.
☐ When the hide is not in use, leave the base of a glass bottle poking through the lens opening as a dummy lens.
☐ Enter the hide unobtrusively, either at night or when the animals are not present, or by taking a friend with you who leaves after a short while to fool the animals into thinking that the hide is empty once more.

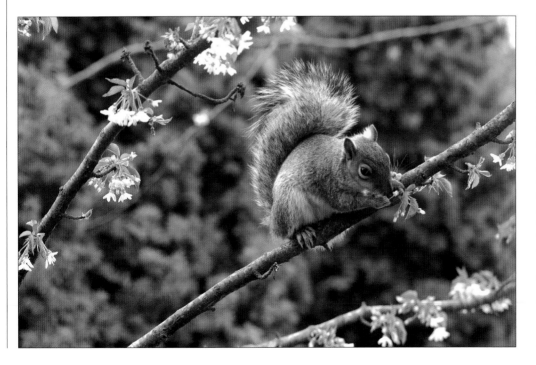

 Gray squirrel

This shot was taken from about six feet (two meters away) and the squirrel was entirely unaware of me and the camera even though we were separated only by glass. I took it from an upstairs window, and I was visible even though the room was darker than the outside. Most animals associate threat with conditions that are familiar. Being behind glass, I was simply not recognizable as another creature. When I inadvertently touched the glass with the lens, however, the squirrel made off at lightning speed.

Wildlife from vehicles

In many wildlife reserves, the standard tour is by vehicle, and provided you don't have to shoot through a window, this is an excellent camera platform.

For most animals, a vehicle, despite its noise, is much less of a threat than a human being on foot. In places with regular traffic, most of the local wildlife becomes accustomed to it. This is particularly noticeable in those wildlife sanctuaries where the only method of touring is by vehicle along established trails–many species will tolerate a remarkably close approach. Although most vehicles are restricted to roads or tracks, and so offer a restricted choice of viewpoints, they have the great advantage of being, in effect, mobile hides.

Ideally, a vehicle should be pretty rugged, with high clearance, as most wildlife locations have unpaved roads; high, so that it offers clear views over surrounding grass and undergrowth; roomy, so that equipment can be laid out ready for use; and equipped with all-round viewing through windows that can be opened fully. Some safari vehicles have provision for shooting through a roof hatch. The extra elevation and all-round view that

◢ Ngorongoro Crater
Typical safari vehicles have provision for shooting through a roof hatch, as in this Land Rover. The extra elevation and all-round view that this gives makes it much better than a regular side window.

this gives makes it much better than a regular side window. Four-wheel drives are standard and meet all of the requirements for wildlife photography, provided that they are not crowded with other passengers. Some organized safaris, however, use small buses, which offer only second-rate conditions for photographers. If you have no alternative but to ride in one of these, try to sit in the front seat next to the driver, or at least sit next to a window that opens.

A vehicle appears least threatening to wildlife when it is either stationary or moving slowly, but starting, stopping, or obvious changes of engine tone can put animals to flight. When approaching an animal, it is better to roll to a stop with the engine switched off. Also anticipate the best viewpoint as you

approach. Starting up again and reversing to avoid an intervening branch may scare the animal. In very well visited game reserves, however, the animals may be sufficiently familiar with vehicles for these precautions to be unnecessary.

Never leave the vehicle, for outside it you will immediately be identified as a threat. The window ledge is, in any case, a good support for even the heaviest long lens, but use a thick cloth or towel to avoid scratching the lens barrel. When shooting, switch off the engine and move around inside as little as possible, to avoid camera shake. If you can, darken the interior so that you are not, from the animal's point of view, silhouetted against the window behind you.

▶ Hunting dogs

This pack of hunting dogs in Tanzania's Mikumi National Park was photographed from about 65 feet (20 meters) with a 600mm efl telephoto, from the side window of a four-wheel drive. They remained completely unconcerned, and it was as good as if photographing from a hide/blind, with several opportunities for behavioral shots.

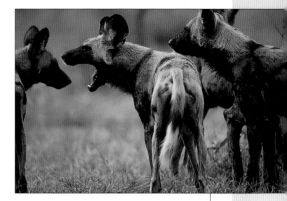

▽ Staying part of the vehicle

With large plains animals, such as this lioness at a water-hole in Ngorongoro Crater, a vehicle is the only safe and practical means of photography. The shot was taken through a roof hatch, like the one shown opposite.

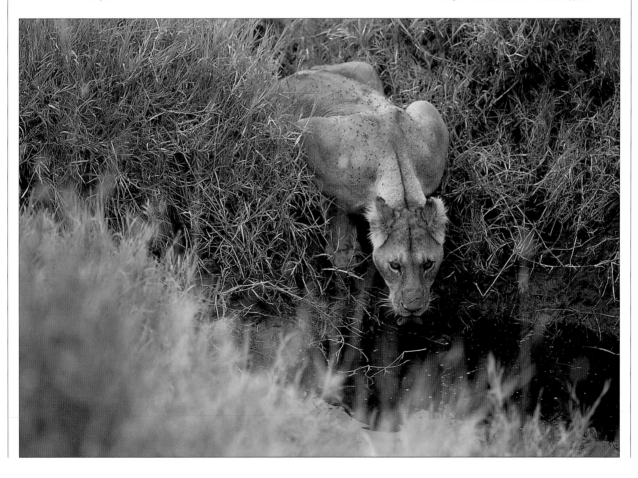

Birds

It is easiest to photograph large birds and colonies of birds, although in most cases a long telephoto lens is essential to capture a worthwhile image.

In flight, birds make wonderful active subjects for the camera, but they are not easy to photograph. There are, certainly, few creative problems, but it takes practice to produce even a technically efficient shot. There are three principal ways of losing a picture: soft focus; wrong exposure; and having the subject too small in the frame. Fortunately, digital cameras can help in overcoming these by efficient autofocus tracking (even predictive tracking with some cameras), the ability to readjust brightness (most effectively when you shoot in RAW format) and digital enlargement.

It's only worth attempting to photograph a bird in flight if you can produce a reasonably large image of it, and freeze the wing beats. Large birds such as herons and storks are easiest, not only because of their size but also because they move relatively slowly. As a rule of thumb, try to make sure that the image of the bird, wing tip to wing tip, fills at least half the picture frame. You can enlarge later with interpolation, but the more you do this the less sharp the image will be, and it's always preferable to fix this issue at the

Exposure

Because the sky dominates pictures of birds in flight, it also influences meter readings. If it is much brighter than the bird, underexposure is likely. If it is much darker (where you have a white bird against a dark blue sky, for example), expect overexposure. To an extent you can readjust this later if you shoot in RAW format and use the camera manufacturer's editing software or a RAW plug-in, but it's better to get it right the first time. It may be better to switch to manual and do one of two things: take a reading from an average subject on the ground, or even from other similar birds if you are near a nesting colony, or else decide, quickly, how much lighter or darker than average you want the sky to appear and set the exposure to suit. Exposure compensation is likely to vary from two stops lighter for a light, cloudy sky, to one stop darker for a deep blue sky.

▶ **In flight**
Late afternoon sunlight catches a pair of white pelicans flying against approaching stormclouds over Lake Manyara, Tanzania. Large birds like these fly slowly, and as they were moving across the field of view, there was only a slight change in distance. Continuous automatic focusing dealt with this easily, even with a 600mm efl lens.

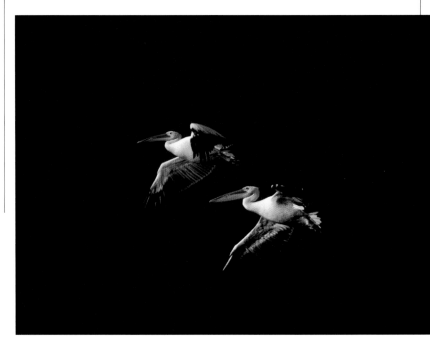

time of shooting. Few fixed-lens digital cameras have sufficient focal length for this kind of shot, but with a digital SLR you can attach a long lens–and the longer the better, 500mm and upward. Fortunately, small sensor size in many SLRs gives extra magnification.

Unless you want to produce a streaked image for creative effect, use the fastest shutter speed possible–at least 1/250 sec–adjusting the sensitivity accordingly. The most usual camera position to find yourself in is below the bird (although many seabirds can be photographed from cliff-tops, looking down) but generally, the higher you can get, the better. Nesting sites usually offer the most reliable opportunities because the birds' flight paths are regular, and can be checked. A nesting colony is better still.

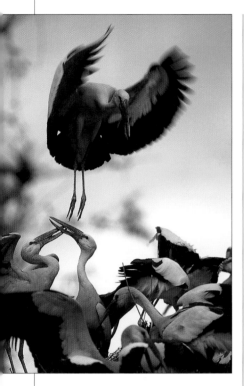

▲ Nesting colony
Seasonal nesting sites for birds that live in colonies, like these Openbill Storks, offer opportunities for great shots.

▼ High sensitivity
An Indian roller in rain. For this close-up of a moderate-size bird, I used a 600mm efl telephoto lens.

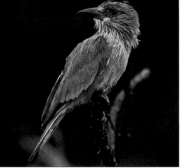

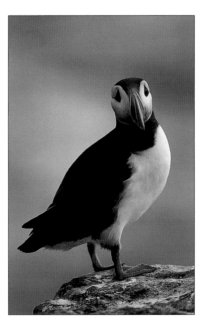

In focus

Pin-sharp focus is essential, and the difficulty with birds in flight is that there are no reference points in the sky against which to measure the rate of movement toward the camera, compounded by the larger focusing movements needed in a long lens. Autofocus should take care of this, but if it's too slow for the circumstances, you can always fall back on the following three tried-and-tested manual techniques:

Follow focus
Try to keep the bird in focus the whole time by turning the focusing ring at a steady rate toward its closest setting, to match the approach of the bird. In practice, the focus often drifts.

Continuous refocusing
With this method, the bird is focused several times as it approaches, but after each shot the lens is moved out of focus to start afresh. This makes each focusing attempt much more positive than trying to maintain a sharp image the whole time.

Fixed focus
This is a one-shot technique with a high chance of success. The lens is focused ahead of the bird, which is then followed in the viewfinder. Without moving the focusing ring again it is fairly easy to anticipate the precise moment at which the image becomes sharp. Without reference points in the sky, focus first on the bird and then quickly refocus nearer.

◄ Puffin
This single-bird, frame-filling shot of a puffin was taken on a North Sea island colony off the coast of northeastern England. Some species, like this one, are extremely approachable, and their obvious lack of fear of humans is enhanced by the monitored and strictly restricted access to the colony.

Underwater

A range of housings makes it relatively easy to shoot underwater, and digital cameras take care of much of the uncertainty and color problems.

Underwater photography is highly specialized, and the diving techniques involved need to be learned from a qualified instructor. This applies to snorkeling as much as to scuba diving. Remember that the most interesting places for underwater photography, such as coral reefs, can have currents, sharp rocks, and a number of creatures that defend themselves, sometimes very actively, by stinging or biting.

Housings

There is a fairly wide range of submersible housings for digital cameras, but the basic choice is between those that are adaptable and fit a number of makes, and those that are custom-designed for a specific model. The best housings, which can be used at serious scuba-diving depths, are expensive.

Water absorbs light, and the deeper you go, the darker it gets. Also, water absorbs light selectively, starting with the red wavelengths. Because of this, the deeper the water, the bluer it appears, and even though the camera's white balance menu can accommodate the color cast down to a few feet below the surface, the results lack the saturation and contrast of pictures taken with flash. For scenic shots, showing more than just a detail, natural light has to be used, but they are nearly always more successful with flash added for the foreground. Flash is essential at depths below a few feet, and underwater units are normally mounted on an arm above and to one side of the camera housing. This off-axis position helps to avoid a special problem in all but the clearest water—back-scattering, in which water particles between you and the subject are lit up to look like falling snow.

The higher refractive index of water has an apparent effect on lens behavior, summarized in the box opposite. Basically, lenses behave as if they are a longer focal length. One correction is to use a port in the housing that is domed rather than flat. This cures the problems of size and distance, although the angle of view remains narrower than in air. However, it has a side effect: an ordinary lens will no longer focus on infinity. To restore normal focusing, add a supplementary close-up lens or, for an SLR, a thin extension ring. Dome ports also correct the problems of distortion and poor resolution close to the edges of the picture, and so are always better than the cheaper flat ports. For the best performance, the curve of the dome should match the focal length of the lens.

▽ Flash

Flash is virtually essential for close-ups at any reasonable depth, particularly with active, moving subjects. The improvement in color intensity and contrast is marked, as in this image of a Tiger cowrie in Malaysia.

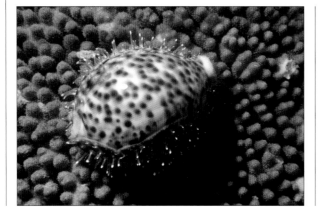

Near the surface

You can shoot without flash within a few feet of the surface, if the water is clear and the sunshine bright. The main precaution is white balance. This pair of images shows the difference between "sunlight" white balance (main) and "auto" (smaller image, right).

Lenses underwater

Being denser than air, water acts as a kind of lens, so that compared with the view on land the image is different in three ways:

1. Objects appear closer, by a quarter of their distance.
2. They appear larger, by a third of their true size.
3. The angle of view of the lens is smaller, by a quarter.

Filter corrections for sunlight

Depth	Filter
5–15ft (1.6-4.6m)	CC20 Red
15–20ft (4.6-6m)	CC30 Red
20–25ft (6-7.6m)	CC40 Red
25–30ft (7.6-9m)	CC50 Red

Light reflected from surface

Sunlight

Light is absorbed passing through water

20 ft (6m) red absorbed
36 ft (10m) orange absorbed
50 ft (19m) yellow absorbed
75 ft (21m) green absorbed
90 ft (27m) blue absorbed

Equipment care

Shooting underwater can be tough on your equipment. Sand, grit, and crystallized salt can cause leaks by becoming lodged in the O-ring groove, if they are allowed to build up after several dives. Take these standard precautions:

☐ Check a new housing by submerging it without a camera. Do this first in a tub or bucket of water and watch for tell-tale bubbles, and then take it to the maximum depth that the manufacturer recommends. Back on the surface, check the interior for drops of water.

☐ Between dives, wipe down the housing, your hands, and hair before changing film. If possible, rinse the housing in fresh water before drying it. When returning to the boat or shore after a dive, do not leave a housing out in direct sunlight; being sealed, it will heat up very quickly and this can cause condensation and damage to the lens and film.

☐ At the end of a day's diving, first rinse the equipment in fresh water by immersing it completely for at least 30 minutes to dissolve all the salt. Then hose it down. After washing, dry the outside thoroughly with a clean cloth, and then open the housing, remove the camera, and pull out the O-ring. Clean the O-rings and their grooves with a cloth soaked in fresh water and with cotton swabs. Wipe them dry with a clean cloth and relubricate, but lightly. Too much O-ring grease prevents a tight fit and may cause a leak. It also attracts grit and sand. Finally, reassemble and protect the port with a cap.

Woodland

Temperate woodlands are rich environments for photography, with a huge variety of plant and animal life, but be prepared for a range of light levels and restricted views.

Woodland offer great opportunities because trees create a number of different habitats, at different heights above the ground, yet all in one place. At the top, where most of the leaves grow to trap sunlight, is a flimsy lattice of thin branches; lower down, the plain, bark-covered trunks provide another food source. Closer to the ground, where less light filters down, bushes and shrubs grow, while on the woodland floor, undergrowth mingles with all the litter that falls down from the higher levels. Because of these different layers, each with its own characteristics, there is less direct competition for food among the animals than there is in a simpler habitat such as grassland.

For all but close-up views, where the surroundings are less obvious, composing woodland photographs generally involves finding clear viewpoints and simplifying the image. The mass of branches, trunks, and

▲ Weak sunlight
For overall views of a complex woodland interior, the weaker light from a hazy or low sun is likely to be better than that from a bright midday sun. When photographing into the sun, take care in positioning the sun's disk. By having it cut by a branch, you will still have the image and halo of the sun without excessive flare.

▼ Olympic rain forest
This shot shows a rare stand of temperate-climate rain forest, in Washington State's Olympic National Park. Shooting mainly in shade, and framing the image so that it was filled with trees and plants, gives the full impression of dense green vegetation.

leaves can make confusing patterns and get in the way of middle-distance shots. If you're stalking an animal such as a deer, tree trunks and undergrowth will help conceal you, but they can also intrude on the picture and careful side-stepping may be necessary for a clear view. In fact, clear views of anything are at a premium in woodland—to improve your chances, look for clearings, glades, ponds, and the banks of rivers and streams, as well as weather conditions that separate the scene into zones, such as mist and fog. Hilly areas usually offer the most choice of viewpoints.

In relatively open forest, tree trunks receding into the distance make depth of field an issue if you are using a long-focus lens. Even at a small aperture it may be impossible to get everything sharp. A tripod helps for this kind of landscape. In photographing animals, however, shallow depth of field from a wide aperture actually helps by blurring foreground and middle-ground vegetation.

There are so many different small habitats in temperate woodland that it's difficult to predict general lighting conditions, but when the trees are in leaf, the shade deep inside most forests is deep. This is a lighting problem if you are stalking active animals, and calls for a tripod for most other subjects—or a very high sensitivity setting. A tall, well-established beech wood, for example, lets so little light reach the ground that even on a sunny day exposures of around 1/50 sec at ƒ2.8 are likely at ISO 100. When the canopy is thin and sunlight does break through, contrast is likely to be very high in summer. Shafts of sunlight are interesting when they pick out just the right subject—a small clump of bluebells, for instance, or a deer emerging from a thicket—but when it simply dapples the scene, it adds to the visual confusion of a habitat that is already quite complex. The range of brightness in these conditions can be as high as 6 f-stops. Small-scale subjects like flowers can be shaded to make the lighting more even, but with overall views it may be better to wait until late afternoon or early next morning when the low angle of the sun picks out the sides of tree trunks. Cloudy-bright weather and hazy sunlight are the easiest working conditions.

Ancient oaks

I took these shots in an old oak forest in a Welsh wildlife reserve. Light levels were low, but a 1-second exposure with the camera on a tripod allowed an aperture of ƒ22 with a 150mm efl lens, and therefore excellent depth of field.

Grassland

Good visibility, open views, and clear lighting are the hallmarks of grasslands, and in some protected areas an abundance of plains animals makes for some of the most exciting wildlife photography possible.

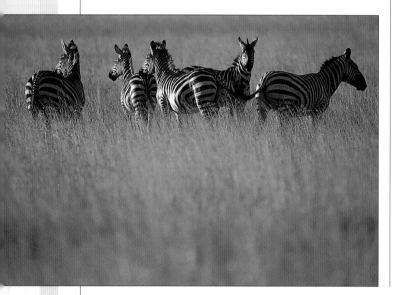

Because of the typically low relief, most subjects in grassland are exposed to the full available light from the sky. While this does not make direct sunlight any more intense, it does increase the level of fill-in reflection from other parts of the sky, and so lowers contrast. On a cloudy day, the lighting is virtually shadowless. In general, plains light is more consistent than elsewhere and, because the horizon is generally flat, lasts longer. However, this can also make it monotonous, particularly when the sun is high and the direction of the light is the same whichever way the camera is pointing. Overcast conditions create very flat lighting, and distant views can appear particularly dull, while at the same time the sky tends to be much brighter than the land (by a difference of up to 5 f-stops)—see pages 42-43 for ways of dealing with this. Photographically, early morning and late afternoon are particularly important times and these coincide, fortunately, with the times of greatest wildlife activity.

The savannahs of Africa are archetypal tropical grasslands, justly famous for spectacular concentrations of wildlife, and in particular, large mammals. African safaris have little competition when it comes to reliable, accessible wildlife photography. Finding animals in open grassland is usually easier than in any other habitat, simply because there is less cover, and herds of large grazers are the most visible of all. At the same

Horizon line
One answer to the problem of making an attractive composition with a flat horizon is to frame the image below it. Here, the backlit grass just before sunset is thrown out of focus by a powerful telephoto lens (600 mm) and becomes simply a wash of color.

Cape Buffalo
A cattle egret tries to land on the back of a huge Cape Buffalo in Africa's Rift Valley. These savannah buffaloes are unpredictable and dangerous and best photographed from a distance.

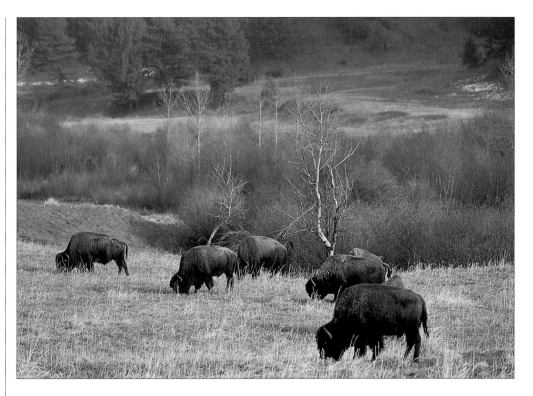

Bison herd
Any elevated point is valuable in grassland—use it to keep the horizon at the top, or to exclude it entirely. This shot captures a downslope view of bison grazing.

time, long grass and clumps of trees can conceal large animals, and predators take advantage of this. For this reason, height is an advantage and a 4WD vehicle ideal (*see pages 88-89*).

Streams and water holes, which provide both water and cover (in the form of trees and shrubs) are usually good sites for photography, and are often busiest late in the afternoon. Some predators, particularly those that use surprise and pouncing rather than speed in the chase, such as leopards, keep close to such places. The most active times of day for many species are early morning and late afternoon, with the middle of the day reserved for resting or grazing. Nevertheless, good visibility makes it as easy to find animals at midday as at any other time.

Flat grasslands make composition difficult. To capture the sense of spaciousness, try using a wide-angle lens and placing the horizon line low in the frame, especially if there are interesting cloud formations in the sky. From ground level, it is not easy to see much more than the foreground and middle distance, and any slight elevation helps. Even using the roof of a vehicle makes a noticeable improvement. A slightly higher viewpoint also makes it possible to photograph animals without always having to include the horizon.

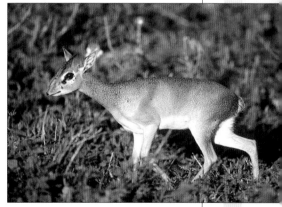

Dik-dik
One of the smallest antelopes (about the size of a hare), the dik-dik lives on the wooded margins of the savannah in East and Southern Africa. Its unusual name comes from the sound it makes through its nose when disturbed or alarmed.

Coastlines

Where the sea meets the land, the contrast between the two environments and the ebb and flow of the tide create an ever-changing range of photographic opportunities.

Coastlines can be flat and muddy; rocky with high cliffs; or feature beaches of sand, coral, or pebbles. The water can be anything from dead calm to violently stormy. Variety and unpredictability, in fact, account for much of the visual appeal of coastal landscapes. Light levels are high, and are enhanced by reflection from the water, and from surf and sand. Be wary of automatic exposure—shots dominated by the sea, and especially if it is backlit, are likely to be too dark for the other parts of the scene. Look carefully at the results in the camera's LCD, and above all check the histogram. Make exposure adjustments as necessary, and if your camera has tone compensation, consider reducing the contrast.

Fine spray is common on windy days, particularly off a rocky shore when waves are heavy, and this creates long-distance haze. This is accentuated by high ultraviolet scattering, so ultraviolet filters are important (they also protect the front element of a lens from damaging salt deposits). Water reflections can be useful or awkward, depending on the image you want to

Rock pools

Use basic close-up techniques for photographing the small-scale life in these pools, but take special precautions to avoid reflections from the water. Direct light gives a much clearer image than diffused light, so both sunlight and flash are ideal. In either case, position the camera so that the light comes from one side and is not reflected directly into the lens. Even then, the water may reflect blue sky. A polarizing filter cuts reflections, but also reduces the light reaching the film; an alternative is to shade the water above and in front of the camera with something dark, such as a black cardboard or even a piece of clothing.

▷ **Monterey**
In this image, back lighting from a late afternoon sun shines through the crest of a wave breaking against a Monterey shore in California.

Sea wrack

This image shows boulders at low tide, covered in sea wrack, at Ocean Point near Boothbay Harbor, Maine. By going in close to the wrack, it shows a very different view of the coast than the dramatic waves or perfect sands so common in coastline photography.

Cliffs

Using back lighting with waves and water highlights waves and foam. In this case, the back lighting also creates graphic silhouettes from the cliffs.

capture. Shooting toward the sun can give an attractive high-contrast pattern of bright reflections and dark rocks, while waves are emphasized when backlit. However, when there is clear, unruffled water close to shore, it may be useful to suppress reflections so as to show some underwater details. In this case, use a polarizing filter and experiment with the camera angle and position of the filter to find the clearest view.

There may be bird and seal colonies along rocky coasts. Although localized, where they exist they are generally well known, so ask around. Most seabird and seal colonies are densely packed, which gives you good opportunities for massed shots. As the locations are deliberately chosen by the animals for being inaccessible from the land, a very long focus lens is usually necessary for strong images. Ideal camera positions are high up and directly opposite the cliff or island that supports a colony. However, this inaccessibility has one advantage—the colonies generally feel secure, so that, from a convenient viewpoint, there is normally no need to conceal yourself.

Tropical beaches

Coastlines in the tropics are not always fringed with white sand and coconut palms, but many are, and they offer a distinctive type of scenery. White sand, derived mainly from shells, is very bright and reflective under a high sun. When the beach slopes off gently under clear water, rich sea colors from green to blue are usual. For scenic views, underexposure is often very effective; it darkens the sky, strengthens the color of the water, and can give very graphic images. To capture this, follow the meter reading without compensating, and even try a darker exposure. Graduated filters and polarizing filters can exaggerate this effect.

Case study: **Bay of Fundy**

Between the Canadian provinces of New Brunswick and Nova Scotia lies the marine basin of the Bay of Fundy, over 600 miles (1,000 kilometers) of coastline that varies from steep, rocky cliffs to mud-flats. Its most dramatic feature is its tides, the highest in the world, with an average range of 40 feet (12 meters) in the Minas Basin near its head. The tides are responsible for a rich intertidal zone full of plant life and small, hardshelled creatures. Above the cliffs are tall coastal forests of spruce, pine, fir, and other evergreens. Mud, seaweed, algae, a tremendous variety of beaches, cliffs, and uninhabited forests make up the character of this wilderness coast.

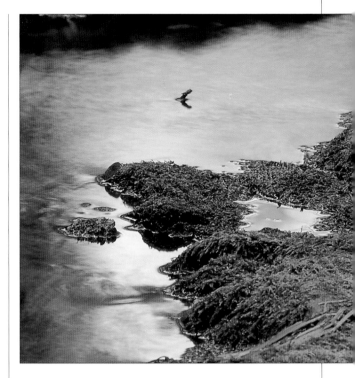

Reflections
Green reflections in a stream below Dickson Falls, Fundy National Park.

Mudflats
Low tide reveals the shape and color of the Mudflats, sitting between the water level and grassland, near Mary's Point.

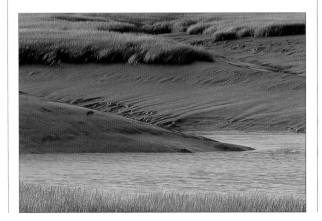

Red stone
Wave-cut red sandstone rocks at Brown's Beach.

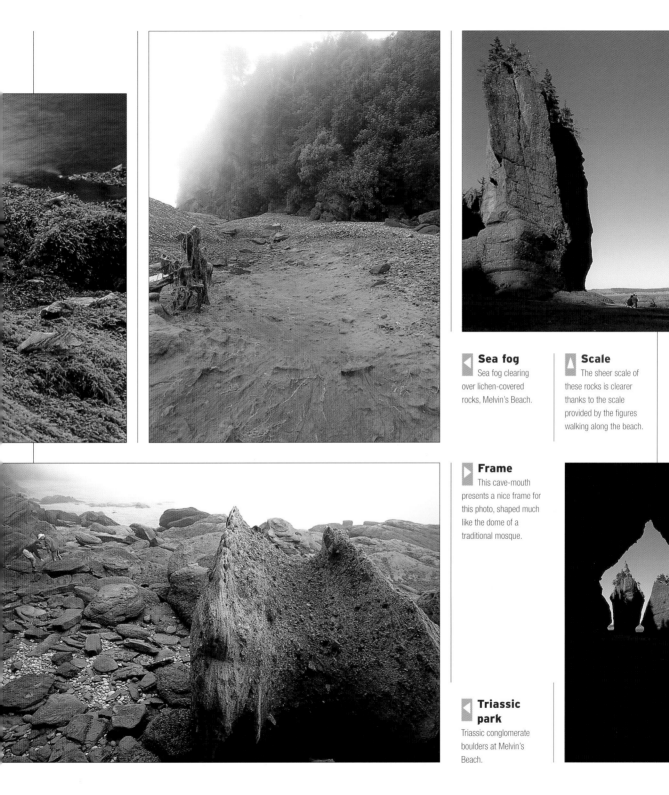

Sea fog
Sea fog clearing over lichen-covered rocks, Melvin's Beach.

Scale
The sheer scale of these rocks is clearer thanks to the scale provided by the figures walking along the beach.

Frame
This cave-mouth presents a nice frame for this photo, shaped much like the dome of a traditional mosque.

Triassic park
Triassic conglomerate boulders at Melvin's Beach.

Wetlands

A flat, watery world offers relatively little in the way of landscapes, but is the habitat par excellence for birds, with a high proportion of larger, easier-to-photograph species.

Being largely flat and open, wetlands share some of the characteristics of grassland. Light levels are high, and there is little in the way of relief or tall forest to hide the attractive light from an early morning or late afternoon sun. However, the repetitiveness of reed-beds and marsh grass, particularly when seen from water-level, can make for dull landscapes. One important visual advantage of wetlands is the water itself, which can at least add a variety of interesting reflections. These are relatively bright habitats, not only because the landscape is flat but also because the surface of the water reflects light. Consequently, both early and late in the day, when there is plenty of animal activity, there is still usually sufficient light to use a long-focus lens at respectable shutter speeds.

Low direct sunlight is particularly attractive in wetlands as it gives a texture to the reeds, grasses, and water ripples. Sidelighting is also generally good for taking close-up photographs of birds. Reflections in water are more intense under a direct sun, and can give well-defined graphic silhouettes. By comparison, the light on an overcast day or under a high sun is more difficult to work with. The lighting conditions in clumps of trees such as the "hammocks" of the Everglades and in mangrove swamps are essentially those of broad-leaved forests.

The water, boggy soil, and tangled vegetation that deter predators also make quiet approach difficult for photographers. Stalking on foot is worth trying from dykes and raised ground, but this only gives access to the edges of lakes and marshes, and, as there is usually little cover concealment, may be difficult. Stalking by wading is noisy and not very efficient, and is usually best reserved for approaching large nesting colonies where birds live in such large numbers that they do not feel threatened by an intruder. In general, a boat often gives the clearest and closest views. Along deeply indented coastlines, estuaries, and marshy areas, it may be the only practical means of transportation. However, in many ways, a boat is far from ideal as a camera platform. Maneuvering precisely is not easy, and it is much better to have someone else steer rather than try to manage everything on your own. On rivers, it is easier to approach by drifting silently downstream than by sailing

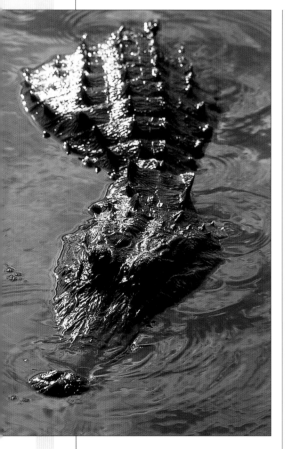

Alligator
Given an even slightly elevated camera position, crocodiles and alligators are reasonably cooperative wetland subjects. This alligator, photographed from a bridge over the Myakka River in Florida, exhibits no fear.

under power upstream. Be prepared to take perched birds by surprise as you round a bend in the river—they will spot you easily at a distance and will eventually flee or dive as you approach. Either hold the camera by hand, or rest it on a soft, padded support. Whenever possible, switch off the engine before shooting, to avoid vibration. In marshes, a flat-bottomed punt is often the best means of transportation as the water is usually shallow enough to use a pole, which is quieter than oars.

For photographing many species, such as ducks and geese, a hide is the only reliable viewpoint. Because most of the wetlands that have spectacular bird populations are also well-known sanctuaries, permanent hides administered by conservation organizations are not uncommon. There may, however, be some competition for access to them among bird-watchers, and it is wise to check in advance whether they are available. Visibility, at least for birds, tends to be good in a wetland habitat—see pages 86-87 for tips on how to use these.

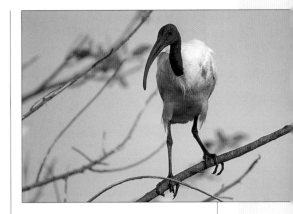

▲ Shooting from a boat
If photographing from a boat, start shooting early, as birds may take flight at any moment.

▼ Florida mangroves
A small flock of flamingos adds a finishing touch to an aerial view of mangrove swamps.

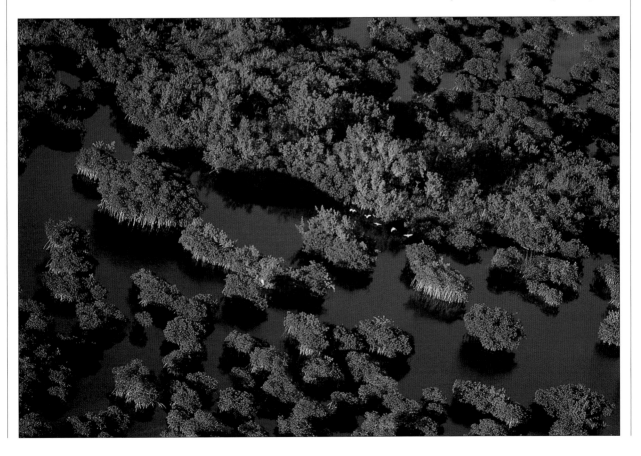

Mountains

For sheer visual spectacle, almost nothing competes with mountain landscapes. The wild terrain, spectacular views, and constantly changing light offer the camera an endless source of dramatic imagery.

Mountain light in clear weather has a special intensity. The sky is a deeper blue, and shadows are stronger, so the contrast in sunlight is often extreme. Because there is less atmosphere, there is much more ultraviolet, and this can give unusual results if you are not prepared for it, as camera sensors are more sensitive than our eyes are to UV rays. Mountain views in sunny weather usually have a blue cast to the distance in photographs, particularly with telephoto lenses. There is not necessarily anything wrong with this—the blue haze gives a good impression of depth—but it does cut down on visibility. To overcome it at the time of shooting, use a strong (that is, yellowish) UV filter and avoid shooting into the sun. During image editing, reduce the saturation of blues.

▼ **Thin air**
With half the density of atmosphere as at sea level, views at 16,500 feet (5,000 meters) altitude are stunningly clear, even with a telephoto lens, as shown in this shot of the north face of Mount Kailash in western Tibet.

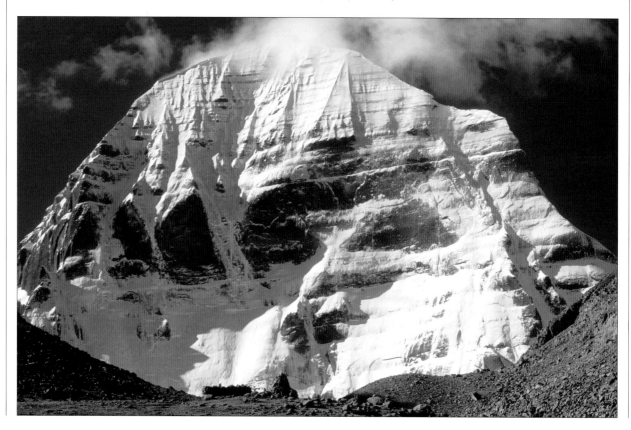

Mountains also have special weather patterns that can change more quickly than in lower altitudes. Be prepared to take advantage of any change as soon as it happens, and don't rely on a slow progression of the light. At high altitudes, watch out for conditions when there are clouds below you—these can sometimes reward you with stunning views of peaks standing like islands in a sea of cloud.

The vertical component in mountain landscapes gives you more freedom when it comes to composition. The best impression of height is either from a distance or from nearby peaks; you can expect to find the most spectacular views first, as you approach a mountain range from a distance, and then when you have climbed up to the upper levels.

Telephoto lenses help to compress the images of foothills and ridges in a way that emphasizes the scale of peaks and ranges in the distance and, unusually for landscape photography, this often works just as well in a vertical format as in a horizontal one (*see pages 18-19*).

Camera care

Cameras and lenses need, above all, adequate protection against physical damage. Knocks and scrapes are likely to occur, and everything you carry should be well padded. A knapsack is ideal, particularly one specially dedicated to cameras, while a regular shoulder bag is useful only for hill-walking on moderate slopes. If you carry a camera at the ready on a neck-strap, add a restraining chest-strap to stop it bouncing about as you climb. Make sure that you have sufficient battery power—carry spares and ensure that they are charged.

◀ Vertical framing
Mountains and hill country afford good opportunities for framing vertical shots. There are often plenty of foregrounds to choose from, particularly when taking downward-looking shots.

▶ Serow
Large mountain animals tend to be browsers and grazers, such as this serow, photographed in the mountains of Nagano prefecture, Japan. Their sharp eyesight makes them difficult to stalk without being spotted.

Equipment

Mountain travel is usually strenuous and all equipment needs to be chosen with an eye on weight. Clothing should give adequate protection against wind, cold, and rain, and must also be adjustable as weather conditions can change sharply in a single day. Layered clothing that traps air gives the best insulation, with a windproof, waterproof parka on top. For severe conditions, add a down jacket, thermal undergarments, snow leggings, spare socks, down mitts with silk inner gloves, and woolen headgear. Choose boots to suit the terrain—either hill-walking or climbing boots. They should have Vibram soles and be watertight, and climbing boots should be rigid, with thick soles.

Snow and ice

Harsh conditions and bright white landscapes make snow and ice specialized conditions for shooting, but the rewards are spectacular scenics and some interesting wildlife.

Although the physical conditions can be difficult to deal with, snow offers a welcome change in landscape photography from the normal tonal arrangement of land and sky. It reduces overall contrast in a scene by reflecting light back up into the shadows, but in detail views it can provide a white background, creating high-contrast silhouettes of trees, rocks, and dark-coated animals. By coating the land, snow also tends to simplify scenes and make them more graphic.

Some exposure precautions are usually necessary. On automatic, the camera will tend to underexpose images, because it reads the whiteness as a midtone. To preserve the delicate texture of snow, adjust the exposure to be brighter by one or two f-stops, either with the compensation control in auto or by setting it manually. Snow needs to be exposed precisely in order to preserve its luminous quality and texture, meaning almost, but not quite, white (that is, between about 230 and 245 on the 256-level scale). Bracketing exposures is a sensible precaution. Being an efficient reflector, snow also picks up the color of its surroundings, and especially the blue of a clear sky. Shadows in snow on a bright sunny day are inevitably blue, but this is only likely to be a problem if the main focus of interest is in the shadow area. Later, in image-editing, you can reduce the blueness by using HSB adjustment, selecting just the blues, and reducing their saturation.

Equipment needs special care. There are different levels of severity of coldness. From freezing point at 32ºF (0º C) down to 0ºF (-18ºC), the precautions are principally the commonsense ones of keeping equipment as dry and as warm as possible. Below 0ºF (-18ºC), however, some of the materials alter

Batteries in the cold

Because digital cameras are completely reliant on electronics, they are more susceptible to environmental extremes than are mechanical film cameras. Cold affects batteries, but in two conflicting ways. On the one hand, batteries lose their charge more quickly, but on the other, they work more efficiently because there is less electrical resistance at low temperatures. The net effect is that you can expect to have to replace the camera's battery with a spare frequently, but warming up an apparently discharged battery will often revive it.

Swans on ice
Swans arrive from Siberia at Abashiri on the northern coast of Hokkaido, Japan's northernmost island, in October. By January, the cold has caught up with them, and the Sea of Okhotsk freezes inshore.

their characteristics—some plastics become brittle, metal can stick painfully to skin, and some lubricants thicken, causing moving parts to slow down or jam up. Severity also depends on the time that you spend out in these conditions. In any low-temperature environment, condensation is potentially serious when cold equipment is brought indoors. It can also be a problem when wind-driven snowflakes melt and then freeze on cameras that have just been taken outdoors, and when warm breath condenses and then refreezes on cold metal and glass.

In extreme conditions, expose the camera to the cold only when shooting. For the rest of the time, keep it insulated in a padded waterproof bag or under as many layers of clothing as possible. A large covering flap on the bag helps to keep out snow, and matching Velcro tabs on the inside of the strap and on the shoulder of your jacket prevents slipping. An oversize front-zippered parka is good protection for a camera on your chest.

When moving into a warm interior, either leave the equipment in a moderately cold room or seal it in a heavy-duty plastic bag containing silica gel and with as much air squeezed out as possible, so that condensation forms on the bag and not on the cameras. Remove film from cameras before bringing them indoors. When moving out into the cold, protect the equipment from snow until it is close to the outdoor temperature; otherwise, the snow will melt and then refreeze in joints. This may be very difficult to remove and can even damage equipment by expanding. Camera tape can be used to seal joints. Never breathe on equipment if you can possibly avoid it. If you can use batteries in a separate pack, do so, and keep it warm under your clothing. Cold batteries will deliver only a fraction of their power, and will need to be replaced and recharged frequently. Another way of keeping equipment warm is to pack it in felt cases with one or more hand-warmers.

Fresh snow

As with sand-dunes, you need to plan your view of fresh snowdrifts a little in advance, particularly if you are using a wide-angle lens from close to capture foreground detail. Footprints usually spoil shots like this when they are visible.

Cranes

Japanese cranes at the crane sanctuary near Tsurui. Like many snow-dwellers, the cranes have partly white plumage. This makes exposure critical, both to keep the whites white without blowing out, and to separate plumage from snow.

Case study: **snow monkeys**

Japanese macaques (*Macaca fuscata fuscata*) are perfectly well adapted to the harsh winters in the mountains of Nagano prefecture on the main island of Honshu (hence their popular name, snow monkeys), but they are not immune to the pleasures of natural hot springs. Geothermal activity is common in many parts of Japan, and the Japanese have developed a culture of taking hot baths in springs fed by underground water. In the isolated valley of Jigokudani, troops of monkeys have invaded the hot baths built by a local inn and are now an attraction in themselves. The macaques are highly photogenic, and they look their best on the coldest days with heavy snow. Photographing them is principally a matter of choosing the right day. The cameras need special care because of the big temperature differences close to the spring. Condensation and refreezing are a problem, and equipment needs wiping down and drying frequently.

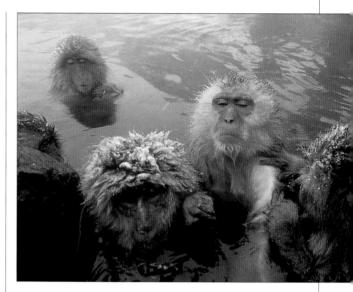

Groups

Like many primates, these monkeys tend to live in troops of between twenty and thirty, perhaps more. This gives plenty of opportunity to look out for difficult social situations.

Hope springs

Given the environment, finding the warmest water usually preoccupies these animals.

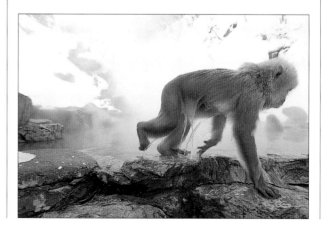

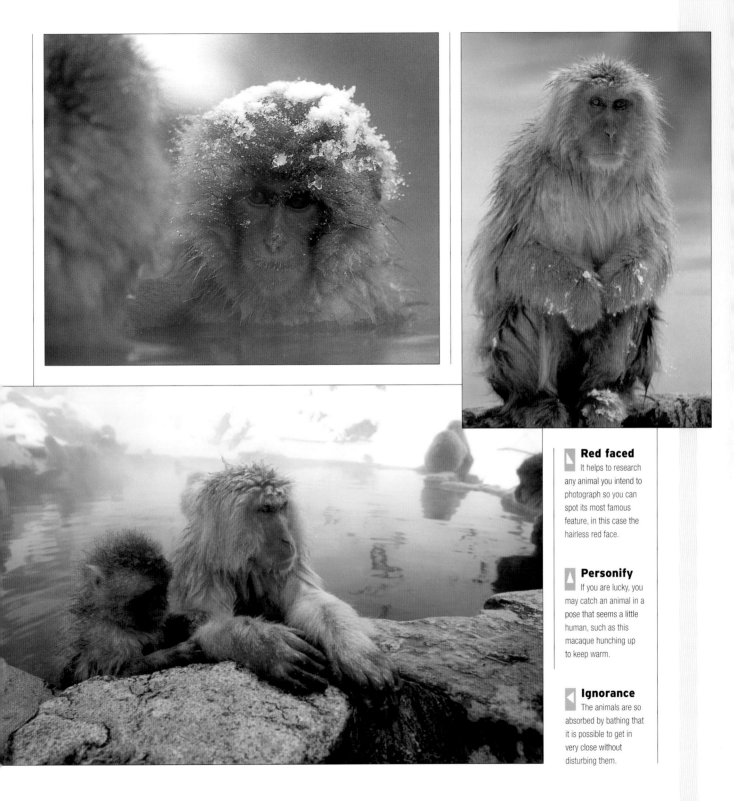

Red faced
It helps to research any animal you intend to photograph so you can spot its most famous feature, in this case the hairless red face.

Personify
If you are lucky, you may catch an animal in a pose that seems a little human, such as this macaque hunching up to keep warm.

Ignorance
The animals are so absorbed by bathing that it is possible to get in very close without disturbing them.

Rain forest and tropics

Lush vegetation, a distinct spectrum of animal life, heat, and moisture make the tropics an exotic and exciting location for photography.

In the tropics, daylight hours vary very little throughout the year. On the equator itself, daylight lasts exactly twelve hours every day of the year. Apart from being so predictable, the sun rises much higher in the sky than in midlatitudes—by nine in the morning, it's like a midsummer noon elsewhere. For many subjects, particularly portraits of people, the light from a high sun

▶ **Specialized adaptation**
Keeping out of sight is a major priority of rain forest life, and involves a considerable variety of adaptations. The two-toed sloth moves with such deliberate slowness in its inverted existence that it attracts little attention from predators attuned to responding to sudden movements from prey.

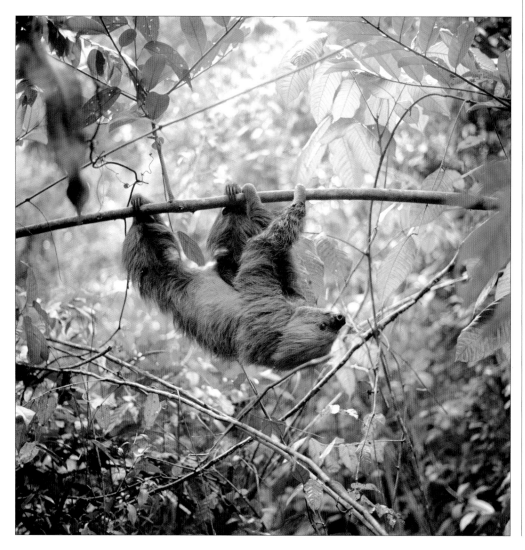

is not very sympathetic: hard shadows are cast straight underneath. For some other subjects, like cityscapes, the starkness of tropical sunlight can sometimes give a graphic edge to a photograph. In general, however, the most attractive tropical light is very early and late in the day, and if you have a photography schedule it is normal to work most intensely at these times.

Many tropical climates are very wet, with the rain either concentrated into a few monsoon months or, in equatorial climates, an almost daily deluge, again concentrated. All of this can make for some spectacular weather and light, although heat and moisture can be damaging to equipment (*see box*).

Rain forest is photographically the most interesting habitat in the tropics. It is not so common any more because of logging, but it is one of the most spectacular environments in the world, with high, multi-tiered canopies, typically reaching over 98 feet (30 meters) above the ground. The hothouse conditions of the equatorial lowlands are responsible for a profusion of plant and animal life unmatched anywhere else in the world. Rain forests are full of diversity. There may be as many as 40 different types of tree in a single acre. Buttressed tree roots, a dark and relatively open forest floor, and large numbers of epiphytes, creepers, and stranglers are characteristic.

Although the animal life is also rich and varied, there are few large species. Indeed, by far the majority are insects. For a number of reasons, it is difficult to catch even a glimpse of most rain forest animals larger than insects. Few live on the forest floor, because most of the plant life and food is in the upper canopies. These upper levels, home to monkeys, other small climbing mammals, and birds, are difficult to reach. The best opportunities for seeing and photographing rain forest wildlife is at its edges, along riverbanks and clearings.

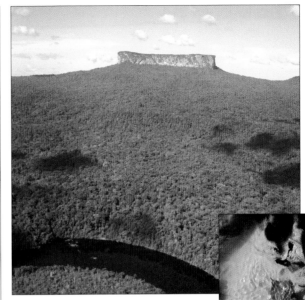

▲ **Sea of trees**
The great rain forests such as the Amazon extend unbroken except for rivers and the occasional mountain.

▶ **Concealed**
Although camouflage is not its only purpose, the rough, drab carapace of a Matamata turtle in an Amazon backwater makes it almost indistinguishable from dead leaves.

Camera care

Heavy tropical downpours are obviously something from which camera equipment needs to be sheltered. Their intensity can come as a surprise to anyone from a temperate climate, and a minute in heavy rain is the equivalent of falling into a pool. To continue shooting in these conditions, put the camera into a clear plastic bag, or seal it in plastic wrap. Apart from rain itself, the combination of high heat and humidity is a potential problem for the camera's electronics, and a few days in the rainy season can also result in fungus growth, even on a glass lens. When not in use, keep the camera and all electronic accessories sealed and dry, in a camera case if you use one, or in a plastic box (such as a food container of the kind sold in supermarkets). Use sachets of silica gel (a standard desiccant) to dry the air inside the case or container, and renew their ability to absorb water by regularly drying them out in an oven. Uncooked rice is a less effective alternative to silica gel.

Deserts

Arid regions offer an exotic, minimalist choice of scenery that favors photography with its rock and sand forms, which are often clear of vegetation.

Camera care

The downside of a desert's picture opportunities is its harsh conditions, inimical to delicate electronic equipment. As far as possible, keep everything in shade, and avoid enclosed and unventilated spaces such as car interiors. If equipment must remain in the sun, cover everything with a white cloth or other reflective material. Keep cameras packed and sealed when not actually shooting (reflective cases, whether metallic or light-colored, absorb the least amount of heat), and, whenever possible, raise cases off the ground for ventilation.

If wind-blown dust and sand is mild but constant, tape over all joints in equipment, but if wind-blown dust and sand is severe, seal the camera in a plastic bag. If dust storms are likely, consider using a soft underwater housing. Keep the lens-cap on until you need to shoot, and if the lens accepts screw-on filters, attach a UV filter. Remove sand and dust particles frequently with a blower-brush. Stay alert for gritty, scraping sounds when operating moving parts.

The more arid a desert, the less vegetation there is and so the more stark the scenery. In extreme desert areas, such as Death Valley, the Namib, and parts of the Sahara, the bare topography makes fine material for graphic, simplified images. Not only are these very arid deserts sufficiently unusual to be interesting for their contrast with other habitats, but they also provide the rare opportunity to construct sparse, geometric photographs. With little or no grass, shrubs, or trees, the shapes and textures of rock and sand can become the most important ingredients.

There are three main types of pure desert topography, all influenced to some extent by the wind, which is an important agent only in the absence of vegetation. Desert pavement is a surface of rocks and gravel scoured of fine particles by wind. Dunes occur where the wind is forced to slow down and so drop some of its load of sand; this happens in the lee of rocks and low hills, but dunes, once begun, are self-perpetuating. Rocky uplands usually stand out abruptly from the generally level desert terrain, and are sharply weathered by occasional violent run-offs from storms, the blast of wind-blown sand, and the flaking due to temperature changes.

Desert scrub, composed chiefly of bushes, bunch grass, or cacti, modifies the lunar quality of desert landscapes and is more common than bare sand and rock. Although most of this vegetation makes for less striking images, certain types of cacti such as the saguaro have such strong shapes that they can be used for very graphic compositions.

With so little rainfall, desert light is more predictable than most. As with many landscapes, a low sun gives the most positive modeling for shapes and textures such as the ripples in the sand-dune or the texture of an eroded rock-face. The midday sun, however, also has some value for creating stark views, and for photographs taken completely in shade in rocky uplands. (The high reflectivity of sand and rock-faces can give a very attractive light for details of sandstone formations.) In the heat of the day, haze may lower contrast in distant views, and heat shimmer just above the surface of the ground can give a partly blurred image, especially noticeable with long-focus lenses. Ultraviolet and polarizing filters help.

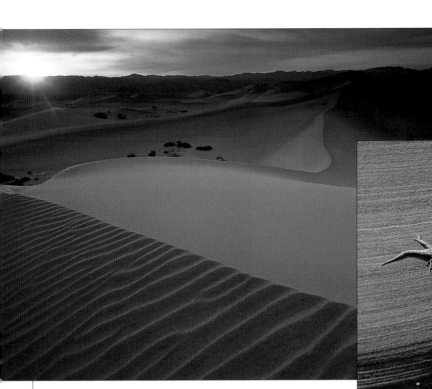

Sand-dunes

Desert dunes are highly sculptural, and have different appearances during the day according to the light. A low sun shows up the ripples on one face of a dune in Death Valley, California. You need to plan your approach carefully in order to avoid photographing your own unsightly footprints.

Sandstone walls

Cross-lighting reveals the fine details of texture on the water-eroded red sandstone wall of a slot canyon in Arizona, near Lake Powell, as a small lizard crosses it.

Organ Pipe cacti

Semiarid landscapes feature specialized vegetation, of which the most well known is the cactus. Organ Pipe National Monument in southern Arizona contains spectacular collections of this relatively rare species.

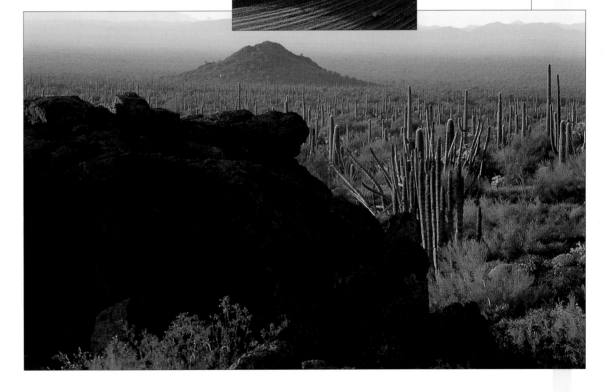

Volcanoes and geysers

The most active of all landscapes are those in areas of volcanic activity. Not always predictable, and sometimes dangerous, these natural features bring a touch of excitement to a normally placid subject.

All the features associated with geothermal activity–volcanoes, geysers, hot springs, fumaroles, and mud pots–are in one sense landscape curiosities, but in another way they are the core of the natural environment, as close as you can get to the workings of the Earth. Just as with active and skittish animals, volcanic activity is unpredictable enough to be an exciting photographic subject.

The most violent volcanic activities are eruptions or lava flows. Volcanoes are complex and individual, but the way in which they behave and look depends mainly on their lava composition. Some lava volcanoes, such as Halemaumau and Kilauea in Hawaii, contain very little silica, and so their eruptions are relatively quiet, with streams of molten lava. Shoot these from a safe viewpoint (the heat is intense, anyway), and dusk will give you a combination of a bright lava glow with just enough daylight to show the surroundings.

Volcanoes with very acidic lava, like Vesuvius, are rich in silica and produce lava that is thick and solidifies quickly. This tends to plug the vent, like a cork in a bottle, and eruptions are often violent and destructive. This kind of volcano conforms to the popular image of a steep cone, whereas many volcanoes are usually flatter and cover much larger areas. Eruptions are obviously dangerous, and unpredictable, so always seek informed local advice before

Kelimutu
Two of the three summit crater lakes of Kelimutu volcano on East Flores in the Sunda Islands, Indonesia. Their colors shift according to the changing mineral content.

Geyser
Spasmodic geyser in Yellowstone National Park lives up to its name as one of the more unpredictable. Small eruptions through different vents are frequent.

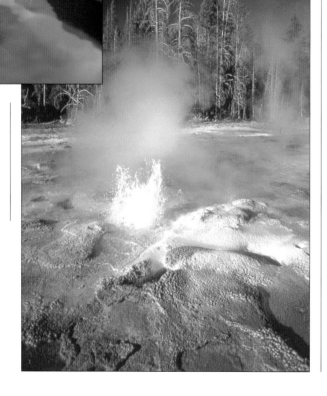

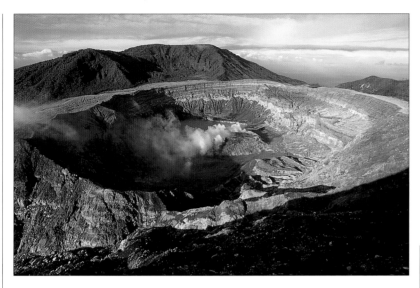

Volcan Poas

Corrosive plumes of steam and gases, including sulfur dioxide, are emitted from fumaroles at the center of Poas volcano in Costa Rica, a collapsed caldera. It took three days before heavy cloud cleared and the crater became visible from the upper rim.

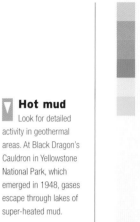

Hot mud

Look for detailed activity in geothermal areas. At Black Dragon's Cauldron in Yellowstone National Park, which emerged in 1948, gases escape through lakes of super-heated mud.

approaching an active volcano. However, even in relatively quiescent stages, volcanoes can be full of interesting activity. For millennia after an eruption, the crater and flanks of a volcano are dotted with fumaroles—vents that emit clouds of corrosive steam.

Hot springs and geysers

Hot springs are upwellings of lukewarm-to-boiling water, heated by molten subterranean rock, rich in dissolved minerals, particularly silica. They are often brightly colored, both from the minerals and from algae that thrive in the heated water, and can be indigo, blue, red, orange, or yellow. Sometimes, the dissolved silica precipitates as a hard deposit, which can form either a surrounding crust or whole terraces.

Geysers are very similar, but spout violent bursts of boiling water at more or less regular intervals. Below ground, a column of water is in contact with hot volcanic rocks, but at this pressure cannot boil. Instead, being very hot, it rises by convection. As it nears the surface, the pressure lessens, the water boils rapidly, and steam then pushes the upper column of water up into the air suddenly. Geysers can spout to any height, and 100 feet (30 meters) is not unusual (the world record is 1,000 feet or 300 meters). In national parks and well-known geyser areas, you can usually find information on times for the main geysers. The behavior of geysers is finely tuned—only the right blend of temperature and pressure distinguishes them from hot springs.

Equipment care

Volcanoes and their surroundings are as extreme a condition as you're likely to find in any landscape. Heat is an obvious problem, but you'll feel it before the equipment suffers. Airborne grit and dirt are more serious, and continuous cleaning is usually necessary. Sulfur dioxide is a major component of volcanic gases, and when combined with steam produces sulfurous acid, which is much more damaging than water. If you are close enough to a fumarole for the sulfur dioxide to make you cough, the camera is too close as well. Consider using a soft plastic housing of the kind sold for underwater photography (*see pages 92–93*).

Caves

Underground landscapes are a strange and specialized environment, quite unlike any other, and call for experienced, imaginative use of off-camera flash.

Water, rock-faces and unremitting darkness are typical characteristics of caving, creating problems that are by no means purely photographic. As with diving, caving is a specialized activity and should not be approached casually. Caves can be dangerous places, and in deep caving photography is necessarily second to all-important safety procedures.

In cave photography, the two main problems are confined spaces and the complete absence of light. SLRs are not ideal. Focusing in the dim light of a flashlight is difficult. A fixed-lens camera with an LCD display is easier to use.

Wide-angle lenses are useful for general views. As most caves are irregularly shaped, distortion, even with an extreme wide-angle lens, is not usually noticeable. One exception is the converging verticals in shots of stalactites or stalagmites aimed upward, but you can correct this later in image editing. Telephotos can isolate details, but a macro capability is essential for small cave life.

Probably the greatest challenge is in keeping the sense of scale. If some light is filtering in, use a tripod

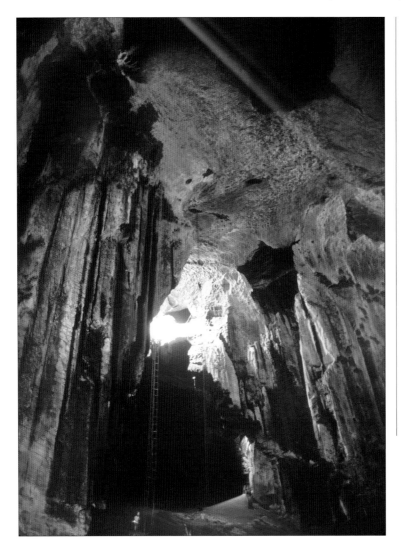

Figures for scale
The lower Gomanton cave in Sabah on the island of Borneo is a major site for the collection of the birds' nests for the eponymous Chinese soup. Only the tiny figure of one of the collectors gives a clue to the immense scale of these limestone caverns.

and a slow exposure. Underground landscapes are unfamiliar and disorienting, so it is often a good idea to include a figure in shot. Apart from these few daylit opportunities, you will have to rely on flash.

There is little point in using on-camera flash for a large cavern. The flash output, even on manual and full power, will be insufficient, and what lighting effect there is will be flat and shadowless. In a large space, with both foreground and background features, the light will fall off sharply away from the camera. A better approach is to have someone carry the flash and use it in one or more distant parts of the cave, facing away from the camera. Mount the camera on a tripod, open the shutter on the "B" setting, and trigger it from different positions. Conceal the flash unit itself from the camera's viewpoint. Try to avoid having the flash-lit areas overlap.

There are three kinds of creatures that live in caves. Troglodytes are the true, permanent inhabitants of darkness. They include cave shrimps, fish, salamanders, and certain fungi. Troglophiles are margin dwellers, including some beetles and spiders, living in the cave only as far from the entrance as there is some light. Trogloxenes are temporary visitors, using the cave as shelter or nesting place—bats, for example.

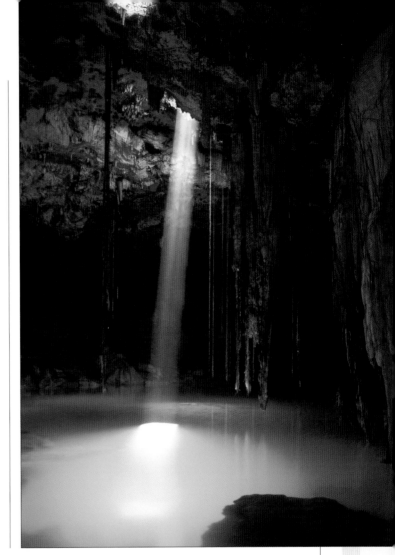

Cenote
The natural underground lake of the Cenote de Dzitnup on the Yucatán Peninsula, Mexico. A cenote is an underground limestone sinkhole, and they were the principal source of water for the Mayans. With a little research, I knew that the sun at midday would light up the water with a shaft through a hole in the limestone roof.

Cave life
These giant centipedes are troglophile inhabitants of the Gomanton caves, living in semidarkness. As with all cave dwellers, flash is a necessity for taking photographs.

Care of equipment

Water and hard knocks are responsible for most camera damage underground. Secure packing is essential, preferably in padded, waterproof cases. Take extra care when handling all unpacked equipment in the dark. Take cameras and lenses out of their cases only when you are about to use them, as the air is frequently saturated with moisture and condensation is common. Pack desiccant, such as silica gel, in the cases to absorb moisture. Remember that even low-voltage flash units can be dangerous when wet.

Landscapes of **Man**

At different times and in different cultures, the assumptions about what makes a landscape have changed. This goes right back to painting, and has an even greater relevance now to photography, in a world where we alter our environment faster and on a bigger scale than ever before. The natural landscapes that we considered at the beginning of this book are rapidly becoming a special case, areas that need to be managed and protected. Indeed, most of those in the West are now national parks or are under some similar kind of official supervision.

A broader definition of landscape photography, however, embraces just about everything else—the parts that humans have carved out for themselves, flattened, built up, manicured. It was an American writer, Henry David Thoreau (1817-62), who argued the most strongly against man's interference with nature—an inspiration for modern environmentalists—but there is an older, European, view of the land as the place where man lives. This Classic view does not have humankind as the despoiler, but as the inhabitant, with history as a justification for a sort of harmony. The painter John Constable's landscapes of hay-wains, cattle, shepherds, and distant cathedrals, all under towering and impressive skies, celebrate this view. He himself wrote, "...old rotten planks, slimy posts, and brickwork, I love such things..." He stressed the point further, "There is nothing ugly; I never saw an ugly thing in my life: for let the form of an object be what it may—light, shade, and perspective will always make it beautiful."

In photography, the Englishman Peter Henry Emerson showed a similar feeling for the Norfolk Broads in his pictures of rural life in the 1880s. The style is different from Constable, of course, but it is also shows a rural world, with plenty of room and time. Some of this has survived the 20th century, although it is becoming more of a relic, worthy of preservation orders. Arguably the true representative of the modern landscape is urban—cities, towns, and suburbs.

In these built-up areas we have created our own landscapes, and they are open to all kinds of visual interpretation by the camera. There's plenty of beauty, but not of the Thoreauvian, Sierra Club kind. And in any case, beauty may not be the aim of the image. If wilderness photography is about adventure, nostalgia, and preservation, the photography of populated landscapes is about realism, history, and change. One of Edward Weston's (*see page 7*) most well-known photographs is titled Quaker State Oil, Arizona. In 1941 he was touring Arizona by car. Most of his outdoor photography up untill then had been firmly focused on nature. Heavy stormclouds were building up above the mesa ahead as the car approached an isolated sign advertising motor oil out in the desert. Weston's initial reaction was that this was a blemish on the landscape. But he immediately changed his mind, shouting at his driver, "No! Back up; the sign is a part of it!" That is what this last section of the book is about. The sign—and the road, and the people, and the buildings—they are all a part of it.

Cityscapes

You can treat cities and towns in much the same way as landscapes, not just as a location for photographing people: the city itself becomes the subject.

As subjects, towns and cities are in many ways similar to natural landscapes, with the important addition that they reflect human activity. Therefore, whether or not people appear in the photograph, a shot of an urban landscape inevitably reveals something of the relationship between people and their surroundings. Architectural photography and candid photography of people have their own distinctive approaches (*see pages 128-137 and 140-141*). Urban landscape photography takes something from both.

For overall scenic, establishing shots, viewpoint is usually more of a problem than it is with natural landscapes. The most effective shots are often taken at a distance and at some height, but the difficulty lies in finding this kind of camera position. Tall buildings may be the obvious choice, but security considerations these days makes many rooftops inaccessible, while the windows of a modern high-rise are likely to be sealed. Otherwise, look for

▼ The distinctive skyline
From an elevated viewpoint, the skyline of a city can often be made to convey some of its distinctive features. Here, aggressively modern towers on former marshes in Pudong form the new view from Shanghai. Skylines are often most striking in silhouette against an early morning or late afternoon sky.

National culture
For a national holiday, a row of giant French flags appeared behind the well-known statue of the national heroine Jeanne d'Arc, looking out over the Place de la Concorde in Paris.

adjacent stretches of open ground or water—a park or the opposite bank of a river, for example. (*See pages 124-125 for more details.*)

Overall views are, in any case, just one of the endless possibilities in shooting a city. Several different stylistic approaches are possible, of which the following are examples:

☐ a comprehensive view of a city's layout

☐ the grand and famous landmarks

☐ by contrast, the real life of the less-glamorous residential districts and suburbs.

☐ the underside of city life; a critical view

☐ exploiting the graphics of skylines, particularly in industrial areas

☐ juxtaposing people and landscape to show how one relates to the other

☐ city life: reportage shooting of people

☐ deliberately excluding people to give a somber, deserted appearance

☐ details that reflect the character of a city and its inhabitants

☐ graphic details of signs, shop windows, street art, graffiti, and so on.

I include this list—and it is by no means comprehensive—to stimulate ideas. Above all, a city offers variety and energy for photography; whether you settle on one kind of picture style and approach in order to make a personal statement, or else go for a photographic coverage that deliberately takes in as many aspects as possible, from people to architecture, cities are rich in imagery.

One type of location deserves a separate mention, because it is in one sense a part of the city, yet in another distanced from it—parks and public gardens. Although the majority of these are creations of an earlier age in city planning (in the West they mainly date from 19th-century attempts to introduce green spaces into the city), few of the world's cities are devoid of at least one central park. As with cities in general, there are many different approaches to photographing them, including juxtaposing them against the surrounding city buildings, as works of landscape art in their own right, for details of flowers and trees, and as places for people-watching.

Long-focus
A long-focus lens (400mm efl) compresses perspective, crowding Caracas's buildings, to fill the frame and appear densely packed.

Relevant detail
By careful selection, close-up details can convey an idea of the complete city. Look for details that are characteristic of, and preferably unique to, one place. This old streetcar, clearly named Desire, could only be in one city—New Orleans.

The rhythm of city life

In addition to the usual visual changes brought about by lighting and weather, urban areas also vary according to cycles of human activity.

The organization of a city means that each has a daily schedule of busiest times for certain activities. By knowing in advance what happens where, you can build up a composite picture of any city or town through its activity. The box opposite lists some of the more obvious, but unless you are working in your hometown and you are familiar with these things, this needs careful research. Rush hour is a case in point—it is usually more concentrated in the morning when workers arrive at a particular time than when they leave, and some locations are bottlenecks where the crowds and movement are at their busiest—London Bridge, for example, or Tokyo Station.

Possibly the biggest change of all to the appearance of a city is when night falls, and the buildings and streets light up. These are usually at their brightest in the city center, particularly in the entertainment district, where there is often display lighting.

Outdoor artificial lighting comes in many forms. Tungsten lamps are now much less common than they used to be, and most town and city lighting is a combination of sodium lamps, which are yellow and often used as street lighting; vapor lamps, which are often bluish; and fluorescent lamps, which are usually greenish, even though it appears white to the eye. When these light sources are mixed together in an outdoor scene the effect is simply colorful rather than being a problem. An auto setting for white balance is a good starting point, but experiment with color temperatures.

There are three basic ways of shooting in a city at night: hand held at high sensitivity (and so with noise); hand held at low sensitivity with flash; and on a tripod at low sensitivity. The results are predictably different. For hand held shooting, almost everything is sacrificed for a workable shutter speed: around 1/30 sec is the normal camera-shake-free minimum with a standard or moderate wide-angle lens. To make shooting easier, use a sensitivity setting of ISO 1600 or faster, and constantly check the results in the camera's LCD. Bright lights in view can throw the meter off and you may need to compensate with more exposure. Flash photography at night is more limited in that you need to shoot from quite close and you can't remain unobtrusive, but it guarantees a sharp, clear view of fast movement. To show the setting

Commuters

London Bridge (the new one, as its predecessor was exported to Arizona) carries pedestrians from the rail-road station at its southern end across the Thames River to the "City," London's financial district. An office rooftop was the perfect viewpoint to capture this shot.

and add atmosphere, shoot with a shutter speed slow enough to record the lights, even if blurred. Some cameras have pre-set programs for nighttime landscapes and for night portraits.

With a tripod, you can treat nighttime cityscapes very differently. If you are using a time-exposure, this is the ideal technique for static shots, but any movement in an exposure of a few seconds will translate into a blur. However, views that include traffic can work very successfully—the headlights and tail-lights become streaks of color that pick out the streets. Often the best time for clear shots is at dusk, when there is just enough light left in the sky to show something of the buildings. At dusk, the best exposure may be slightly darker than the meter reading to give more of an impression of night.

Timing for all these activities and variations can be exact. Lights for buildings, streets, and public areas are usually on automatic timers. This means that in all but tropical cities, where there is little seasonal difference, you get more lighting in winter months. Floodlighting for specific buildings is rarely coordinated, and if you want to include a particular landmark lit up, it may be worth enquiring when the lights come on.

Activities that follow a schedule

- ☐ morning and evening rush hour
- ☐ late-night shopping
- ☐ weekends
- ☐ produce markets
- ☐ morning deliveries
- ☐ market days
- ☐ summer lunch breaks
- ☐ civic holidays
- ☐ festivals and parades, memorial days, Labor Day, national day
- ☐ entertainment district
- ☐ nighttime

City views

Like scenic overlooks for natural landscapes, city viewpoints are valuable locations if you need an establishing shot that gives an overall impression of the city.

With a few notable exceptions, such as San Francisco and Rome, most towns and cities are built on relatively flat land, and this puts overviews at a premium. Unlike natural landscapes where, in wilderness areas at least, you can explore as much as you like, in a city you don't have unrestricted access. Most buildings are privately owned, and in any case, in these days of heightened security, very few rooftops are accessible.

Also, as construction fills more and more cities with high-rise buildings, the increased density narrows the choices of clear views. Where there are surrounding hills, or else isolated hills within the city, such as in Athens, there are likely to be a number of good viewpoints, but this is the exception. Some of the most effective shots are those taken at a distance and at some height with a telephoto lens. Try the following, while bearing in mind that the most obvious viewpoints will already have been used extensively for photographs, and you may find little new to shoot:

High points
Most cities have some elevated spot from where tourists can look out over the rooftops. In Brugge in Belgium, it is the 290 foot (88-meter-high) medieval belfry tower, built in the 13th to 15th centuries. Viewpoints like this always offer a number of different shots, particularly with a telephoto lens.

☐ The top of any prominent tall building. Look first for well-known locations publicized in tourist literature and designed as tourist attractions—the viewing platform of Tokyo Tower, for example. High-rise residential blocks sometimes have open access through exterior emergency staircases. Some public buildings may have custom-built viewing galleries or restaurants, but for offices and official buildings you normally need permission in advance.

☐ Any high ground, such as a hillside.

☐ The opposite side of a stretch of open ground or water, such as in a park, or on the opposite bank of a river.

Anticipate the lighting conditions that will give the effect you want. As with landscapes, a low sun in the early morning or late afternoon is usually more attractive than a high sun. Midday sunlight usually gives more contrast in a city than in an open landscape, as tall buildings cast large, strong shadows. Sunrise and sunset can be as effective as anywhere else. Cities also usually look good after dark, especially at dusk when there is still enough light to show the shapes of buildings. Nevertheless, the sheer variety and mixture of buildings and spaces means that something will look good in any kind of lighting; it's just that if you are fixed on shooting a particular site, you may have to wait for the best light.

Dusk for the best mix

For a nighttime shot, cities are more brightly lit after sunset than before sunrise, and more so in winter than summer, when offices are still full. Different types of light—street lighting, neon displays, and public building spotlights—are switched on at different times. You may have to check the scene the evening before to guarantee the timing for the brightest array of lights.

◢ From a distance

Downtown Los Angeles emerges like an island from the all-too-familiar smog, seen from the swimming pool of a house in the Hollywood Hills. What the view loses in detail and clarity, it gains in atmosphere.

▶ Dusk and city lights

Late dusk, when there is just a recognizable tone in the sky, gives a better impression of night than the complete blackness later. It works best when combined with floodlighting, as in this view across Marseilles harbor to the basilica of Notre Dame de la Garde.

Street furniture, street art

Details and decoration are a subject in themselves, ranging from the things that identify (and even symbolize) a particular city, to the odd and idiosyncratic, such as graffiti.

The fittings and fixtures of a city are for the most part utilitarian, but they have a distinctive visual flavor. They vary in interest, according to their design, age and how specific they are to a particular city. Some were never designed, but simply evolved. Others are nondescript, but some, such as the Art Nouveau Metro stations of Paris, are worthy of museum display (one did, in fact, feature in a recent exhibition). And always, of course, their interest depends on who is looking at them—foreign visitors to Britain have always seemed to be more taken with the classic red telephone box than the British themselves, who have largely replaced them. The list of street furniture is eclectic and not formalized; guidebooks do not normally identify them, but these are features of a cityscape that are ideal for spotting just when you are walking around.

Even more striking visually are city graphics, which can be in the form of advertising, signage, commissioned and official art, and the unofficial art of graffiti. Advertising changes frequently and follows fashion, and from one point of view—that of someone looking for a long-lasting (if not exactly timeless) view—is an element to be avoided. A stock photographer, for example, hoping to sell one image over and over for at least a few years, has to search for views that do not include billboards and shop displays that will date the image. Yet by the same token, advertisements can add strikingly to a photograph, and some, such as the Marlborough Man on Hollywood's Sunset Boulevard, become iconic—and eventually history.

Together with signage (which includes directions, instructions, and building names), urban graphics also have cultural interest. In India, for

Reflections
The bright new texture of a parked van picked up street colors in downtown San Francisco. A wide-angle lens was used from very close and stopped down for good depth of field.

Juxtaposed
Large murals in urban settings are usually eye-catching, and offer opportunities for striking juxtapositions.

example, most of the country's display advertising is hand-painted, which gives it a pleasing idiosyncrasy. Other languages can be interesting simply for their appearance. Some like, Cambodian and Thai, have a particular cursive beauty, while ideograms, as in Chinese and Japanese, lend themselves easily to graphic design.

Then there is art for art's sake, temporary or permanent. Municipal authorities often have programs promoting art in public places. Gustav Vigeland's sculptures in Oslo's Frognerparken, for example, have been one of that city's famous sights since 1906. Look also for privately funded art in the forecourts of large corporations, and for murals. Large construction sites sometimes decorate the temporary exterior with imaginative designs. The possibilities are endless. And on top of all this officially sanctioned graphic work, there is graffiti, which in some American cities, notably New York, makes a strong statement.

Rope sculptures

Increasingly, municipal spaces are sites for art, mainly sculptures. Their intention, which is of equal benefit to photography, is to bring life and visual surprise to what might otherwise be bleak urban spots.

Pub sign

English pubs of Victorian and Edwardian vintage often carry their names in a variety of decorative means, such as windows. This Docklands pub, in east London, is, of course, called The Ram.

Buildings grand and modest

Architectural photography is part record and part interpretation, with plenty of scope for using your imagination. Digital controls can overcome many of the possible lighting problems.

At its best, architecture is art, and deserves some care and interpretation in photography. If you are taking a picture of a building of any consequence, first take some time to study its design and function. For instance, what was the architect's intention? Was it designed to be imposing, or to make the best use of available space, to make a particular visual statement, or to blend in with the surroundings? Was it designed for a single best view? Does it have one feature that is either remarkable or at least more important than any other? These are the kinds of questions that should guide you toward a particular treatment and viewpoint.

Most architectural photography involves interpretation–appreciating the design and function of a building, and conveying a representative impression.

▽ Southern living
The Cottage (1790s) is a raised cottage style of plantation house, in West Feliciana, Louisiana. This viewpoint made the most sense, with the tree and hanging Spanish moss a key element.

Before setting up the camera and tackling the technical problems, study the building from all viewpoints and decide the following:

1. What was the architect's intention? Was the building, for example, designed to be imposing, or to make the best use of available space, or to blend in with existing architecture, or what?
2. Was the building designed for a best view?
3. Does the building seem more relevant when photographed in isolation or in its setting?
4. Does the building have one outstanding quality?

From these, you can determine what the photograph should convey, selecting suitable lighting, filtration, lens, and viewpoint. With some buildings, these technical considerations may virtually dictate the shot—if there is a restricted view, for example. In some cases, more than one shot may be necessary. Pay particular attention to details, which can bring a welcome variety of scale, just as in landscape photography (*see pages 136-137*).

Usually, there are two aims in architectural photography, which may or may not conflict. One is to show the building and its principal features as clearly as possible. In other words, the photograph is to function as a good documentary record, the type of image that an architectural historian would want. The way of preparing for this is to follow through the checklist above, and learn something about the history of the building, or at least its period. This kind of research is never wasted. The other aim is to make the building look as good as possible—essentially, to beautify it in some way. Given that there is little that you can do to the building itself, other than move away some of the more obvious obstructions, such as trash cans, signs, and inconveniently parked cars (the effort depending on how important the picture is to you), the two means of improving the appearance are viewpoint and lighting. These two options are often linked, and we deal with them on the following pages. In addition, as photographers we also like to show something of our own individuality and skill, which can add a third layer to the process—that of interpretation. In commercial work, this is an area for potential disagreement with the client or architect, because imaginative treatments sometimes come at the expense of clarity. All of this argues for trying out more than one treatment of a building.

US Supreme Court
Although built only in 1935, the US Supreme Court is firmly in the Greek style, with an intentionally imposing portico of Corinthian columns. This wide-angle view, taken on a summer evening, stresses the grandeur.

Icelandic house
In Reykjavik, corrugated iron is a traditional material for modest dwellings. Its humble origins are partly masked by bright paint. This was highlighted by close cropping.

Architectural viewpoints

As with most static subjects in photography, viewpoint is always an issue in architectural photography; sometimes it is the most important ingredient in the image.

.The single most important practical matter is deciding where to shoot from. There may be a choice of camera positions, in which case you will have the luxury of deciding which you prefer. More usually, however, you may have difficulty finding an unobstructed view. Study all the options by walking around the building and stay flexible about focal length. Sometimes a telephoto view from a distance will allow you to close in more effectively than a wide-angle shot from just in front. A frame-filling picture of the façade is the most obvious treatment, but there are others–for instance, a view that shows the building in its wider setting, surrounded by other buildings or the landscape, or a more tightly cropped view that concentrates on just a representative part. Check out the possibilities from other surrounding buildings. Getting up to a higher level often gives a clearer view because you are above street-level obstructions, but you will normally need to arrange permission for this.

A strongly angled upward view from nearby can give an unusual and powerfully graphic composition, but this is a treatment that is best used sparingly. With a wide-angle lens, the vertical lines converge strongly; with a telephoto, details are foreshortened. In both cases, because the view is a little strange, take care over the framing–your subject may end up being scarcely recognizable. If you are using a very short wide-angle lens, try a position and angle that give a symmetrical composition. This will bring some order to the picture.

Wide angle and close
Probably the most classic viewpoint is close up with a wide-angle lens. This position eliminates the problems of finding an unobstructed view from a distance, but also demands correction of converging verticals by one of the techniques described on the following pages.

Although natural light is not always predictable, work out in advance what the ideal daylight conditions for the photograph would be—the angle of the sun, whether cloudy or bright, and the color temperature. Try to plan around these, even if it means delay or more than one visit. Like any object, a building has many possible appearances according to the light, but, unlike a still-life, you have limited choice. Strong frontal lighting gives good color saturation; backlighting can be used to silhouette buildings with strong outlines; the diffuse light on an overcast day reduces shadows on complicated details; and cross-lighting—the most generally useful—reveals texture and shape. Some public buildings may be well floodlit at night, usually with tungsten or sodium lamps. In this case, twilight is normally the best time to shoot, while some tone remains in the sky to define the building's shape.

Use the white balance and tone compensation controls to give the optimal color and contrast, as with a landscape. Also consider using a polarizing filter to darken blue skies, for contrast with a light-colored building, but keep in mind the many other possibilities at the stage of image editing. See pages 134-135 some of these options.

Telephoto

The success of this kind of shot depends very much on obstructions, or rather, their absence, in between the camera position and building. When the view is clear, the shot is easy. Telephoto helps with converging verticals.

Reflections

Reflections are always a possibility, particularly if there is a strong contrast in light and shade. One possible advantage is shown in this shot of a Colorado ghost town: the combination of two images in one.

Converging verticals

Most buildings are straight-sided, and a strong visual convention is that they should appear that way in a picture, even when this conflicts with real perspective.

The way in which lines appear to converge with distance is the perfectly normal effect of perspective. We are not normally aware of this geometric distortion when we look at things in real life, because we are a part of the actual, three-dimensional scene. It does become obvious, however, in an image, which is an object that we look at rather than experience. There is still nothing particularly unusual about this so long as the view is more or less level, and so long as the perspective leads toward the horizon.

However, looking upward is a different matter. Unfortunately for architectural photography, our eyes see convergence as less normal in a photograph taken looking up at a building. Then, the vertical lines lean in toward each other, and the effect tends simply to look wrong. If you do it in an exaggerated and obviously intentional way with a very wide-angled lens, such as in the photograph on page 133, this can work to your advantage, but otherwise you do need to take the trouble to avoid it. If the shot were of people, and the building were just a backdrop in the picture, none of this would matter. If the subject is the building itself, however, the photographer is expected to sort this out.

The obvious problem in shooting is that, in order to take in the whole of a building from close up, which is a standard method of doing it, you would normally need to tilt the camera upward. The laws of optics are fairly simple: the image plane, which in our case is the sensor in the camera, has to be parallel to the

△ Upward shift
A specialized shift lens is available for digital SLRs, which allows the view to be shifted upward. Otherwise, use a wide-angle lens and crop off the lower foreground.

▷ Foreground interest
Following the principle of aiming the camera horizontally, look for shots that make use of foreground detail, such as this gravestone in an English churchyard.

façade, meaning vertical. And that means keeping the camera aimed horizontally. There are a number of ways of doing this:

☐ Look for a higher viewpoint, such as halfway up the building opposite. You keep the camera level and simply find the right focal length of lens. The only problem with this solution is that halfway up is not a normal view of a building, and looks strange if you do this all the time.

☐ Use a wide-angle lens and aim the camera horizontally so that the building's sides stay vertical, but move far enough away to include everything. Later, crop off the lower unwanted foreground, which occupies almost half of the image. This is easy, but reduces the size and resolution of the image.

☐ Use a wide-angle lens in the same way as above, but compose the shot to include some relevant foreground interest, such as a flower bed or ornamental pond. This way, the composition looks intentional.

☐ If the view is unrestricted, move much farther back and use a telephoto lens, which will not then need to be tilted very much.

☐ Tilt the camera upward as much as you need to, and correct the distortion during image editing (see the following pages).

☐ The ideal solution is to use a perspective-correction (PC), or shift lens, which is available, for a price, for SLR cameras. It works by covering more of the scene than you can actually see through the viewfinder, projecting an image circle that is much larger than the sensor. By working a rack-and-pinion arrangement on the lens, the front part of it containing the lens elements is shifted upward. This brings the upper part of the image down into frame. Therefore, you can aim the camera horizontally and still include the top.

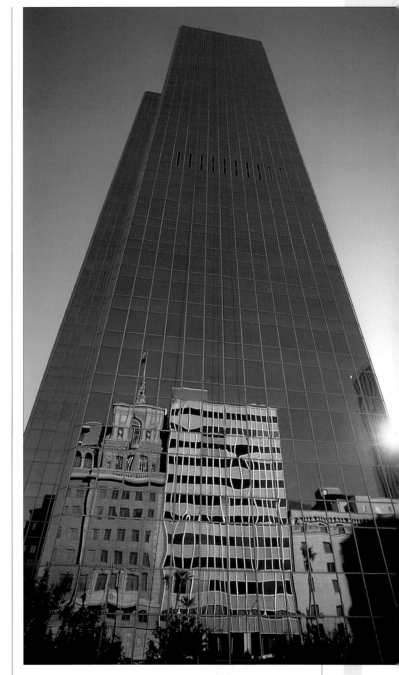

Using convergence
If by tilting the camera strongly upward you make the convergence obvious and deliberate, this is usually acceptable for what it is—a strong, graphic composition.

Digital solutions

Image editing provides the means to overcome most of the practical difficulties inherent in architectural shooting, from light and color to distortion and obstructions.

Any problems that you are likely to encounter in shooting buildings mainly derive from the scale of the settings. If these were manageably sized objects, you could alter most things to suit the photography. Digital techniques, however, give an outstanding degree of control, beyond what you can do with the in-camera controls. Their most useful role is probably that of correcting perspective distortion—converging verticals—but they can also assist in adjusting color and brightness. For instance, you could use a polarizing filter to darken a blue sky behind a light-toned building for stronger contrast. Another method would be to adjust the blue with the HSB controls during image editing. Even more useful is the ability to remove offending obstructions, from parked cars to scaffolding and overhead cables. This is possible with cloning tools or cutting and pasting. For absolute accuracy, photograph parts of the building that are concealed by stepping to one side or by shooting at a larger scale from the other side of the

Perspective tool
In image editing, the straightforward procedure is to apply the Perspective tool to the image. Perspective tools are one variety of distortion tool, controlled by a bounding box, in which the scale is changed at one end only, and symmetrically, as shown here. Because considerable interpolation is needed, it is safer to drag inward at the bottom rather than outward at the top, to preserve quality. Then crop in. Be prepared to lose a considerable amount of image at the sides. The building shown here is an ante-bellum mansion called Magnolia Hall in Natchez, Mississippi.

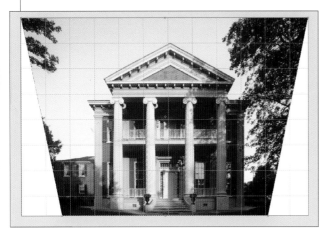

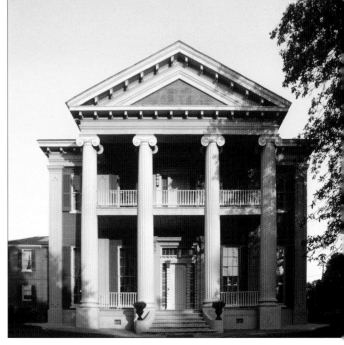

obstruction. You can then scale and distort this patch and paste it over the obstruction.

Perspective correction is straightforward, using either the Perspective tool in an image-editing program, or in a plug-in (there is third-party software available to deal with this). Switch on the grid overlay to align the verticals accurately, and apply. Remember that geometric corrections like this do damage the image, and to minimize these it is better to compress the lower part of the image rather than expand the upper. You will then need to crop. Note that even when this kind of perspective correction has been applied, the proportions may still look a little strange—squatter than it should.

There is no perfect solution to perspective distortion, because it's a perceptual construct to do with the way that we think things should look rather than the way they are. Straightening the vertical sides of a building so that they are vertical in the picture works because it gives a rightness to the image, but it can never be the same as an architectural elevation. The view of the upper stories and of the roof is still from ground level, meaning that most of this structure simply can't be seen. You can stretch and squeeze any part of the image as photographed, but not restore the parts hidden from view.

Having said this, there is an argument for trying to restore the proportions of a façade to those of the original, rather than the proportions that someone experiences looking up at a building. I'm not sure that it's a good argument, because many, perhaps most, buildings were designed to be seen from close up. In any case, there is a digital procedure, shown here, which progressively stretches the upper part (or progressively compresses the lower part if you choose to do it that way). The technique is a graded displacement map, in which a vertical gradient from gray (no displacement) to black (maximum displacement) is applied to the image.

Displacement map for progressive correction

A displacement map is grayscale and can be much smaller than the image to which you apply it. To extend the upper part of a building progressively, make a gradient from gray to black, and apply the displacement vertically upward. Experiment with the amount, as the effect depends on the image size.

Displace		
Horizontal Scale 0 %		OK
Vertical Scale –50 %		Cancel

Displacement Map:
● Stretch To Fit
○ Tile

Undefined Areas:
○ Wrap Around
● Repeat Edge Pixels

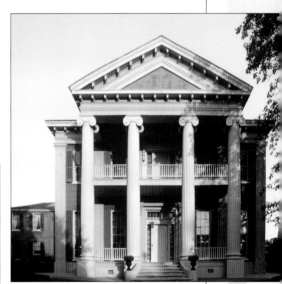

Architectural details

While a minimum of one clean overall view of the building is usually the major challenge, the details of construction and decoration may be just as important, and call for different techniques.

In many branches of photography, closing in on details within a subject discloses a different, refreshing range of imagery. In professional shooting, switching to detail becomes second nature–if only to enable us to produce a more varied-looking set of images to show the client. This applies equally to buildings, but it also has a more important role. Architectural detail, whether decorative or structural, is an intrinsic part of the portrait. A professional brief for an architectural assignment will almost always include a list of highly specific features. These might include, for example, the order of the capital in a classical façade, an architrave, the pointing of brickwork, or a finial.

After setting up for an overall shot, with all its attendant issues of lighting, viewpoint, and obstructions, photographing detail is usually a pleasant relief–really, it is a separate exercise. The first step is to identify exactly what details to shoot. There are essentially two kinds: the documentary ones that have architectural importance, and the ones that simply make interesting images irrespective of their significance. For the first group you

Georgetown
This detail captures a cast-iron star and bolt used to strengthen old brickwork in the historic Georgetown district of Washington DC. Sited between two adjacent terraced properties, the star is also divided by the owners' contrasting color schemes.

Victorian hotel
The façade of an old waterfront hotel in Fremantle, Western Australia, displays its origins as accommodation provided by a large shipping line for its liner passengers as they disembarked at the small port.

need a list, either from the client if this is a professional assignment, or from some published guide. Architecture and architectural history are specialized subjects, and if you are not trained in them yourself, it's best to rely on expert knowledge. Nonessential but attractive details justify themselves, and depend very much on what appeals to you—the way a shadow falls across stone, for example, or the texture of wood planking. Just pick these up as they appear.

Access to the details is the first consideration, and a long telephoto is usually the lens of choice. Details at ground level are no problem, and you can normally shoot with any focal length, but for the architectural elements on upper levels you need either to climb up—which may be impossible—or magnify with a long focal length. There will, naturally, be some convergence, but as this is never so extreme as with a wide-angle lens, it normally doesn't matter much. The longer the telephoto (a choice you would have only with an SLR), the less it needs to be angled upward, so the less the convergence. If you can avoid verticals in the detail, so much the better.

Evening shadows

This bas-relief sculpture high on the roof of the Federal Reserve Building in Washington DC appears at its strongest in evening sunlight. The figure faces the sun and for a few minutes stands out strongly against the wall. The location was researched the day before to determine the perfect time.

Convent gate

This shot shows the well-preserved entrance to the Begijnhof convent in the Belgian city of Brugge, in dappled early morning light.

▷ The finger of God

A startling spire to the First Presbyterian Church, built in 1859 in Port Gibson, Mississippi, photographed with a 400mm efl telephoto.

Case study: **American modern**

The single-storied De Napoli house near Los Gatos, California, was designed and built between 1987 and 1990 by architect Stanley Saitowitz on the brow of a hill. According to the architect, the inspirations for this embedded dwelling were Machu Picchu and the work of other architects Mies van der Rohe and Luis Barragan. The key to its structure and appearance is the interplay of various terraces and rooms at slightly different levels between themselves and with the slope of the hill.

◁ Entrance
The entrance to the dwelling is from above, at the back of the house, and therefore the view from the driveway is of a roofscape—a separate elevation in which trees are enclosed by the geometric divisions of walls and staircases.

△ Rocks
The entrance approach seen from slightly below, where more rocks punctuate the concrete architecture.

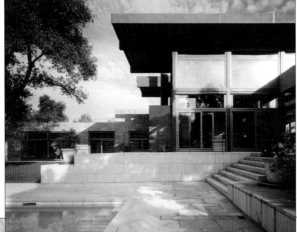

Groups

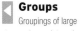

Groupings of large stones play an integral part in the complex, creating an interplay between ancient earth and modern architecture reminiscent of both ancient ruins and a Japanese Zen sensibility in their arrangement.

Pool

The main living space in the center of the complex is a steel-framed structure that features a prominent oversailing roof and steps leading down to the swimming pool.

Parallels

The linear nature of the house comes across most strongly from the front, where it resolves itself into three parallel wings that slide past each other. The dining, kitchen, and services wing is on the left; the main living room is in the center, and a swimming pool and receding master-bedroom wing is at right.

People unobserved

People are an endlessly varied subject in cities, and a compact, almost-silent digital camera set to automatic allows you to shoot unobtrusively.

There are a few ways of photographing people unobserved, and not all of them involve being hidden. The most direct way is simply to shoot very quickly, quietly, and without fuss. This is easily enough said, and some great reportage photographers such as the Frenchman Henri Cartier-Bresson have made this approach their hallmark, but it necessitates astute observation and fast reactions.

Observing people, even without a camera, is an art in itself, but something that you can practice all the time. Try to anticipate what people will do next in any kind of situation—how they will react or look or move—because this will give you an edge in the next step, which is catching their expression or movement on camera. When you see the moment that you think is right, shoot without hesitating. Many people using a camera pause out of uncertainty before pressing the shutter, and so nearly always lose that split-second shot. The more regularly you shoot, the faster you should become, out of sheer familiarity. The majority of digital cameras have an advantage here because they are small and work quietly, and so attract less attention than the older film models. They are light enough to carry and operate with one hand, and if all the functions are set to automatic—focus, exposure, white balance, and contrast—you should simply be able to raise and shoot.

Auto-functions simplify quick-reaction shots, provided that the system works virtually instantly. There are, however, two potential problems, and they depend on the make of camera. One is a slight delay in calculating and implementing automatic settings, partly because of processor speed and partly, in the case of auto-focus, with the servo motor. Some makes of camera are faster than others, and this is not easy to judge before you buy (although a comprehensive camera review on a website or in a magazine may help you to decide). The other potential problem is that, to save the battery, many digital cameras power down after a specified period, and may take several seconds after touching the shutter release before they are ready for action, making them useless in this kind of situation. Study the manual carefully, and find the user settings that minimize these delays. Certainly, the powering-down can usually be adjusted.

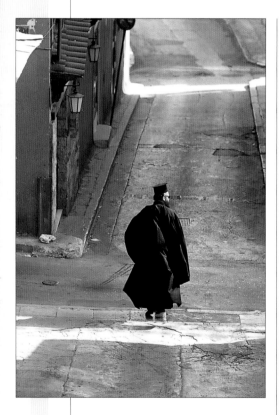

Telephoto down the street
A telephoto lens enables shooting at a distance from which people are unlikely to notice you. It also has the advantage of compressing perspective, which was useful in this Athens street view of a Greek Orthodox priest crossing the road.

In some ways, candid photography of people is similar to wildlife photography. They both contain an inherent unpredictability. After all the preparations you make, you never quite know when the moment to shoot will arrive. When it does, you may need to shoot again, several times. And in both, unreadiness loses the shot. Being prepared to shoot quickly not just once but a number of times in succession poses a problem with image quality and film format. Large images and formats that need more processing slow the camera down. In the worst case, a simple digital camera with the ability to save a large file as a TIFF may need many seconds before it is ready to shoot again. Digital cameras designed for professional use employ larger memory buffers. You can improve your camera's performance by choosing a less demanding file format, such as JPEG rather than TIFF. Other operations, such as noise-reduction, also increase the time it takes to save an image.

◁ Watch seller
Open-air markets afford endless opportunities for unobtrusive photography, with buyers and sellers fully occupied.

△ Reflections
Shop windows in shade on a sunny day offer a different kind of candid shot, in which the people opposite are combined with details from the shop itself, as here in a fashionable Paris shopping street.

Street-life and markets

The anonymity of city life makes candid photography relatively easy, provided that you keep a low profile and make the best use of different focal lengths.

For this kind of candid photography, and particularly if you are walking around in the street, or some other public place like a market, a standard or wide-angle focal length is probably best. This range, from around 50mm efl to 24mm efl, allows you to shoot from fairly close, which is useful if there are a lot of people around who might otherwise get in the way of a shot. You also stand a better chance of observing people from close. The difficulty, although only occasional, is that people can also see you, and that may make it impossible to get a second natural-looking shot. Quite often, you will get only one opportunity, and if you fluff it there's nothing you can do but move on. A wide-angle lens of around, say 24mm efl, however, can help in this. If you compose the view so that the person you want to photograph is off-center, it will appear as if you are aiming the camera to one side. On occasions, you can continue shooting as much as you like within a few feet of the person, and you can reinforce the deception by pointedly looking beyond them when you lower the camera. Very wide-angled lenses are available for SLRs; fixed-lens zooms tend to have a more modest range.

▲ **Light and shade**
In sunny weather, the arrangements of buildings and the orientation of streets give a complex of unexpected lighting effects.

▶ **Standing at the corner**
Street-life in Italian towns always includes groups of young men standing around, showing off and eyeing the girls.

You can also make good use of longer focal lengths, though in a different way. A telephoto lets you stand at a distance from the people you are photographing, and as long as you are reasonably discreet about the way you hold it, there is every chance that you will not even be noticed. The extent to which you can do this depends on the kind of digital camera. As with wider angles, the telephoto possibilities with a

Market in wide-angle

A partly covered market in the old town of Nice on the Mediterranean is full of detail and interest—perfect material for a wide-angle view. It often helps to have one specific person in the foreground to key the composition. Here, I waited until the old gentleman with a walking stick came into view.

Fish seller

Fish for sale on the harbor front at Marseilles. Open-air trading activity like this is always worth looking for as a subject. People rarely mind photographs being taken as long as you are not intrusive, and in any case they are usually too busy to notice.

fixed-lens zoom are fewer than with an SLR, which gives you the choice of lens. Compact and prosumer models overcome telephoto limitations in two ways. One is digital zoom, which magnifies the image beyond the optical limit of the zoom lens, but this does no more than interpolate the image digitally, which you could do yourself later on the computer. The other is a tele-converter that fits over the lens like a filter. This isn't the best optical solution in the world, but it's better than nothing.

If you use a digital SLR, you have a much greater choice of focal length than the limits of one zoom lens, and different strengths of telephoto make it possible to shoot candidly in different ways. Of course, a larger telephoto lens in itself makes the camera bulkier and more obvious than usual. A medium-telephoto—say, 180mm efl—is particularly good for "across-the-street" shots for framing a full-length figure, and for full-face shots from a few yards. Longer telephotos, such as 300mm efl and 400mm efl, are trickier to use—they are heavier, need a faster shutter speed to overcome camera shake, but have smaller maximum apertures. One of the best ways of using them is from somewhere that you can sit quietly for a while without drawing attention, such as a sidewalk cafe. With all telephotos, watch out for other people, or cars, crossing in front of the camera and spoiling a shot.

Outdoor portraits

Natural light may not always be perfect for portraiture, but it allows spontaneity, and outdoors you can take advantage of a wide range of backgrounds and settings.

Portraits can be prearranged or impromptu. If the session is set up in advance, you have the opportunity to plan ahead and select the setting, time of day, and details such as dress and props to suit the photograph. It also presupposes that the person being photographed has an interest in the shot. With impromptu portraits, on the other hand, you will usually have to make the best out of the situation. You may even have to apply some persuasion to get full cooperation. Here the instant feedback on the camera's LCD display can be invaluable for showing your subject how the session is going.

An important choice has to be made between the different styles of an eye-contact portrait and one where the subject is involved in some activity. When your subject looks directly at the camera, the resulting photograph almost inevitably has an air of formality. The character of the person you are shooting may help decide which approach it is best to use: some people find it less of a strain to be photographed doing something, while others are able to take up an informal pose naturally. An assistant can be useful to distract the subject's attention, and one approach that is sometimes used in photojournalism is to photograph the person at the same time that they are being interviewed.

In composition, most outdoor portraits are either tight shots, concentrating on the head and shoulders or upper torso, or environmental shots with the subject clearly set in his or her surroundings. This is a basic division, and within each set there are

Arunachalesh
The wide-angled environmental shot places the subject in his surroundings; in this case, a south Indian temple town. Viewers can draw conclusions about the subject based on his context.

variations. Which type of composition you choose depends on a number of factors, and one or other will be clearly suggested by the situation.

If the setting is attractive, interesting, or relevant, there is a good case for including it. Such environmental shots can also be helpful when, for example, the person you are photographing has a stiff, awkward expression. Stepping back makes this less important. A wide-angle lens is the most generally useful. Longer lenses can be used from farther back, but the greater distance makes it more difficult to communicate with your subject.

Excluding the environment and concentrating on the person places more emphasis on his or her individual character. As this inevitably means moving closer to the subject, use a moderately long-focus lens for a more attractive perspective effect. A wide-angle or even standard focal length will distort the face noticeably when used in close-up, making the nearer features, particularly the nose, seem larger in proportion. A medium telephoto (around 80mm efl to 200mm efl) is the most useful. Longer focal lengths than this still give good perspective, but you have to shoot far from the person, making it a little more difficult to talk to them. Long telephotos also have shallow depth of field and smaller maximum apertures. Where a restricted depth of field is a problem, focus on the eyes.

You have limited control of lighting with outdoor photography, and will often simply have to make the best of the existing conditions. Hazy sunlight is generally ideal for most portraiture, giving good modeling without harsh shadows. Cloudy weather lacks contrast, but you can partly overcome this by setting high contrast in-camera. Also try placing the person next to a dark area such as the open doorway to an unlit room or dark vegetation. In bright sunshine, the contrast range on a face is usually uncomfortably high, with dense, sharp-edged shadows, and it is usually better to move into open shade (adjusting the white balance accordingly). Professional solutions include filling in shadows by holding a large white card or crumpled foil reflector close to the person, and a screen of translucent material to soften the sunlight. Alternatively, use fill-in flash.

Eye contact
Direct eye contact holds the viewer's attention. Here, the appropriate lighting was achieved, despite bright sunlight, by working in the shade of a tree and using white sheets to reflect light onto the eyes and face.

At work
Here the subject, seemingly unaware of the camera, seems more natural than he might had he stopped working and looked straight into the lens.

Gardens

Artfully created landscapes on an accessible scale, gardens in all their variety are intended for display, and the key to photographing them is first to understand the how and why of the design.

There are many types of garden, varying according to historical period, culture, and the individuality of the designer, but almost all attempt to introduce some aspect of nature into the manmade world. In some, the view (or several views) are the important feature; in others, the planting. To photograph a garden successfully, it's important, as with architecture, to have some knowledge of what it contains and why it was designed in that particular way.

In the West, one major division is between the formal, geometrically laid-out garden, such as that of Fontainebleau, which symbolizes the taming of wild nature, and the more English design which recreates natural features, often presented from a winding path. In the first case, there are always a few best viewpoints from which the layout can be appreciated, and these are normally the prime camera positions. A more informal design of garden gives a greater opportunity for interpretation in a photograph.

Many Asian gardens follow completely different principles. The Chinese, for example, invented the concept of the borrowed view, in which a part of the landscape beyond the garden's borders was deliberately included, by means of optical illusion, suggestion, and tricks with perspective. The Japanese developed this as shakkei. In both cultures, controlling the viewpoint was a necessary feature. In the case of a stroll garden, the visitor was led from view to view, with deliberate surprises at each stopping point. Another noticeable feature of Chinese and Japanese gardens is the importance of rocks, considered as features with their own spirit. In the form of a Zen garden, plant life may be completely absent; instead rocks, sand, and gravel precisely symbolize Buddhist landscapes.

Then there is the planting itself. It very much helps to know what the individual plants are, which are important or rare, which are the best specimens in a garden, and in which month they are at their best. Many gardens are designed so that they have different appearances according to the season. The weather and lighting are as important as they are for any natural landscape, often with special emphasis on the early morning, when many flowers are at their most fresh.

△ **Sculptured English**
A small, precise and highly decorative detail from the Tudor gardens at Hampton Court, near London. Visually, many gardens work on several scales, including close-up.

Gardens vary greatly in scale, and this too affects the way in which they can be photographed. Small patio gardens can be highly miniaturized, and the main effort goes into finding a camera position that takes in sufficient of the view, inevitably with a wide-angle lens. At the other end of the scale there are the masterpieces of landscaping that were created in some of the great English country estates, with rivers diverted, hills raised, and forests planted. In the hands of landscape gardeners such as Capability Brown and Humphry Repton, particular viewpoints were essential, and it would be perverse to ignore these with the camera. For example, the first view of Blenheim in Oxfordshire as the visitor enters through the estate through the Woodstock gate was called "the finest view in all of England," and indeed, it is a large landscape intended to be seen from exactly one point on the driveway.

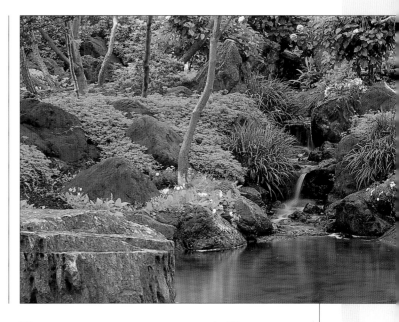

The "finest view"
The first sight of England's Blenheim Palace, designed to be seen from the driveway, is a triumph of eighteenth-century landscaping. The distribution of features is intended to be seen as a long panorama, making a series of three frames and stitcher software the ideal answer.

Japanese
This Japanese garden features colorful flowers among the traditional green ground cover and carefully placed rocks.

Blenheim1 Blenheim2 Blenheim3

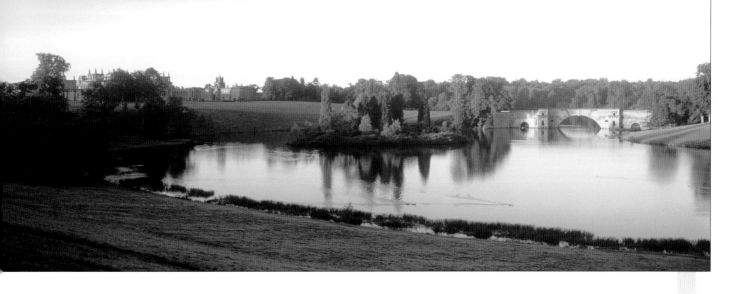

Case study: **Japanese gardens**

These photographs were taken for a book on modern Japanese gardens. This was a first; all the previous books had concentrated on traditional Japanese garden design, and no one had looked at contemporary work. This made research and sourcing absolutely key, and we visited each garden with its designer, who explained the principles. The photography stressed the modern elements, some of which were strikingly obvious, others subtle, but it was evident that the designers drew on their knowledge of Japan's long garden tradition, even when they deliberately broke the mold.

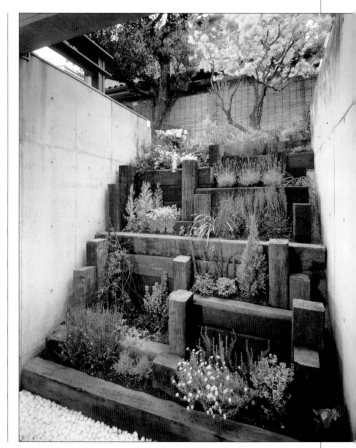

Architectural planting
This integrated modern house and garden is striking for its juxtaposition of steel and glass buildings with an architectural planting of bamboo very tightly pruned into these distinctive shapes.

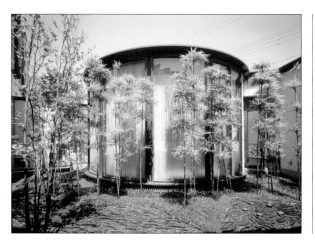

Step garden
Here, imaginative use was made of a small space leading up from a basement to the garden level. Old railroad sleepers were employed to partition off a planting that is changed every season. This shot was taken in spring, and the composition is topped with a cherry tree in full blossom.

Modern tea ceremony

Tea ceremony rooms have long been traditional in Japanese houses that have sufficient space for them. This modern cantilevered version looks out onto a miniature landscape of water, pebbles, and rocks, with the striking juxtaposition of a stainless steel pillar.

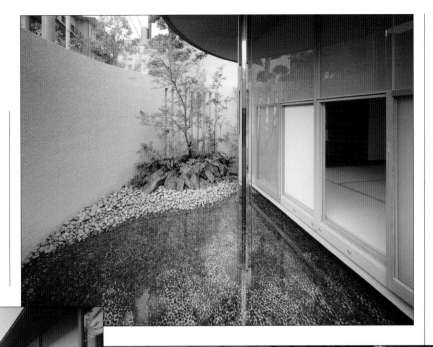

Pebble garden

This shot shows a highly restrained but adaptable small garden of black pebbles, with an old stone horse trough containing a single plant (which is changed seasonally). The area can be flooded to turn it into a pond, in which the pile of larger pebbles in the foreground becomes an island.

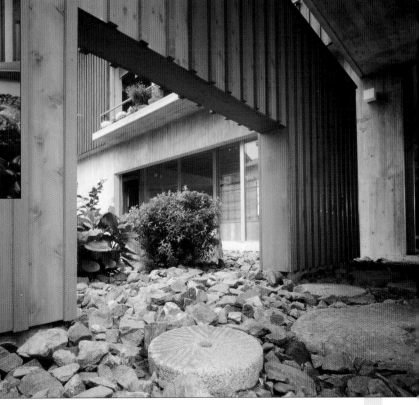

Modern dry stone

One of the influences of Zen on Japanese gardening has been the construction of entire gardens from stones of various sizes to represent miniature landscapes. This modern version uses broken stones and a wooden "gate" deliberately positioned to encourage visitors to stoop and peer through to the space beyond.

Zoos

Zoos are both good places for people-watching and outstandingly convenient locations when looking to photograph animals you could not possibly reach in the wild.

⏵ Action
Late afternoon is feeding time at India's largest crocodile breeding center near Madras. As chunks of meat were thrown into the pit, I waited until a flurry of action took place in a small dispute. The slight blur from the slow shutter speed enhances the sense of violent movement.

For the photographer, zoos are in effect large captive sets. They offer many of the opportunities of a studio, but often lack the degree of control that is possible in a set that is specifically designed for photography. Ultimately, the outstanding advantages of zoos are that they are convenient and normally have good, healthy specimens of animals that might be impossible to photograph in the wild. Early and late are usually the most active times of the day. To see active behavior may mean waiting for long periods, but the results are likely to be much more interesting than pictures of animals sleeping or resting.

Zoos vary greatly in the settings that they provide for their inmates. Older ones are handicapped with outmoded conditions, with the animals in barred cages, but fortunately, modern zoo design tends toward naturalistic settings that are open to view, using moats and pits to replace bars. The first step is to choose, whenever possible, a zoo that has good photographic possibilities. You cannot expect every exhibit to present a good picture, and finding a good camera viewpoint and lighting may involve an element of chance. The ideal is an isolated shot of an animal in a setting free from obtrusive and artificial elements. The background may be simulated, such as a bamboo thicket in a tiger compound, or artificial cliffs for a herd of mountain goats, and this can be indistinguishable from the real thing in a photograph. More commonly, the background may be a plain wall. Even this can be made to look fairly natural, or at least inconspicuous, by using a wide aperture to achieve a shallow depth of field and throwing the background out of focus.

In order to be able to control backgrounds in this way, and also to isolate the subject, a medium long-focus lens is often most suitable for zoo photography. The shallow depth of field at a wide aperture makes it possible

to reduce inappropriate backgrounds to a blur. Shallow depth of field also provides a solution with barred compounds. Even closely spaced bars can be shot through with a long-focus lens–they become so far out of focus as to be unnoticeable. Lenses with very long focal lengths can occasionally be useful, but there is usually insufficient working distance to be able to frame the whole animal.

You should also think about a zoo as a place for photographing people. In the life of a city, zoos function as a kind of amusement park, in particular a day out for children. Some of the best opportunities are the ways in which visitors interact with animals–not necessarily touching or feeding, which these days tends to be frowned on except in special areas–but in behavior. There are possibilities for interesting or unusual juxtapositions, and these depend very much on viewpoint and timing. Wide-angle lenses have a role here, as well as the telephoto.

▲ Open zoo
A long-focus lens is useful in zoos not only to overcome the distance that separates visitors from animals but also because the narrow angle of view makes it possible to select limited and nonintrusive backgrounds. Shallow depth of field from shooting at a wide aperture also helps to keep the background blurred.

◀ Close-up
A young orang-utan's experiments with plumbing in the Jakarta zoo, Indonesia, made a good opportunity for a portrait. This is one of several young orang-utans recovered from the illegal traffic in pets.

Rural scenes

Fields, farms, lanes, and villages are another aspect of landscape—more traditional and in tune with nature than cities, yet not wilderness.

Moving out of the cities and towns to the countryside, the scenery becomes not exactly natural, but less obviously manmade, with farming dominating the view. In painting, and in photography, this is a more European kind of landscape, with fields and hedgerows, dotted with dwellings, inhabited by cattle, sheep and so on. These components were indeed very much a feature of Classical landscape painting.

Most of the techniques that we went through under Natural Landscapes apply to these landscapes too, and in some ways there is a wider visual choice for photography, because of the variety of manmade features. The overall landscapes tend to be softer and gentler, but there are villages, small roads, gates, and fences, and so on. By the same token, there are also more instances of ugliness in the form of wasteland, abandoned vehicles, and the encroachment of shopping malls, although this is a matter of taste.

True countryside, as opposed to the residential kind, is farmland, and in most cases this accentuates the seasonal variations as the land is turned to specific use—lambs in the early spring in sheep country, for example, or apple orchards with rows of trees in blossom, or "amber waves of grain" in the American Midwest in summer. The rhythms of plowing, planting, harvesting, herding livestock, and shearing sheep make rural seasons themselves a rich subject for photography. In some places there

Welsh farm
Late afternoon sunlight filters through the trees over a Welsh hill farm. Springtime is one of the best seasons for photographing sheep country because of the presence of the young lambs.

Japan
Rice terraces are typical of much Asian countryside, and in wealthy Japan are characterized by their neatness and the evident prosperity of houses and farm buildings.

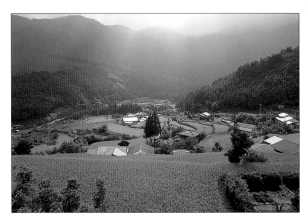

may be one striking "best" time to shoot; in others it is worth revisiting at different times of the year for different views.

This specific nature of countryside extends beyond the seasons to the differences in soil and terrain, and in culture. Regional differences within any country are most obvious through their particular rural landscapes. Think how individual are the vineyards of California's Napa Valley, Kentucky's white-fenced bluegrass country, the dairy pastures of Normandy, and the Yorkshire Dales crisscrossed with dry-stone walls. This character becomes all the more definite when conditions are less than ideal, and people have to find solutions to farming on land that is too steep, too waterlogged, too dry, or too impoverished. Over much of Asia, rice is the staple, and paddy rice needs static water more than it needs good soil. This need accounts for the highly labor-intensive and spectacular-looking terracing that follows the contour lines of hillsides in locations as far apart as the Himalayan foothills, Bali, and the Philippines.

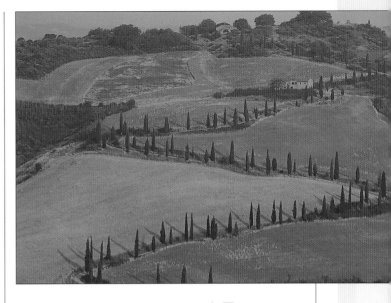

Tuscany

Poplars lining lanes and brown fields are familiar elements of the archetypal Tuscan landscape around Siena and Florence. The rolling hills make it relatively easy to find good viewpoints looking toward opposite slopes, as in this telephoto view.

Colors

Early summer rapeseed fields cover large areas of southern England, and bring a striking yellow to the landscape. Using a 600mm efl lens made it possible to isolate this graphic composition.

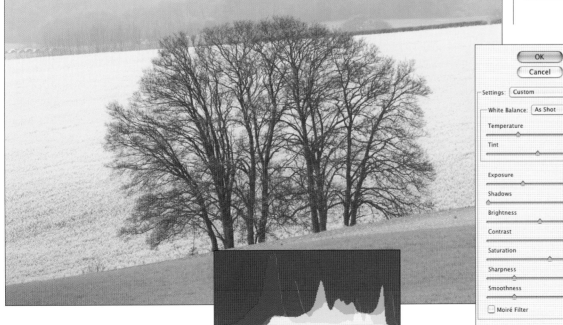

Monuments and ancient sites

Some of the most visited locations in the world are archaeological sites. Preserved yet restricted, they are a real challenge for photography.

Archaeological sites call for many of the same camera techniques as regular buildings, but they are much more than that. Some of the more remote, or extensive, sites offer possibilities for very evocative photography. However, as more and more come under the pressure of tourism—victims of their own success as heritage sites—they challenge the photographer to find views that have not already become common currency, that are accessible because of entry regulations, and are free from hordes of other visitors.

Access is usually the first consideration if you are planning to photograph an archaeological site. There are nearly always some kinds of restriction placed on entry (and an entry fee), to protect delicate monuments. Check these carefully before going, particularly the opening and closing times, if any—you may want to shoot at sunrise or sunset, but not all monuments are open to the public at these times. In addition, check to find out if there are extra fees for photography. This varies from place to place, but in general you are more likely to be charged if you appear to be a professional photographer. A tripod is often considered an indicator of this, and increasingly you may need a special permit, not necessarily obtainable at the site. Light-sensitive artifacts, such as polychrome murals, may be off-limits for photography.

For atmospheric shots, treat the site as you would a landscape, and try to plan the photography for interesting light—at the ends of the day, or possibly with stormclouds. Also look for wide-angle views that take in close details such as a fragment of sculpture, as well as the distance. In addition to these basic scenic shots, consider the more documentary shots, such as a record of a bas-relief and other

◀ Ruins in the jungle
At some sites, nature visibly returns, as in the temple of Ta Prohm at Angkor, Cambodia, and this can give evocative details.

▼ Battlefield
A row of Confederate cannon at Hazel Grove is the only remains in this part of the Chancellorsville battlefield, Virginia, long reclaimed by forest.

Mayan

In the Yucatán Peninsula, Mexico, this unique arch stands among shrubs and collapsed ruins at the Mayan site of Labna. Timing and light are important for a clear view such as this.

Life goes on

Always worth considering are shots in which local farming life continues around ancient sites. In the case of Bagan, a site covered with thousands of brick pagodas in Burma, a passing ox-cart is essentially timeless, and helps evoke a sense of both history and decay.

carvings. Here again, the lighting is important: raking light across the surface is usually the clearest for bringing out carvings in low relief.

Ancient monuments, more than most other buildings, benefit from not having people in view, but with a large monument this is rare. The best opportunities are nearly always as soon as the site opens. Otherwise, it is usually a matter of waiting for moments when other visitors are out of sight. But of course, there are always digital solutions, and one of the neatest involves no artful retouching, although it does feature brushwork in an image-editing program. This is the multishot technique explained below.

Multishot removal of people

This technique works even if a site is crawling with tourists, as long as they keep moving and you have the camera fixed (ideally on a tripod). Take a number of identical exposures over a period of time, possibly several minutes. As people walk in and out, climb staircases, and peer out of windows, they move while the building obviously does not. A part that was obscured in one frame will be revealed in another, and by assembling the images in layers, you can brush out the people by deleting small areas in each layer.

Glossary

aperture The opening behind the camera lens through which light passes on its way to the CCD.

artifact A flaw in a digital image.

backlighting The result of shooting with a light source, natural or artificial, behind the subject to create a silhouette or rim-lighting effect.

bit (binary digit) The smallest data unit of binary computing, being a single 1 or 0. Eight bits make up one byte.

bit-depth The number of bits of color data for each pixel in a digital image. A photographic-quality image needs eight bits for each of the red, green, and blue RGB color channels, making for an overall bit-depth of 24.

blind A camouflaged cover for observing wildlife, also known as a hide.

bracketing A method of ensuring a correctly exposed photography by taking three shots; one with the supposed correct exposure, one slightly underexposed, and one slightly overexposed.

brightness The level of light intensity. One of the three dimensions of color in the HSB color system. See also **hue and saturation**

buffer Temporary storage space in a digital camera where a sequence of shots, taken in rapid succession, can be held before transfer to the memory card.

calibration The process of adjusting a device, such as a monitor, so that it works consistently with others, such as a scanners or printer.

CCD (Charge-Coupled Device) A tiny photocell used to convert light into an electronic signal. Used in densely packed arrays, CCDs are the recording medium in most digital cameras.

clipping path The line used by desktop publishing software to cut an image from its background.

channel Part of an image as stored in the computer; similar to a layer. Commonly, a color image will have a channel allocated to each primary color (e.g. RGB) and sometimes one or more for a masks or other effects.

CMOS (Complementary Metal-Oxide Semiconductor) An alternative sensor technology to the CCD, CMOS chips are used in ultra-high resolution cameras from Canon and Kodak.

color temperature A way of describing the color differences in light, measured in kelvins and using a scale that ranges from dull red (1,900K), through orange, to yellow, white and blue (10,000K).

compression Technique for reducing the amount of space that a file occupies, by removing redundant data.

contrast The range of tones across an image from bright highlights to dark shadows.

convergence The distortion of parallel lines, especially in architecture, caused by the angle of view and the lens.

cropping The process of removing unwanted areas of an image, leaving behind the most significant elements.

depth of field The distance in front of and behind the point of focus in a photograph in which the scene remains in an acceptable sharp focus.

diffusion The scattering of light by a material, resulting in a softening of the light and of any shadows cast. Diffusion occurs in nature through mist and cloud-cover, and can also be simulated using diffusion sheets and soft-boxes.

edge lighting Light that hits the subject from behind and slightly to once side, creating flare or a bright "rim lighting" effect around the edges of the subject.

extension rings An adapter that fits into an SLR between the sensor and the lens, allowing focusing on closer objects.

extraction In image editing, the process of creating a cut-out selection from one image for placement in another.

feathering In image-editing, the fading of the edge of a digital image or selection.

file format The method of writing and storing information (such as an image) in digital form. Formats commonly used for photographs include TIFF, BMP, and JPEG.

filter (1) A thin sheet of transparent material placed over a camera lens or light source to modify the quality or color of the light passing through. (2) A feature in an image-editing application that alters or transforms selected pixels for some kind of visual effect.

focal length The distance between the optical center of a lens and its point of focus when the lens is focused on infinity.

focal range The range over which a camera or lens is able to focus on a subject (for example, 0.5m to Infinity).

focus The optical state where the light rays converge on the film or CCD to produce the sharpest possible image.

fringe In image editing, an unwanted border effect to a selection, where the pixels combine some of the colors inside the selection and some from the background.

f-stop The calibration of the aperture size of a photographic lens.

graduation The smooth blending of one tone or color into another, or from transparent to colored in a tint. A graduated lens filter, for instance, might be dark on one side, fading to clear at the other.

grayscale An image made up of a sequential series of 256 gray tones, covering the entire gamut between black and white.

histogram A map of the distribution of tones in an image, arranged as a graph. The horizontal axis goes from the darkest tones to the lightest, while the vertical axis shows the number of pixels in that range.

hot-shoe An accessory fitting found on most digital and film SLR cameras and some high-end compact models, normally used to control an external flash unit.

HSB (Hue, Saturation, and Brightness) The three dimensions of color, and the standard color model used to adjust color in many image-editing applications.

hue The pure color defined by position on the color spectrum; what is generally meant by "color" in lay terms.

ISO An international standard rating for film speed, with the film getting faster as the rating increases, producing a correct exposure with less light and/or a shorter exposure. However, higher speed film tends to produce more grain in the exposure, too.

lasso In image editing, a tool used to draw an outline around an area of an image for the purposes of selection.

layer In image-editing, one level of an image file to which elements from the image can be transferred to allow them to be manipulated separately.

luminosity The brightness of a color, independent of the hue or saturation.

macro A mode offered by some lenses and cameras that enables the lens or camera to focus in extreme close-up.

mask In image-editing, a grayscale template that hides part of an image. One of the most important tools in editing an image, it is used to limit changes to a particular area or protect part of an image from alteration.

megapixel A rating of resolution for a digital camera, related to the number of pixels forming or output by the CMOS or CCD sensor. The higher the megapixel rating, the higher the resolution of images created by the camera.

midtone The parts of an image that are approximately average in tone, falling midway between the highlights and shadows.

monobloc An all-in-one flash unit with the controls and power supply built-in. Monoblocs can be synchronized together to create more elaborate lighting setups.

noise Random pattern of small spots on a digital image that are generally unwanted, caused by nonimage-forming electrical signals.

o-ring The rubber ring designed to prevent leaks in a waterproof housing.

panorama A wide framed image, generally at least twice as wide as high.

photomicography Taking photographs of microscopic objects.

pixel (PICture ELement) The smallest unit of a digital image—the square screen dots that make up a bitmapped picture. Each pixel carries a specific tone and color.

plug-in In image editing, software produced by a third party and intended to supplement a program's features.

ppi (pixels-per-inch) A measure of resolution for a bitmapped image.

reflector An object or material used to bounce available light or studio lighting onto the subject, often softening and dispersing the light for a more attractive end result.

resampling Changing the resolution of an image either by removing pixels (lowering resolution) or adding them by interpolation (increasing resolution).

resolution The level of detail in a digial image, measured in pixels (e.g. 1,024 by 768 pixels), lines-per-inch (on a monitor) or dots-per-inch (in a half-tone image, e.g. 1,200 dpi).

RGB (Red, Green, Blue) The primary colors of the additive model, used in monitors and image-editing programs.

saturation The purity of a color, going from the lightest tint to the deepest, most saturated tone.

selection In image editing, a part of an on-screen image that is chosen and defined by a border in preparation for manipulation or movement.

shutter The device inside a conventional camera that controls the length of time during which the film is exposed to light. Many digital cameras don't have a shutter, but the term is still used to describe the electronic control over the length of exposure for the CCD.

shutter speed The time the shutter (or electronic switch) leaves the CCD or film open to light during an exposure.

SLR (Single Lens Reflex) A camera which transmits the same image via a mirror to the film and viewfinder, ensuring that you get exactly what you see in terms of focus and composition.

soft-box A studio lighting accessory consisting of a flexible box which attaches to a light source at one end and has a diffusion screen at the other, softening the light and any shadows cast by the subject.

spot meter A specialized light meter, or function of the camera light meter, that takes an exposure reading for a precise area of a scene.

stitching In image editing, the process of merging a number of frames to form a larger, usually panoramic, image.

telephoto A photographic lens with a long focal length that enables distant objects to be enlarged. The drawbacks include a limited depth of field and angle of view.

TTL (Through The Lens) Describes metering systems that use the light passing through the lens to evaluate exposure details.

white balance A digital camera control used to balance exposure and color settings for artificial lighting types.

zoom A camera lens with an adjustable focal length giving, in effect, a range of lenses in one. Drawbacks include a smaller maximum aperture and increased distortion over a prime lens (one with a fixed focal length).

Index

Acknowledgments

The Author would like to thank the following for all their assistance in the creation of this title:

Bowens International	Photon Beard Ltd
Calumet	Redwing
Domke/Tiffen	nikMultimedia
Nikon UK	Zero Halliburton

Useful Addresses

Adobe (Photoshop, Illustrator)
www.adobe.com

Agfa www.agfa.com

Alien Skin (Photoshop Plug-ins)
www.alienskin.com

Apple Computer www.apple.com

Association of Photographers (UK)
www.the-aop.org

British Journal of Photography
www.bjphoto.co.uk

Corel (Photo-Paint, Draw, Linux)
www.corel.com

Digital camera information
www.photo.askey.net

Epson www.epson.co.uk www.epson.com

Extensis www.extensis.com

Formac www.formac.com

Fractal www.fractal.com

Fujifilm www.fujifilm.com

Hasselblad www.hasselblad.se

Hewlett-Packard www.hp.com

Iomega www.iomega.com

Kodak www.kodak.com

LaCie www.lacie.com

Lexmark www.lexmark.co.uk

Linotype www.linotype.org

Luminos (paper and processes)
www.luminos.com

Minolta www.minolta.com
www.minoltausa.com

Nikon www.nikon.com

Nixvue www.nixvue.com

Olympus
www.olympus.co.uk
www.olympusamerica.com

Paintshop Pro www.jasc.com

Pantone www.pantone.com

Philips www.philips.com

Photographic information site
www.ephotozine.com

Photoshop tutorial sites
www.planetphotoshop.com
www.ultimate-photoshop.com

Polaroid www.polaroid.com

Qimage Pro
www.ddisoftware.com/qimage/

Ricoh www.ricoh-europe.com

Samsung www.samsung.com

Shutterfly (Digital Prints via the web)
www.shutterfly.com

Sony www.sony.com

Sun Microsystems www.sun.com

Symantec www.symantec.com

Umax www.umax.com

Wacom (graphics tablets)
www.wacom.com